# The Utopian Fantastic

# The Utopian Fantastic

Selected Essays from the Twentieth
International Conference on the
Fantastic in the Arts

## *Edited by Martha Bartter*

*Contributions to the Study of Science Fiction and Fantasy, Number 105*
*C.W. Sullivan III, Series Adviser*

**Westport, Connecticut**
**London**

**Library of Congress Cataloging-in-Publication Data**

The utopian fantastic : selected essays from the twentieth International Conference on the Fantastic in the Arts / edited by Martha Bartter.
  p. cm.—(Contributions to the study of science fiction and fantasy, ISSN 0193–6875 ; no. 105)
  Includes bibliographical references and index.
  ISBN 0–313–31635–X
  1. Fantasy literature—History and criticism—Congresses.   2. Horror tales—History and criticism—Congresses.   3. Fantastic, The, in literature—Congresses.   4. Fantastic, The, in art—Congresses.   I. Bartter, Martha A.   II. Title.   III.   Series.
PN56.F34158   2004
809′.915—dc21        2003053627

British Library Cataloguing in Publication Data is available.

Library of Congress Catalog Card Number: 2003053627
ISBN: 0–313–31635–X
ISSN: 0193–6875

First published in 2004

Praeger Publishers, 88 Post Road West, Westport, CT 06881
An imprint of Greenwood Publishing Group, Inc.
www.praeger.com

Printed in the United States of America

The paper used in this book complies with the
Permanent Paper Standard issued by the National
Information Standards Organization (Z39.48–1984).

10 9 8 7 6 5 4 3 2 1

In memory of Lynn Williams, who introduced me to Utopia.

# Contents

# 1

# Not So Blind Hope: An Introduction

## Thomas J. Morrissey

"Dreams come in the day as well as at night."

—Ernst Bloch
*A Philosophy of the Future* (86)

"September 11," "Al Qaeda," "Osama bin Laden," "anthrax," "Iraq," "weapons of mass destruction": these are terms that either have become familiar or have taken on new meaning since attendees at the Twentieth International Conference on the Fantastic in the Arts explored utopia in 1999. For us who live in the far north, Ft. Lauderdale in March approaches utopia: nothing like an eighty-degree rise in temperature or the temporary replacement of snow-blinding landscape with eye-soothing green to make one believe in alternate realities. But as we flew to and from this extraordinary exploratory meeting of academicians, writers, editors, and artists, we could not know how different and traumatic air travel and much else would become just two and a half years later. We could not foresee the fall of the Twin Towers, the U.S. invasion of Afghanistan, and whatever horrors have plagued humanity since the writing of this Introduction. Younger conference participants could certainly recall the bombing of the Oklahoma City Federal Building, genocide in Rwanda, or the Tiananmen Square massacre. Many of us were old enough to remember the murders of the Kennedys and Dr. Martin Luther King, Jr. and the Cuban Missile Crisis. A smaller number could remember the initial revelation of the Holocaust or the spirit-killing deprivation of the Great Depression. No one present would have had first-hand experience with the Black Death, Genghis Khan, the fall of Troy, Knossos or a thousand other ancient cities, or the bitter last gasp of the most recent Ice Age that nearly finished off our species some 70,000 years ago. And Chicxulub—well, let's not go there. But we all knew that things like these have happened.

Neither the events of 9/11 nor the plethora of natural and self-inflicted disasters that preceded them have stopped the dreaming of better realities that probably began with the first beings who could be called genetically fully human. Why did those early people who braved the darkness to mount precarious scaffolds to paint the cave walls of the Pyranese undertake such a costly venture? Were they trying to appeal to a higher authority that could make their world more manageable? Were they practicing magic in the hope of taking control of nature? Or were they just dreaming?

We will never have definitive answers to these questions, but we do know that envisioning better, or at least different, worlds—whether in this world or the next, whether on this world or on others, whether in our time or some other, whether in plans for revolution or in philosophical and psychological musings, whether in serious works or comic spoofs—seems to be a more or less permanent human pursuit. There is, it seems to me, a path, however circuitous, connecting the caves of Lascaux and Zhoukoudian to the vatic vaults at Delphi and Cumae, to the recesses of Qumran that housed the mysterious Essenes and their Dead Sea Scrolls, to Plato's cave of hopeful allegory, all the way to the imaginary icy caverns of Coleridge's Xanadu and Kim Stanley Robinson's south pole of Mars. The utopian impulse would seem to be very real and very strong; however, whether that impulse is part of what it is to be human or simply the repeated manifestation of people's responses to their surroundings has been debated by scholars and worked over in utopian fiction. I tend to agree with Ruth Levitas that "utopia is a social construct which arises not from a 'natural' impulse subject to social mediation, but as a socially constructed response to an *equally* socially constructed gap between the needs and wants generated by a particular society and the satisfactions available to and distributed by it" (182–183). So, Lt. Commander Data (may he rest in pieces) would not need to feel impulsively utopian in order to achieve his positronic brain's desire. It would be a much easier thing for him to analyze any lingering imperfections in the socially constructed institutions that govern his being, Star Fleet and the Federation.

Of course, the human mind has conjured orgies of destruction too that have given utopians and dystopians plenty to which to respond. We have had our caves of death, such as those in the Pacific Theater in World War II and Afghanistan's Tora Bora region. But most of what we have done to ourselves has taken place right out in the open—the bloody battles, death camps, rape and pillage, enslavement, colonization, and murder that make some of us question whether our genes doom us to self–destruction. At the end of the early *Star Trek* episode "Arena," Captain Kirk says to Spock, "We're a very promising species, as predators go. Did you know that, Mr. Spock?" To which the half Vulcan responds, "I've frequently had my doubts." So have we all.

Collectively and repeatedly, we have displayed the pride of Ramses II or Ozymandias. Smug self-satisfaction is a primal enemy of utopia, for it assumes that in what Ernst Bloch calls the "Not-Yet," utopians will have nothing better to do than to fix their uncritical and adoring gaze on the monuments of the past. Nothing could be farther from the truth, for until utopia

is realized it cannot be fully conceptualized, nor can the perspective of the utopian be accurately or fully imagined.  In his cogent explanation of Bloch, Carl Freedman puts it this way:

Utopia can never be fixed in the perspective of the present, because it exits, to a considerable degree, in the dimension of futurity; not, however, in the future as the latter is imagined by mere chronological forecasting, or in mechanistic and philistine notions of bourgeois "progress," but rather as the future is the object of *hope*, of our deepest and most radical longings.  These are longings that can never be satisfied by the fulfillment of any individual wish (say, for personal wealth) but that demand, rather, a revolutionary reconfiguration of the world as a totality.  Utopian hope or longing, in other words, possesses an inherently collective character and at bottom has nothing to do with individualist impulses like greed. (64)

Hope is the magic ingredient that informs and vitalizes Levitas's "socially constructed response."   Aeschylus knew this 2,500 years ago when he wrote these lines for Prometheus: "I caused mortals to cease foreseeing doom" and "I placed in them blind hopes" (211).  Without critique or response, why would we expect the future to be any better than the present?  Without hope, why would we imagine a new day, and how could we appreciate the joyful audacity of the speaker of Yeats's "Lapis Lazuli," who, fully aware of the range of human suffering, tells us that "All things fall and are built again,/And those that build them again are gay" (292)?  It is a gift of the utopian imagination and a testament to those who have put their lives on the line for social change in the "real" world that some of those building current utopian visions are, in fact, gay—and lesbian too, as Lyman Tower Sargent tells us (343).

In addition to entering caves to paint pictures or plot murder, we are also very fond of storytelling.  What we think the world is, is becoming, or should be; what we think we are, were, or will be; what we think our stories are, or what they tell us, or what they do—these are conscious and unconscious attributes of the stories we have been telling each other since communication began, or so I imagine.  But for our purposes here, we are inviting you to read about our contributors' views on works which are generally recognized to be examples of or commentaries on the utopian project that began when Thomas More simultaneously invented and named a genre in 1516 and thereby set in motion an undertaking—utopianism—that, according to Sargent, "is not merely alive and well but flourishing" as the new century begins (343).

Despite the protections More builds around his person, his *Utopia* condemns the injustices of his society and invites his readers to make an imaginative leap of faith so that they might behold a new world.  The lens More uses is Christian, and we must not forget that he would one day be martyred for his adherence to some pretty conservative principles.  Fearing both the masses and the king, More wrote in Latin; hence, his critique of the corruption of his nation and time was accessible to but a small number of well-educated people, usually men, many of whom might have agreed with him but who were not likely to take up arms or cobblestones to bring about Christian communism.  Writing in the lingua franca of the elite affords More a freedom to criticize that he could not have had writing in the vernacular.  More further insulates himself

from the revolutionary thrust of his travelogue by filtering the criticisms of persons and institutions through Raphael Hythloday.  Despite this distancing, the program of his fictional traveler is unabashedly radical; Raphael says simply and forthrightly, "Thus I am wholly convinced that unless private property is entirely done away with, there can be no fair distribution of goods, nor can mankind be happily governed" (31).  This sentiment has, perhaps, different connotations for us, since we have seen nearly 500 years of capitalist evolution and many responses to it, most notably those of Marx and Engels.  But the central problem for Raphael's auditors is essentially the same failure of imagination that makes it hard for people to transcend their localized situations and imagine the Not-Yet. More the author describes Raphael's response to the skepticism about utopian achievements expressed by More the character in the book when he writes, " 'I am not surprised,' said Raphael, 'that you think of it in this way, since you have no idea, or only a false idea, of such a state' "   (32).

More and his successors are now available to pretty much anyone who wants to read them, and the wellsprings of hope are still gushing.  Since his day the world has enjoyed a vast array of visionary social critiques, but it has also endured unspeakable misery at the hands of those who would use force to impose on others their warped conceptions of utopia or those who would stop at nothing to defend the status quo and ideological hegemony.  I do not mean to suggest that utopian thinking is necessarily dangerous, for ever since as a teenager I read Aldous Huxley's *Island*, I have spent much of my time thinking utopian thoughts and, to some small but personally satisfying extent, trying to effect their implementation.  Utopian dreaming must not be lost in the day-to-day mess of the world.

More's *Utopia* is not science fiction and neither are quite a number of contributions to the utopian project, including Huxley's *Island* and some of the works discussed by the contributors to this volume.  However, the scientific revolution that began in More's century has changed the world in ways that he and his contemporaries could never have imagined.  Since Mary Shelley invented science fiction with *Frankenstein* in 1818, utopianism and science fiction have had a fruitful relationship.  It is not hard for some to dismiss as lightweight, unacceptably fantastic, or noncanonical utopian writing or science fiction, but they do so at their own peril.  Science and technology do not govern our world, but those who determine their use do, and science fiction, as the natural heir to prescience utopianism and as the crucible in which so much contemporary critique is forged, is just as "subversive a genre" (86) as Carl Freedman has claimed.  It is often contemporary science fiction that utopian dreams and dystopian nightmares are finding such exciting expression.  Patrick Parrinder writes that the coupling of science fiction and utopia is timely and fortuitous:

It stresses science fiction's commitment to visions of human transformation and credits it with an inherent—though frequently fragile, ambivalent, and compromised—potential for political radicalism.  To yoke science fiction and utopia together is also to direct scrutiny on the word science in science fiction: why science?   What effect do scientific perspectives have on utopian speculation? (2)

The fantastic in literature is certainly not limited to science fiction, but contemporary utopian fiction writers do tend to favor this route to the Not-Yet. Paul Kincaid writes, "What we are actually doing when we read science fiction is allowing ourselves to be mystified" (81). Could there be a better way to be transported toward the Not-Yet?

The chapters in this book grew out of presentations at the Twentieth Annual Conference on the Fantastic in the Arts. Their authors have had a chance to refine their ideas, so that we can now give you a book that asks some of the key questions that need constant and ongoing asking. We have grouped the chapters thus: (1) the why and where of utopia (2) reactions to hegemonic mechanization (3) the postcolonial Other in utopia (4) the question of hope and (5) thinking and doing utopia.

Thomas More was a polyglot punster: "Utopia" is *eutopos*, "the good place," or *ou topos*, "no place." Any utopian projection can be either or both of these or, in the case of dystopias, their opposites. More probably was not thinking of future theorists when he coined this particular neologism, but he certainly gave those who came after a lot to think and write about. How do we know if we have found eutopia and where are we when we do? The two largely theoretical chapters that introduce the book can give our readers a glimpse into some of the complications that bedevil utopianism. Roger C. Schlobin and John C. Hawley look at utopia from complementary perspectives. Schlobin searches the criteria that determine eutopia and dystopia. He tells us that "individuality, whether exalted or thwarted, is central to both utopias and dystopias." His chapter explores, among other things, personal freedom and will and the extent to which a work can be said to be utopian or dystopian by virtue of how much control it affords the individual. He surveys eighteen works, several of which are discussed in greater detail elsewhere in this volume, and he exposes the thinking of a number of the most important utopian theorists. The advent of the truly efficient totalitarian state in the mid-twentieth century and the emergence of powerful multinational corporations toward century's close lend great urgency to this issue. Hawley interrogates the spatial and temporal loci of utopia and discusses eloquently the open-endedness of anti-utopia, the utopian projection that cannot reach closure. A character who travels to utopia—and by extension the readers who share the journey—is never the same upon his or her return but must nonetheless function in a less-than-perfect environment. This cognitive dissonance underscores the richness of More's pun; is the *eut*opia that was visited *ou*topia or could we reach it one day?

What happens when the greedy leaders of More's England get their hands on advanced technology and can shape society to their own selfish purposes? Answer: we get the present. The concentration of wealth in the hands of a few that results from and perpetuates their control of the means of production and communication is a real and present barrier to utopia. The next five chapters explore responses to these phenomena of postmodern life. Donald E. Morse begins with a penetrating look at Kurt Vonnegut, Jr.'s *Player Piano*, a novel that he sees as the author's call for a society ruled by free citizens rather than by machines created by those who would enslave us all. Jeanne Beckwith is the only contributor to write about a dramatist's reaction to a world not much

different from the one in *Player Piano*. She sees Mamet's *The Water Engine* as a subversion of the "edisonade" and as an exposé of the big lie of materialist culture. Both Morse and Beckwith are, in effect, writing about critiques of what Ihab Hassan has called "GRIM," or the "Great Rumbling Ideological Machine" (22). Harlan Ellison's Ticktockman can stop one's heart; Hassan's GRIM can stuff one's head. Either way, the dominant culture is pervasive and cunningly persuasive. Political scientist Carl Swidorski explores the Marxist dimensions of Kim Stanley Robinson's Mars trilogy. Whether the Not-Yet is fully realized in *Blue Mars*, Robinson's novels take us through a series of Martian revolutions aimed at eradicating on that planet the barriers to true human freedom that are so entrenched on Earth. Mars has figured prominently in utopian projections, including, among others, Weinbaum's "A Martian Odyssey," Bradbury's *The Martian Chronicles*, Heinlein's *Stranger in a Strange Land*, Bear's *Moving Mars*, and the film *Total Recall*, so it is fortunate that we have an incisive reading of one of the most overtly political works in the Martian/Utopian megatext.

The scientific revolution that began in sixteenth-century Europe and which has ever since picked up steam, electricity, and nuclear fission has made the contemporary world both possible and impossible. In her fast-paced chapter, "Women and Mad Science: Women as Witnesses to the Scientific Re-creation of Humanity," Cherilyn Lacy explores via *The X-Files* and *Frankenstein* scientific ethics, or the lack thereof. Her central thesis is "that since the very outset of the Scientific Revolution, Western conceptions of science have frequently relied upon gendered metaphors that characterize science as a masculine enterprise that manipulates Nature and coerces *her* secrets out of *her*." Moving from biology to computer science, Dennis M. Weiss probes the work of William Gibson to ask what the digital cosmos offers us where we might fit in it. Weiss's chapter is important reading at a time when identity theft and cyber surveillance have emerged not only as potential enemies of utopia but as real, everyday dystopian nightmares. Consider this report from computer scientist Neil Gershenfeld concerning a startling near-future invention and try to decide if it is utopian or dystopian:

We have made prototypes of a computer that fits in a shoe and is designed to recover energy from walking, so it wouldn't need batteries. By manipulating tiny voltage changes receivers in different parts of the body, we can turn the body into a network capable of transmitting data. So you could shake someone's hand, transmit data from your shoe computer, or exchange electronic business cards. ("Discover Dialog" 14)

Computer technology, like all technology, is not just a tool. As Michael Philips explains, "our technology does not simply constitute an environment within which we act; it also constitutes an important and increasingly pervasive domain of action" (297). How do we separate the dancer from the digital dance? Weiss asserts that William Gibson's work is ambivalent on the subject of our cyber future. The playfulness of such contemporary cyber explorers as Neal Stephenson and Jeff Noon would suggest that cyber utopian writing can still imagine multiple gates to the future.

Ernst Bloch ends his 1963 book *A Philosophy of the Future* with this vision of a global quest: "In all its revolutions, the Western concept of progress has never implied a European (and of course not an Asiatic or African) vanguard, but a better Earth for all men" (141). This might seem like a shocking statement to some since it is likely to evoke the nineteenth century's myth of progress so artfully debunked by H. G. Wells in *The Time Machine* and *The War of the Worlds*. Among this myth's pernicious offspring are the legacy of Social Darwinism and the Scramble for Africa. Bloch's idea of progress is the humanity-saving hope associated with social visionaries such as Marx: "The meaning of human history already there from the start is the building of the commonwealth of freedom" (139). In the four decades since this book, however, it has become painfully clear that the colonial hangover is not about to go away and that utopian progress in the former colonies faces huge obstacles. The crushing international debt of poor countries that owe their poverty to their creditors; the destruction of traditional ways of life, including land use and agricultural practices; the not-so-benign neglect of suffering, whether violence inflicted by the corrupt heirs to colonial government or the social dislocation brought about by AIDS are all part of the legacy of colonialism as manifested in the discouraging realities of contemporary geopolitics. Then, there is the question of alterity and the extent to which the invaders still occupy part of the minds of their former subjects. This kind of deep psychological colonization is important to the utopian project in a diverse world, and it is well suited to science fictional interrogation.

Two chapters in our volume address postcolonial issues. Bill Clemente's treatment of Suzy McKee Charnas's Alldera novels stresses the near impossibility of reconciliation when a power-mad industrial society engages in the radical dehumanization of the Other, in this case women. Both colonizer and colonized are damaged, and Charnas's Free Fems and horse women face a problem that is all too familiar in our world: "the patterns of power their history taught them weave a tight web of behavior not easily unraveled." Lynn F. Williams and Martha Bartter elucidate the painful case of Kirinyaga, the space colony started by traditional Kikuyus, where the white man's ways and wares are rejected at almost any cost. A desire for stasis and separatism is not uncommon in the utopian canon, but in this novel the issues are flavored by postcolonial backlash. Although it is true that the space colony is not Kenya and that its leader, the *mundumugu* Koriba, himself rails against the damage that Europeans have wrought, Koriba's radical and unyielding utopianism seems to be infected with same malady that Leela Gandhi attributes to the formerly colonized: "we might conclude that the postcolonial dream of discontinuity is ultimately vulnerable to the infectious residue of its own unconsidered and unresolved past. Its convalescence is unnecessarily prolonged on account of its refusal to remem-ber and recognise its continuity with the pernicious malaise of colonialism" (7). What we were not able to do in this section because of the array of essays available to us was to include genuine subaltern voices. In a conversation about utopianism and science fiction recorded in the pages of *Foundation*, Nalo Hopkinson comments, "I think the genre is mutating as people from different communities claim space in it." She specifically cites women,

gays, and working-class writers, but she laments, "It's still largely a North American and European genre" (Burwell 46). She herself has claimed that space in her own novels. Although we have included two fine chapters, we must acknowledge that we would like to have been able to present more postcolonial voices.

Does hope spring eternal in the human breast? Not in Robin Anne Reid's feminist reading of Sheri S. Tepper's trilogies, books she feels advocate reform at the most basic level: the human genetic code. Where are Arthur C. Clarke's Overlords or Octavia Butler's Oankali when we need them? Speaking of Butler, at the other pole, Oscar De Los Santos looks for iconic deliverance from among the ruins of *The Parable of the Sower* and David Brin's *The Postman*. Salvation through the Earthseed philosophy and the Postal Service is not as farfetched as it might sound: hang on to the Not-Yet with the help of positive icons and you just might have a chance.

The last trio of chapters merge utopian thinking and action in the dynamic processes of reader response. Tamara Wilson presents us with a kind of ethnography of a class of students struggling with Tepper's *The Gate to Women's Country*. Her essay is at once personal and academic as it recounts how she and her students tried to come to terms with the horrors of the post-nuclear environment in which the ruling women must wrestle with the most fundamental ethical question that any leaders can face: how many sins must we commit in order to guarantee happiness for the greatest number? Teaching utopian literature often poses such challenges because students are often deeply moved or troubled by what they read. Is this not the goal of teaching a genre the essence of which is thinking out of the conventional box? Tepper's novel is one of three prominent examples of separatist feminist utopias from the 1980s (Pamela Sargent's *The Shore of Women* and Joan Slonczewski's *A Door Into Ocean* are the others), and we are glad to have one of them explored in this volume.

Sharon Stevenson's postmodern reading of three women novelists treats their versions of impending dystopia as calls to action. Have we reached the point at which the human failings that plagued the world of Thomas More have become so out of control that the utopian project must be a bastion of hope and resistance? The final chapter is Kelly Searsmith's elegant recuperation of romance tradition fantasy. When I began reading this chapter I wondered how it could possibly make me rethink my assumptions about this genre, but soon I found that my prejudices were unfounded and that even in unlikely places we might find books that can inspire readers to consider "mutual definitions of what is sacred, what contested, what inert, and what taboo." Why that should have come as a surprise to someone who has just coauthored a book on *Pinocchio* I don't know, but it did. Searsmith gets to the heart of the power of art to permeate the consciousness.

Utopian writing is alive and well because it is important. It speaks directly to readers who are seeking alternative visions of reality, new lenses with which to focus an often blurry or dark world. It can also surprise readers who didn't think they were looking for anything but entertainment. Whether it comes from reading such books or from combating the day-to-day stresses of a

society that seems to so many people to have taken leave of its sensibilities, everyone who has not bought into a packaged vision of reality faces (and I'm sure even they do in moments of doubt) some version of the problem that Kelly Searsmith succinctly describes in the closing chapter: "For Postmodern thinkers, identity is not a coherent understanding of a whole, unique self that one works toward; it is a negotiation of social constructs, a performance of social scripts, a mediated and dynamic process of self-fashioning." Thomas More looked at his world and found it wanting, but that was not necessarily at odds with his Christianity, as much as it might have offended his Humanism. In our world ideological certainties are more and more being packaged for us and fed to us through nearly every avenue of cultural transmission. Some may find Jack Zipes's description of postmodern to be a little harsh, but the sentiment he expresses is at the heart of much of contemporary utopian/dystopian thought:

Total control of our natural and induced desires seems to offer hope. So it is no surprise to me to see totalizing tendencies in all aspects of society. The totalitarian nature of the former communist states in Eastern Europe and the Far East were vapid in comparison with the capitalist conglomerates that penetrate our lives constantly in the name of globalization. (xi–xii)

His Holiness the Dalai Lama says much the same thing from a very different perspective, but one that should resonate with anyone who has been paying attention to the developing machine metaphor in this introduction, when he writes, "Modern industrial society often strikes me as being like a huge self-propelled machine. Instead of human beings in charge, each individual is a tiny, insignificant component with no choice but to move when the machine moves" (8). While individuals are being disempowered, humans as a species are more powerful and dangerous than at any other moment in history. We—no matter who "we" includes—have the power to end the world; the future is literally in our (or someone's) hands. Can we avoid the abyss of destruction, escape the cogs of the machine, maintain hope and look not to a GRIM future but a bright one? That is the question that in one way or another inheres in every chapter in this volume. Think about the various barriers to utopia that I have presented as you read this comment from the Dalai Lama: "we need to take others' feelings into consideration, the basis for which is our inner capacity for empathy. And as we transform this capacity into love and compassion, through guarding against those factors that obstruct compassion and cultivating those conducive to it, so our practice of ethics improves" (77). Can we imagine a utopia that is not informed by ethical behavior? Are not compassion and empathy the bulwarks against dystopia? Exactly where does each of us want to live today and tomorrow? In a lyrical explanation of Ernst Bloch, Carl Freedman writes, "Utopia is the homeland where no one has ever been but where alone we are authentically at home" (65). We hope you are at home as you read these fourteen authentic contributions to utopian thinking.

## REFERENCES

Aeschylus. *Prometheus Bound*. Trans. David Grene. *The Complete Greek Tragedies, Vol. I.* New York: Modern Library, 1942.

"Arena." *Star Trek*. Created by Gene Roddenberry. Dir. Joseph Pevney. Episode 19.1967. Hollywood: Paramount Home Video, c1978.

Bloch, Ernst. *A Philosophy of the Future*. Trans. John Cumming. New York: Herder & Herder, 1970.

Burwell, Jennifer, and Nancy Johnston, eds. "A Dialog on SF and Utopian Fiction, between Nalo Hopkinson and Élisabeth Vonarburg." *Foundation*. 30.81 (Spring 2001): 40–47.

Dalai Lama (His Holiness). *Ethics for the New Millennium*. New York: Riverhead Books, 1999.

"Discover Dialog: Physicist Neil Gershfeld." *Discover* January 2003: 14.

Freedman, Carl. *Critical Theory and Science Fiction*. Hanover, NH: Wesleyan University Press, 2000.

Gandhi, Leela. *Postcolonial Theory: A Critical Introduction*. New York: Columbia University Press, 1998.

Hassan, Ihab. "Pluralism in Postmodern Perspective. *Exploring Postmodernism: Selected Papers Presented at a Workshop in Postmodernism at the XIth Annual Comparative Literature Congress, Paris, 20–24 August 1985*. Ed. Matei Calinescu and Douwe Fokkema. Amsterdam and Philadelphia: John Benjamins, 1987.

Kincaid, Paul. "What Do We Do When We Read Science Fiction?" *Foundation*. 29.78 (Spring 2000): 72–82.

Levitas, Ruth. *The Concept of Utopia*. Syracuse, NY: Syracuse University Press, 1990.

More, Thomas. *Utopia: A New Translation, Backgrounds, Criticism*. Ed. and Translator Robert M. Adams. New York: W. W. Norton, 1975.

Parrinder, Patrick, ed. *Learning from Other Worlds: Estrangement, Cognition, and the Politics of Science Fiction and Utopia*. Durham, NC: Duke University Press, 2000.

Philips, Michael, ed. *Philosophy and Science Fiction*. Buffalo, NY: Prometheus Books, 1984.

Sargent, Lyman Tower. "Utopia and the Late Twentieth Century: A View from North America." *Utopia: The Search for the Ideal Society in the Western World*. Ed. Roland Schaer, Gregory Claeys, and Lyman Tower Sargent. New York: Oxford University Press, 2000. 333–345.

Yeats, William Butler. "Lapis Lazuli." *The Collected Poems of William Butler Yeats: Definitive Edition with the Author's Final Revisions*. 1950. New York: Macmillan, 1966: 291–293.

Zipes, Jack. *Sticks and Stones: The Troublesome Success of Children's Literature from Slovenly Peter to Harry Potter*. New York: Routledge, 2001.

# Dark Shadows and Bright Lights: Generators and Maintainers of Utopias and Dystopias

## Roger C. Schlobin

The search for the sources of utopias and dystopias—their generators and maintainers—requires a consideration of others' suggestions before arriving at perhaps a simpler distillation of their bright and dark hearts. However, before preceding even to that, it is important to observe that utopia is, almost certainly, fantasy in its conception and realization, and dystopia science fiction, horror, or reality in its. Richard Gerber, in *Utopian Fantasy*, observes that "utopian creations tend to be fantastic because their civilizations are so unheard of that they cannot be placed anywhere on earth without being wildly incongruous; while, as soon as placed among the stars or in the future, they become even more fantastic, because they are out of our reach of knowledge" (86). While Brian Attebery disagrees and contends that "utopias attempt to show how mankind could satisfy all needs, whereas fantasy, as Tolkien says, exists not to satisfy desire but to awaken it" (8), the failures of real-world utopias, such as the Ephrata Community, New Harmony, Brook Farm, and Oneida Community, and the minor successes of religious communal societies, such as the Hutterites, do seem to indicate that ideal worlds remain beyond human reach and, at their essence, are fantasy, whether they pursue Isaac Asimov's opposing Foundations or Stephen R. Donaldson's freedom from "despite." Of course, in heroic fantasy, the seductively languorous pleasant place is anathema to the hero (Schlobin, "*Locus*" passim). Dystopia, the nightmare to utopia's daydream, is very real and constitutes mimetic literature, especially since the Holocaust.

For their inspirations, it seems appropriate to begin with someone like H. G. Wells. He observed that "Throughout the ages the utopias reflect the anxieties and the discontents amidst which they were produced. They are, so to speak, shadows of light thrown by darkness" (119). Paul Ricoeur echoes Wells and suggests that at "a time when everything is blocked by systems which have failed but which cannot be beaten . . . utopia is our resource. It may be an escape, but it is also the arm of critique. It may be that particular times call for

utopias" (300).   Beatriz de Alba-Koch's examination of utopian novels in nineteenth-century Mexico builds on Ricoeur's unspecified "systems" to assert that, during the Mexican civil strife from 1857 to 1871, "many Mexicans felt that their society was 'blocked' and in need of utopias" (17).

Given this discontent, emphasized in dystopias and alleviated in utopias, it becomes difficult to specify the exact nature of inspiration, but there are numerous attempts.   Tom Moylan, drawing heavily on the theories of Ernst Bloch, suggests utopias are "expressions of unfulfilled desire resisting the limitations of the present system and breaking beyond with 'figures of hope' not yet realized in our everyday lives" ("Locus" 165).   This type of conflict has long been outlined by the Marxist dialectic, but that has not prevented some from trying to reinvent it under different titles and descriptions.   Lyman Tower Sargent asserts that dystopias, while not being anti-utopias, do recall a pleasant, contrastive past (138).   Moylan outlines further resurrections of thesis-antithesis from Søeren Baggeson and Hoda Zaki ("Global" 186).   Christian Marouby calls these the "paradigmatic oppositions" that distinguish savagery from civility (150), such as "order/disorder; hierarchy/anarchy; teleological/repetitive time; accumulation/consumption, etc." (150).   For Frederic Jameson, utopia is "a symptom and reflex of historical change" and a reaction to culture ("Progress" 149).   Of course, the penultimate example of antithetical extremes existing simultaneously is C. S. Lewis's *The Great Divorce* (1945) although Hell is hardly a dystopia in Judeo-Christian thought.   In *The Great Divorce*, the condemned and the saved occupy the same space with vastly different comfort levels.

Another approach is that "the ideological and the utopian are inextricably intertwined" as in Samuel Delany's *Triton* (1976) and *Star Trek* (Golumbia 91).   Frederic Jameson more emphatically asserts the ideological purpose of science in utopias (*Seeds* 77), an observation supported by N.I.C.E. and its "head" in C. S. Lewis's *That Hideous Strength* (1945) and numerous other works.

In the postmodern and poststructural world, there is considerable support and discussion of utopianism as a rebellion against elemental and ideological tyrannies of gender and color with their socially oppressive languages and symbols (Ketterer 97, Guerin 199).   For example, Hélène Cixous's *Le Nom d'Oedipo. Chant du corps interdit* (1978—*The Name of Oedipus. Song of the Forbidden Body*) and Christina Wolf's retelling of the Cassandra myth, *Kassandra* (1983) both describe intelligent and sensible women who come into conflict with social norms and taboos so intensely that "they are rendered mute" (Brügmann 41). Sally Gearheart's *The Wanderground* (1978) describes a female utopia arising when "the earth finally said 'no' " to men's exploitation, viciousness (Fitting 103), and law, which parallels J. S. Bradford's much earlier *Even a Worm* (1936), in which the animal kingdom raises up against all of humanity.   Elizabeth Mahoney explains how women challenge gender-inherited power and culture-specific power in Margaret Atwood's *The Handmaid's Tale* (1985) and Vlady Kociancich's *The Last Days of William Shakespeare* (1990), respectively (29–30), just as Christine Brooke-Rose's *Out* (1964) creates a world in which the "Coloured" are masters.   While

these examples may seem negative or exclusionary, that doesn't mean that postmodernists reject utopia. Tobin Siebers is much less specific about the utopian goals of this era but that doesn't blunt the desire: "Postmodernists, then, are utopian not because they do not know what they want. They are utopian because they know they want something else" (3). Further, Wilfred Guerin, in exploring psychoanalytical feminism, observes, "French feminists who follow Lacan, particularly Hélène Cixous, propose a utopian place, a primeval female place which is free of symbolic order, sex roles, otherness, and the Law of the Father and in which the self is still [?] with what Cixous calls the Voice of the Mother. This place, with its Voice, is the source of all feminine power, Cixous contends; to gain access to it is to find a source of immeasurable feminine power" (204).

For David Ketterer, American society was a hoped-for utopia that has, disappointingly, violated expectations and become a dystopia (23, 94); the penultimate example of this is Nathaniel Hawthorne's "Young Goodman Brown." Ketterer indicates that this explains the messianic impulse, the search for a panacea, in Kurt Vonnegut's novels, especially in *Cat's Cradle* (1963) (296), and Robert A. Heinlein's *Stranger in a Strange Land* (1961). This disillusionment with the American dream may also explain why an increasing number of negative novels and films are set in California. Interestingly, Roger Zelazny deconstructs this messiah or superman in *Lord of Light* (1967) with his reluctant and quickly departed protagonist, Sam. Zelazny, also, demonstrates the perils of world making in both *Isle of the Dead* (1969) and the Amber series (1970–1991). Arthur C. Clarke demonstrates the irony of saviors in *Childhood's End* (1953). One of the more whimsical of utopian heroes is the dragon in Eden Phillpotts's *The Lavender Dragon* (1923). He steals peasants away to his own antifeudalism village where they prosper, become self-sufficient, and ultimately mourn when he, much in the manner of Beowulf, dies slaying an evil dragon that threatens them. Not being an American might explain why J.R.R. Tolkien never gets interested in messiahs at all, preferring that a gardener and an obsessed outcast destroy Sauron's potential dystopia.

In William Gibson's cyberpunk trilogy—*Neuromancer* (1984), *Count Zero* (1986), and *Mona Lisa Overdrive* (1988)—the dystopian control is supplied by international corporations and criminal organizations. They contend with utopian revolutionaries for control of an information matrix that is the key to economic and social control (Moylan, "Global" 187).

Another way that dystopia is inspired is through greed and its resultant dehumanization. Harold Nicolson, in a contemporary review of *Nineteen Eighty-Four* (1949), indicates dystopia is quick to follow those who allow their "humanistic heritage to be submerged in a flood of Materialism" (Meyers 257).

Christian Marouby explains that only by perceiving themselves as the deliverers of order to savages could the European's justify colonialism (150– 152), yet another way one person's utopia is another's dystopia. Interestingly, one of the contemporary reviews of *Nineteen Eighty-Four*, Frederic Warburg, inadvertently stressed this when he observed that one of Orwell's failures was that "*he nowhere indicates the way in which man, English man, becomes bereft of his humanity*" (Meyers 247, Warburg's stress).

Patrick Parrinder explores a body of work that develops physical beauty through eugenics as the utopian goal and inspiration (1), seemingly indicating that ugliness is dystopian.

Finally, the dystopian can be self-inflicted, as King Haggard and Mommy Fortuna prove in Peter S. Beagle's *The Last Unicorn* (1968) or as numerous malcontents demonstrate in John Brunner's "Traveler in Black" short series (1971).

To summarize from this perhaps selective survey, dystopias and utopias certainly pervade everywhere and can be produced by the following: reactions to anxieties and discontent, suffering and pain, blocked and failed social systems, tyrannical languages and symbols, oppression of gender and color, dehumanization, loss of the "American dream," science and machines, materialism, antithetical cultures, ideologies, and colonialism. They can also be produced by natural historical conflict and by the pursuit of human autonomy, change, control of information, and beauty. Finally, they can be self-inflicted or self-generated.

However, none of these eighteen seem to cut to the seminal impulse. Eric S. Rabkin comes close when he suggests, using Ayn Rand's *Anthem* (1946) as an illustration, that the death of "I" is central to dystopia (5). The logical assumption would be that the life of "I," then, is central to utopias. Thus, all dystopias "struggle with a paradox: individuality is messy, inefficient, harmful to others, and often just as harmful and distressing to it possessor. Freedom is necessary for individuality. Making man into a happy machine, however, robs life of its sense of meaning. Freedom blights happiness for many people, but insured happiness for the greatest number can only be achieved by abolishing freedom" (Hume 111). This explains why the majority of the characters in the television series *The Prisoner* (1967–1968) are happy in the Village, their gilded cage, which appears to them to be utopia but is actually dystopia.

Certainly, individuality, whether exalted or thwarted, is central to both utopias and dystopias. As a result, both deal with personal and collective history in different ways. Marouby says that "It is a well known characteristic of [seventeenth- and eighteenth-century] classical utopia that it has no history. A static society artificially created once and for all in its perfect state, and for this very reason impervious to change, utopia is fundamentally ahistorical" (159). However, if utopias are visionary, his conclusion does not extend to nineteenth- and twentieth-century examples. Of course, an immediate example of a dystopia attempting to control the individual by controlling history, and eliminating the past, is George Orwell's *Nineteen Eighty-Four* and its "double-speak." In contrast, and as further support for a utopian awareness of history, Peter Fitting argues for self-awareness and for "utopian visions as a mobilizing imagery in the struggle for a more human world because they help us to articulate exactly what we are struggling for and what we understand by a qualitatively different society" (101). Jack Zipes adds action to the mix when he indicates "the fairy tale has always projected the possibility for human autonomy and eros and proposed means to alter the world" (3). Finally, and if only for comic relief, Kurt Vonnegut, in *Player Piano*, provides a definition of self-realization and utopia as myopic as anyone's. As Finnerty watches the

aftermath of the luddites' abortive rebellion against all machines, including their foolish destruction of even the bakery and the sewage plant, he observes, "If only it weren't for the goddamned people . . . always getting tangled up in the machinery. If it weren't for them, earth would be an engineer's paradise" (313).

The final clue for the actual essence of the utopian/dystopian is provided by Thomas P. Dunn and Richard D. Erlich. They observe that human triumph is not a foregone conclusion in

recent dystopias and in novels, films, and stories with strong dystopian elements. In such works, the hive or machine or hive-machine becomes an important feature or the major setting for the work. The hive or machine is the essential condition of human life. To resist the hive or machine is to rebel against the entire social system, and, as often as not, the protagonist is crushed, destroyed, or rendered trivial. In such worlds, the hive or machine becomes the symbol for the things in human life that can render us helpless, insignificant unhuman. This, we believe, is why so many recent dystopian or generally pessimistic works stress images of containment and restricted movement, and why allusions to insect societies are so frequent. And this, we believe, is why so many recent works, dystopian and pessimistic, have a central theme in which the protagonist is imprisoned, or bound, or allowed to walk free only on the condition of perpetual surveillance or control. We find literal binding of the protagonist, or strong capture- and containment-imagery, in *every* major work we have looked at (49).

There are those who believe such inescapable entombment, like Room 101 in the Ministry of Love in *Nineteen Eighty-Four* or the dentist's chair at the end of the film *Brazil* (1985), is the archetypal human phobia. It is not. Loss of control is (which demonstrates that dystopia is a subset of horror—cf. Schlobin, "Children"). Thus, utopias will always celebrate the power of individual will, and dystopias will negate it. Their appeals, then, are sharing the wish fulfill-ments of the enfranchised and empathizing with the nightmares of the disen-franchised, respectively. Their inspirations are not the eighteen narrower ones listed earlier, although they all point to variations of this essential characteristic. Rather, in utopias, the inspirations are the perceived needs to exercise the will in the reverie of the ideal world to escape or create in and, in dystopias, to mourn or satirize the impotency of the will to free itself from the dark world.

## REFERENCES

Alba-Koch, Beatriz de. "The Dialogues of Utopia, Dystopia and Arcadia: Political Struggle and Utopian Novels in Nineteenth-Century Mexico." *Utopian Studies: Journal of the Society for Utopian Studies* 8.1 (1997): 20–30.

Attebery, Brian. "Fantasy as an Anti-Utopian Mode." *Reflections on the Fantastic: Selected Essays from the Fourth International Conference on the Fantastic in the Arts.* Ed. Michael R. Collings. Westport, CT: Greenwood, 1986.

Brügmann, Margret. "Critical Resistance or Utopia? Questioning the Use of Mythical Protagonists to Explore Feminine Identity." *Who's Afraid of Femininity? Questions of Identity.* Ed. Margret Brügmann et al. Amsterdam and Atlanta: Rodopi, 1993. 31–42.

Dunn, Thomas P., and Richard D. Erlich. "A Vision of Utopia: Beehives and Mechanization." *JGE: The Journal of General Education* 33.1 (1981): 45–57.

Fitting, Peter. "For Men Only: A Guide to Reading Single-Sex Worlds." *Women's Studies* 14.2 (1987): 101–117.

Gerber, Richard. *Utopian Fantasy: A Study of English Utopian Fiction Since the End of the Nineteenth Century*. 1955. New York: McGraw-Hill, 1973.

Golumbia, David. "Black and White World: Race, Ideology, and Utopia in *Triton* and *Star Trek*." *Cultural Critique* Winter 1995-96: 75–95.

Guerin, Wilfred L., et al. *A Handbook of Critical Approaches to Literature*. 4th ed. New York and Oxford: Oxford University Press, 1999.

Hume, Kathryn. *Fantasy and Mimesis: Responses to Reality in Western Literature*. New York and London: Methuen, 1984.

Jameson, Frederic. "Progress Versus Utopia: or, Can We Imagine the Future." *Science Fiction Studies* 9.2 (1982): 147–158.

———. *The Seeds of Time*. New York: Columbia University Press, 1994.

Ketterer, David. *New Worlds for Old: The Apocalyptic Imagination, Science Fiction, and American Literature*. Garden City, NY: Anchor/ Doubleday, 1974.

Mahoney, Elizabeth. "Writing So to Speak: The Feminist Utopia." *Image and Power: Women in Fiction in the Twentieth Century*. Ed. Sarah Sceats and Gail Cunningham. London and New York: Longman, 1996. 29–40.

Marouby, Christian. "Utopian Colonialism." *North Dakota Quarterly*. 56.3 (1988): 148–160.

Meyers, Jeffrey, ed. *George Orwell: The Critical Heritage*. London and Boston: Routledge & Kegan Paul, 1975.

Moylan, Tom. "Global Economy, Local Texts: Utopian/Dystopian Tension in William Gibson's Cyberpunk Trology." *Minnesota Review* 43–44 (1995): 182–197.

———. "The Locus of Hope: Utopia Versus Ideology." *Science-Fiction Studies* 9.2 (1982): 159–166.

Parrinder, Patrick. "Eugenics and Utopia: Sexual Selection from Galton to Morris." *Utopian Studies: Journal of the Society for Utopian Studies* 8.2 (1997): 1–12.

Rabkin, Eric S. "Atavism and Utopia." *No Place Else: Explorations in Utopian and Dystopian Fiction*. Ed. Eric S. Rabkin, Martin H. Greenberg, and Joseph D. Olander. Carbondale and Edwardsville: Southern Illinois University Press, 1983. 1–10.

Radway, Janice A. *Reading the Romance: Women, Patriarchy and Popular Literature*. London: Verso, 1987.

Ricoeur, Paul. *Lectures on Ideology and Utopia*. Ed. George Taylor. New York: Columbia University Press, 1986.

Sargent, Lyman Tower. "Utopia—The Problem of Definition." *Extrapolation* 16.2 (1975): 137–148.

Schlobin, Roger C. "Children of a Darker God: A Taxonomy of Deep Horror Fiction and Film and Their Mass Appeals." *Journal of the Fantastic in the Arts*, 1, No. 1 (1988): 25–50.

———. "The *Locus Amoenus* and the Fantasy Quest." *Kansas Quarterly* 16.3 (1984): 29–33.

Siebers, Tobin. "Introduction." *Heterotopia: Postmodern Utopia and the Body Politic*. Ed. Tobin Siebers. Ann Arbor: University of Michigan Press, 1994. 1–38.

Vonnegut, Kurt, Jr.. *Player Piano*. 1953. New York: Avon, 1970.

Wells, H. G. "Utopia." [1939]. *Science-Fiction Studies* 9.2 (1982): 117–121.

Zipes, Jack. "Recent Trends in the Contemporary American Fairy Tale." *Functions of the Fantastic: Selected Essays from the Thirteenth International Conference on the Fantastic in the Arts*. Ed. Joe Sanders. Westport, CT: Greenwood, 1995, 1–17.

# 3

# Mapping Utopia: Spatial and Temporal Sites of Meaning

## John C. Hawley

In classic imaginings of places that are pointedly *Not Here* (More's *Utopia* itself, Swift's *Gulliver's Travels*, Butler's *Erewhon*, Hilton's *Lost Horizon*, Hudson's *Green Mansions*, Barrie's *Peter Pan*) one could argue that such sites are proposed specifically to provide a unique angle of vision on the society against which they are "placed": their rules for living are offered as implied commentary on the (less acceptable) rules of the author's home land. In such worlds, the critique frequently enough casts the "real" world as a dystopia, one that may or may not be open to improvement. A softer version of the critique might be seen in works such as Thoreau's *Walden*, Adams's *Watership Down*, and St. Augustine's *The City of God*, with their implied suggestion that this better world may, in some sense, be already present in front of our faces, had we but eyes to see. The fault is in ourselves, so the message goes, and we are offered hope that we may gain *new* eyes through a new way of seeing and, of course, of being.

An observation that links these two spatial envisionings of utopia would be that the effect that visiting such a place on the protagonist is, itself, of major interest to the authors. More often than not, one returns a changed individual, in some sense a better person but less able to accommodate oneself to the world others consider "ordinary"; such afflicted individuals are consequently less acceptable to those who never left home. It is a reversal of the worldly adage, "How ya gonna keep 'em down on the farm, after they've seen Paree?": after Swift's protagonist visits the Houyhnhnms, the farm (or the stable, at least) doesn't look bad at all.

In various other utopian journeys, though, the trip is as much temporal as it may be spatial. If I may be permitted a neologism, we might more suitably describe this literature as "uchronian" rather than utopian. Think, for example, of Wells's *The Time Machine*, Asimov's *I, Robot*, Clarke's *Childhood's End*, Bellamy's *Looking Backward*, Woolf's *Orlando*, various Kurt Vonnegut novels, innumerable Star Trek episodes. Some novels, like Rider Haggard's *She*,

combine the spatial and temporal defamiliarization apparently to transgress the rules of both (only to fall back into a rather stodgy late Victorian sense of the dangers of a woman not knowing her place): Ayesha ("she who must be obeyed") significantly claims that "[her] empire is of the imagination" (175). It is interesting to observe that the temporal fantasies are arguably, as often as not, dystopic as they look to the future; they are immobilizing as they look to the past, since one dare not disturb the time line—everything connects, everything depends, and in these stories the ethical demands of assassinating a Hitler usually get portrayed much like the hubris of a Faust or a Dr. Frankenstein. The reader learns that the devil one knows may be preferable to the one our intervention could release.

In fact, for all the reforming impulse that one expects in utopian writing, at its heart is often conservative, sometimes paranoid, sometimes a self-indulgent whistling past the graveyard. In some cases, like Baum's *The Wizard of Oz*, we may be asked to conclude rather comfortingly that "there's no place like home"—and that, for all its fantastic amusement, those strange places that divert us for awhile are really the things of children, phases that one must pass through before seriously grappling with the nitty gritty responsibilities of adulthood—and grimly accepting that Kansas is as good as it's going to get.

On the other hand, a less conservative view shapes stories like Blish's *A Case of Conscience*, where it is the very foreignness of the "other" that frees the reader to reimagine his or her own world with fresh eyes that may require a new ethics to cope with responsibilities that are discernible only from far, far away. Many of these more exploratory utopian books seem reminiscent of Tennyson's account of an aging Ulysses, home at last from Troy but restless, finally leaving the rule to his son Telemachus so that he, aging though he may be, may strike out to the territory ahead, the new frontier. In an optimism that seeks, perhaps, to shout down the terrors of secularization, the loss of a sacred canopy, the rationalization of an empty universe, these works show the essentially romantic underpinnings of both utopias and dystopias—the hope (sometimes disguised as a fear) that there may *be* some "other" time and place, accessible to few of us, of course, but *perhaps* available to the individual reading the book. The "unrealistic," even self-indulgent nature of this imagining of the enterprise perhaps provides the underpinning for Judith Shklar's sad observation that "utopia and utopian have mostly come to designate projects that are not just fantasies but also ones that will end in ruin" (41).

And this connects us to the analysis Huntington brings to H. G. Wells. After discussing the mirror relations between utopian and dystopian writing, Huntington defines *anti*-utopian fiction, by which he means

a type of skeptical imagining that is opposed to the consistencies of utopia-dystopia. If the utopian-dystopian form tends to construct single, fool-proof structures which solve social dilemmas, the anti-utopian form discovers problems, raises questions, and doubts. . . . .It is a mode of relentless inquisition, of restless skeptical exploration of the very articles of faith on which utopias themselves are built. . . . .It is not an attack on reality but a criticism of human desire and expectation. . . .It enjoys the construction of imaginary community, but it does not succumb to the satisfactions of solutions. By the same mechanism the anti-utopia can acknowledge virtues in dystopia even while denouncing it. At the core of the anti-utopia is, not simply an ideal or a nightmare, but an

awareness of conflict, of deeply opposed values that pure utopia and dystopia tend to override.  If utopia seeks imaginative solutions, anti-utopia goes beyond to return to the powerful and disturbing ambivalences that come from perceiving simultaneous yet conflicting goods. (Huntington 142–43)

Thus, Huntington's usage of the term (and my own) are not to be confused with Krishan Kumar's, which seems roughly to equate it to dystopian writing (Kumar 99–130).

Without detailing Huntington's reading of Wells's career, which, in brief, he describes as a movement from "anti-utopian imaginings to utopian prophetic ones" (143)—in other words, as an increasingly conservative movement—I wish to refer to his study principally for this insight into the anti-utopian.  Though Huntington does not seem to make the connection between this and postmodernism, they share in common a distrust of endings or of systems; this goes far in explaining some recent science fiction and fantasy that raise more questions than they answer. In Wells's case, his late fiction loses some of its power because, in trying to become engaged with the problems of the world and therefore trying to offer solutions in his later utopian novels and stories, he is too aware of discrepancies in the world to propose convincing (utopian) solutions.  As Huntington notes, "a writer less attuned to the anti-utopian ironies of the world might succeed better at ignoring them" (147). But, grasping at straws to force a solution, the late Wells (as in *When the Sleeper Wakes*) sometimes "prefers the unambiguous horror of dystopia which, [he] implies, might be transformed to utopia" (148).

Huntington observes that this dilemma is the same for many utopian writers:

the deep structural contradictions cannot be mediated.   Either, as in the case of Zamyatin's *We*, we commit ourselves to an infinitely dialectical anti-utopianism, or, as in the case of Orwell's *Nineteen Eighty-Four* or, in a different spirit, Bradbury's *Fahrenheit 451* or Huxley's *Brave New World*, we quash ironic conflict and replace the puzzle with a single-valued structure, either dystopian or utopian. (148)

In short, Huntington notes that anti-utopia, which resists the wiles of both utopia and, ironically, dystopia, is an unsettling mixture of "yearning and skepticism" (149).

But there is another way of viewing this dynamic, as posed by the philosopher Paul Ricoeur. In his *Lectures on Ideology and Utopia* he joins together much of what Huntington criticizes in utopian and dystopian literature and calls it ideology—the drive toward integration, system, institution, dogma. Utopia, on the other hand, is "the constant ideal, that toward which we are directed but which we never fully attain" (xxi). It "functions to expose the gap between the authority's claim for and the citizenry's beliefs in any system of legitimacy" (xxii).

On the other hand, according to Ricoeur utopian writing has a darker side as well, because it can regress into "the completely unrealizable" and become fancy, madness, or escape:

Here utopia eliminates questions about the transmission between the present and the utopian future; it offers no assistance in determining or in proceeding on the difficult path

of action. Further, utopia is escapist not only as to the means of its achievement, but as to the ends to be achieved. In utopia no goals conflict; all ends are compatible. (xxii)

This escape from consequences, Ricoeur calls "the magic of thought." He therefore pushes for the ethical component possible in utopian writing, noting that "we must try to cure the illnesses of utopias by what is wholesome in ideology . . . and try to cure the rigidity, the petrification, of ideologies by the utopian element" (xxiii).

However, lest Ricoeur suffer criticism from such as Huntington for being naïve, we should note his emphasis on the process, on the "conflict of interpretations," on the paradigm shifts involved in conflicting metaphors for the ever-newly-coming-into-being of truth (xxix). As he writes, "we wager on a certain set of values and then try to be consistent with them; verification is therefore a question of our whole life. No one can escape this" (xxiii).

I will conclude with a brief example from two recent books that illustrate aspects of the two structures I have alluded to in this paper. One is Ken Grimwood's 1986 temporal utopia, *Replay*; the other is Mary Doria Russell's spatial dystopia, *The Sparrow* (1996). Russell tells the story of a combined scientific and missionary journey gone very bad. Only one explorer returns to earth, the Jesuit priest Emilio Sandoz. When he had been introduced, finally, to a leader of Rakhat (the target planet) his life had apparently suddenly come into a meaningful focus. Here is his reaction:

And then, suddenly, everything made sense to him, and the joy of the moment took his breath away. He had been brought here, step by step, to meet this man: Hlavin Kitheri, a poet—perhaps even a prophet—who of all his kind might know the God whom Emilio Sandoz served. It was a moment of redemption so profound he almost wept, ashamed that his faith had been so badly eroded by the inchoate fear and the isolation. He tried to pull himself together, wishing he'd been stronger, more durable, a better instrument for his God's design. And yet he felt purified somehow, stripped of all other purpose. (Russell 390)

But the encounter turns violent. The priest is continuously raped. Hlavin Kitheri then writes poetry rapturously describing the experience. Sandoz suddenly realizes that it was just such poetry, now revealed as pornography, that had reminded his fellow priests of religious music and had lured him to the planet in the first place. In short, his hermeneutical structure, his controlling metaphor, his paradigm of meaning, has been eviscerated. One might say he is experiencing the open-endedness that Huntington describes as anti-utopia, or the conflict of interpretations that Ricoeur posits as the dynamic for an engaged ethics that is both meaningful and non-ideological. But the others around him, and one suspects the author and most readers, as well, insist on bringing closure (and meaning) to the experience. His religious superiors remark:

"He's the genuine article . . . He is still held fast in the formless stone, but he's closer to God right now than I have ever been in my whole life." (400)

"Emilio is not despicable. But God didn't rape him, even if that's how Emilio understands it now." He sat back in the bench and stared at the ancient olive trees defining the edge of the garden. "There's an old Jewish story that says in the beginning God was everywhere and everything, a totality. But to make creation, God had to remove

Himself from some part of the universe, so something besides Himself could exist. So he breathed in, and in the places where God withdrew, there creation exists." (401)

Even as they recognize that he is *in process* ("held fast in the formless stone") they insist on stepping outside that process themselves and finding a false stasis that seems utopian in the extreme. "I don't even have the courage to envy him" (400), one priest remarks, failing to acknowledge that his own situation, in stark existential terms, is not that different from his rape victim's: both are still *engaged*, and can determine meaning for that process only in a never-to-be-achieved retrospect.

Ken Grimwood's novel, on the other hand, seems tailor-made as a parable of utopian possibilities that are open-ended, but it issues forth into a rather remarkably ambiguous (postmodern) conclusion. The protagonist, Jeffrey Winston, dies in 1998 but suddenly finds his consciousness back in his 1963 body and circumstances. He brings with him all his knowledge of what is now the future, and he makes choices accordingly—making spectacularly successful bets on the World Series and the stock market. Then he dies again in 1988, and is reborn a bit later than the first time. This happens again and again, with the time before death shortening with each replay. And in each life he makes new choices, finally meeting a woman in similar "replaying" circumstances. A unique love affair ensues (over several half-lifetimes). Finally they both approach what appears to be their final death, but their ordinary lives surprisingly resume and continue forward from 1988.

Comparisons might be made to Bierce's story, "An Occurrence at Owl Creek Bridge," and the films *Groundhog Day* (1993), *Forever Young* (1992), *Sliding Doors* (1998), and others. But the most telling comparison, perhaps, might be with the recent film *Pleasantville* (1998), where the people in black and gray in 1958 are portrayed as neo-fascist in their commitment to a "non-changist view of history, emphasizing continuity." When they once take a chance, express an uncomfortable emotion, do something out of character, they suddenly take on a bit of color. But their lives, of course, become less predictable, and more dangerous. Along similar lines, and sounding much like Paul Ricoeur, *Replay*'s protagonist concludes as his life moves into 1989 and beyond:

Each lifetime had been different, as each choice is always different, unpredictable in its outcome or effect. Yet those choices had to be made. . . . And yet, he mused, the years themselves would all be fresh and new [now], an ever-changing panoply of unforeseen events and sensations that had been denied him until now. New films and plays, new technology developments, new music—Christ, how he yearned to hear a song, any song, that he had never heard before! The unfathomable cycle in which he and Pamela had been caught had proved to be a form of confinement, not release. . . . Now everything was different. This wasn't "next time," and there would be no more of that; there was only *this* time, this sole finite time of whose direction and outcome Jeff knew absolutely nothing. He would not waste, or take for granted, a single moment of it...The possibilities, Jeff knew, were endless. (Grimwood 309–310)

This very didactic conclusion may be typical of utopian literature. Perhaps the ending could even be confused with that of *The Wizard of Oz*—but the focus is

not on "home" but on movement in time. The joy Jeff experiences is not because he has found security: in fact, with the irony typical of anti-utopian writing, he senses the energy and rectitude of the fact that, even though the possibilities are endless, *he* is *not*.

Even this bittersweet sense of an ending cannot long dwell in the imaginative invention of that apparent closure. The hand of the clock moves beyond the moment of imaginative surety, and the actual life remains open-ended. This is the sort of contemporary writing that acknowledges, with a hopeful brio, the deconstructive turn of postmodernism. The trick is to avoid paralysis. "Between the presently unrealizable and the impossible in principle lies an intermediary margin" (301), in Ricoeur's analysis, and it is on that intermediary border that we must tentatively enter utopian thinking. Rather than attempt to step outside time or space "we must let ourselves be drawn into the circle"—and then, in a mystical logic that utopias would applaud, he adds that we "must try to make the circle a spiral" (312).

## REFERENCES

Baum, L. Frank. *The Wonderful Wizard of Oz.* Chicago: Rand McNally, 1976. [1900].
*Forever Young.* Dir. Steve Miner. Warner, 1992.
Grimwood, Ken. *Replay.* New York: Quill (William Morrow), 1988. [1986].
*Groundhog Day.* Dir. Harold Ramis. Columbia, 1993.
Haggard, H. Rider. *She.* Oxford: Oxford University Press, 1991. [1887].
Huntington, John. *The Logic of Fantasy: H .G. Wells and Science Fiction.* New York: Columbia University Press, 1982.
Kumar, Krishan. *Utopia and Anti-Utopia in Modern Times.* Oxford: Basil Blackwell, 1987.
*Pleasantville.* Dir. Gary Ross. New Line Cinema, 1998.
Ricoeur, Paul. *Lectures on Ideology and Utopia.* Ed. George H. Taylor. New York: Columbia University Press, 1986.
Russell, Mary Doria. *The Sparrow.* New York: Villard, 1996.
Shklar, Judith N. "What Is the Use of Utopia?" in Siebers: 40–57.
Siebers, Tobin, ed. *Heterotopia: Postmodernism Utopia and the Body Politic.* Ann Arbor: University of Michigan Press, 1994.
*Sliding Doors.* Dir. Peter Howitt. United International, 1998.

# 4

# We Are Marching to Utopia: Kurt Vonnegut's *Player Piano*

## Donald E. Morse

I like Utopian talk, speculation about what our planet should be, anger
about what our planet is.

<div align="right">Kurt Vonnegut</div>

Kurt Vonnegut's *Player Piano* (1952) falls within one of the longest and strongest
suits in twentieth-century science fiction. "From H. G. Wells to Samuel Delany,
science fiction is full of utopias, dystopias, ambiguous utopias, and 'hetero-
topias'" (Attebery 5).[1] As Kermit Vanderbilt observes, "*Player Piano* is
astonishing for the richness of utopian and dystopian matter in this first major
outing of the writer who would soon own the best utopian imagination in
American literature since World War Two" (139–140).[2]

In *Player Piano*, the world, having passed through the First Revolution
where machines took over man's manual labor and the Second Revolution where
machines took over all human routine work, is now about to undergo a Third
Revolution where machines will do all the thinking. The huge computer, EPICAC
XIV—the one the president of the United States with not the slightest trace of
irony refers to as "the greatest individual in history"—sits in the Carlsbad Caverns
in New Mexico determining all of the country's needs from the number of
refrigerators to be manufactured this month, to the kinds of books people should
read, to the types of educational degrees universities may offer.[3] Vonnegut used as
his model for the all-wise, all-powerful machine the first digital computer, the
"Electronic Numerical Integrator and Calculator" or ENIAC. Developed at the
University of Pennsylvania's Moore School of Electrical Engineering from a
proposal by John Presper Eckert and John W. Mauchly and weighing in at thirty
tons with eighteen thousand vacuum tubes, the first public demonstration of
ENIAC occurred on February 14, 1946. It was followed by a series of lectures at a
conference in Philadelphia in the summer of 1946, which led in turn to the
widespread adoption of stored-program which eventuated in the modern
electronic computer. Only a few short years later, Vonnegut extrapolates from
these events to create EPICAC XIV. In *Player Piano* the United States has

become a planned society run by corporations for profit.[4] But this governing by computer results predictably in an increasingly sterile American society—a society with no real place or need for humans. As Norbert Wiener, who is often referred to as "the father of cybernetics," caustically observed in his popular book, *Cybernetics, or, Control and Communication in the Animal and the Machine*, "the average human being of mediocre attainments or less has nothing to sell that it is worth anyone's money to buy" (quoted in Kenner 163).[5] In *Player Piano*, a discerning visitor from another culture, the Shah of Bratbuhr, the spiritual leader of six million people, correctly identifies all the citizens of this new ideal United States as "takaru" or slaves.

The power and wealth of the United States, which grew through the nineteenth and twentieth centuries in large measure thanks to an amazing outburst of creative technology and invention, remain almost synonymous with the machine. The machine may take the form of the car that provides the famous American mobility while contributing heavily to American personal isolation. Or it may take the form of the telegraph/telephone, or more recently, the "net" that tied the country together through instant communications. Or it may be the various electronic media machines (radio, movies, and television) that shifted the emphasis from news to instant event. Or it may be any of the vast array of technics that transformed agriculture into agribusiness, the company into the multinational corporation, or the sleepy stock market into that behemoth of arbitrage, leveraged buy-out, and institutional investment of the new turn of the century. Lewis Mumford as early as 1934 maintained in his prescient study, *Technics and Civilization*, that:

Mechanization and regimentation are not new phenomena in history: what is new is the fact that these functions have been projected and embodied in organized forms which dominate every aspect of our existence. Other civilizations reached a high degree of technical proficiency without apparently, being profoundly influenced by methods and aims of technics. (4)

In the United States of *Player Piano* and especially in Vonnegut's Ilium, where Paul Proteus tries but does not really succeed in becoming his own person, a "free man" remains squarely within and controlled by a society dominated by such technics. The novel thus satitizes both the over-dependence on technology and the over-reliance on the expertise of technocrats. Sheppeard contends that "because technology is inextricable from twentieth-century man's life and has profoundly changed him, Vonnegut cannot reflect upon contemporary man's metaphysical anguish without also commenting upon his technology" ("Kurt Vonnegut" 15). But the reverse may be even truer in that Vonnegut cannot reflect upon the role of technology in the twentieth century without also reflecting on human metaphysical anguish, especially as exemplified in Paul Proteus.

Proteus's flailing about, trying to be at home in Homestead, buying a farm that he cannot run, and attempting to be the Messiah of the saboteurs all reflect his blind desire to become a conscious being, to become fully human. The corporation, on the other hand, wants him to be its ideal manager—bright, but completely within the corporate mold. His wife, in her turn, wants him to be her ideal husband—loving but totally dedicated to succeeding in the corporation. The revolutionary Ghost Shirts want him to be their ideal leader—famous, but

selflessly dedicated to their cause. None of these—the corporation, his wife, the Ghost Shirts—wants him simply to be or to be for himself alone. Needless to say, no one ever asks what he wants. The wonder is that he does not become like his fellow workers: alcoholics, dropouts, or flunkies—the hollow shells of wasted men. When the corporation or his wife is not using Paul, then the revolutionaries are. The latter write letters in his name, issue manifestoes he does not know if he agrees or disagrees with, and act generally as if he were their Messiah—a role he definitely does not wish to play. If he does not really know what he wants to be or become, Paul at least knows that he does not want to be a lone human manager overseeing machines.

Vonnegut's book is a plea for human beings to be what they are able to be best: human—which is frail and strong, thickheaded and intelligent, cruel and kind, failing and succeeding hating and loving. This belief in the humanness of human beings will become a constant in all of Vonnegut's later novels and stories. It is also his warning against that ancient human desire for perfection, especially perfection in society that all too often, as in this novel, leads simply to sterility. Aldous Huxley, similarly worried, chose for the epigraph to *Brave New World* a telling quotation from Nicolas Berdiaeff's *Slavery and Freedom: "Les utopies apparaissent comme bien plus réalisables qu'on ne le croyait aurefois. Et nous nous trouvons actuellement devant une question bien autrement agoissante: Comment éviter leur réalisation définitive?"* (Huxley 5). (Utopias appear far more realizable than we had formerly believed. And now we find ourselves facing a question equally painful in a new kind of way: How to avoid their actual realization? My translation.)[6]

In *Player Piano*, the corporation, working to establish its notion of utopia here on earth, actively opposes any belief in the importance of variety in humans and their experience. All in the name of making everything as easy as possible for everyone and granting everyone a far greater degree of certainty than is usually possible in a nonplanned, unregulated, free society. The good life in *Player Piano* will be achieved thanks to the corporation responsible for running everything in Ilium that demands in return complete loyalty and service. Such loyalty and service are, however, not just expected, they are required. Vonnegut satirizes the kind of husband-wife working relationships that may and often do result from such expectations in the meaningless conversations which take place daily between Paul and Anita. Proteus proves the upwardly mobile, aspiring young husband, while his wife, Anita—"Ilium's Lady of the Manor" (12)—dutifully spends all her time and energy plotting ways to boost him up the corporate ladder. Vonnegut's sharp satiric eye neatly skewers his target as Anita dresses Paul for success by buying him clothing identical with that of those who appear just a bit higher up the ladder. She then coaches him on how to behave at meetings, how to deliver speeches effectively, and how to conduct himself on various social occasions. Anita and Paul's juvenile relationship reflects the price of the certitude promised by an EPICAC XIV–run society.

The theologian Paul Tillich observed that "men will quickly commit themselves to any cause that promises certainty in their existence" (307). The all-knowing computer in *Player Piano* not only promises but delivers such certainty but at some cost. The Shah several times points to an obvious cost when he "equates American society with the noxious materialism suggested by the

nephew's name . . . Khashdrahr ('cash drawer') Miasma" (Sheppeard, "Signposts" 18–19). Another but not quite so apparent cost of this utopia lies in what is absent from the world of *Player Piano* and what is often overlooked in creating such a good life in a perfect world. The noted Irish writer Francis Stuart pinpointed this lack when we wrote, "Where everything is seen as making life easier for all, there is no room for grief, pain and doubt, in which are the roots of a thriving organic consciousness" (19). Stuart's prescription holds true for individuals but it also proves important for fiction. As Kevin Alexander Boon emphasizes, "Vonnegut's fiction [especially in *Player Piano*] points to the confluent boundary between the morbid and the sublime where humor and grief are inevitably conflated" (111n86).

In extrapolating from the present to create his future utopian society, Vonnegut includes a satiric, highly amused look at the morés of the corporate world as he had observed them while working for the General Electric Company. One of his prime satiric targets—on which he scored a direct hit—was the North Woods summer festival where General Electric executives had to go and play the silly games described in hilarious detail in *Player Piano* (see especially 181–194). "The island was shut down after the book came out" ("A Talk" 113), Vonnegut boasts in various interviews. "So, you can't say that my writing hasn't made any contribution to Western civilization" ("Two Conversations" 199).[7]

Juxtaposed to the corporate world in *Player Piano* lies Homestead, where ex-workers and those with minimal jobs live and where revolt may be incipient but life itself is as dead as it is at the top of the corporate organization chart.[8] Here there is no dignity in labor, no virtue in an honest day's wages, no reward for exceeding expectations. Instead, people realize that the corporate world wishes to use their labor as cheaply as possible and will replace them with more reliable machines whenever and wherever possible, not stopping to count or even acknowledge the human cost of those dismissed, fired, or forced to quit. This point becomes clear early in the novel when Bud Calhoun is fired because he had invented a machine to replace himself and so made himself redundant (62–65). Much of Vonnegut's theme of the exploitation of human workers and of machines that make people redundant leaving behind a pile of human rubble with little or nothing to do appears familiar from some nineteenth- and many twentieth-century British and American writers. John Ruskin, Thomas Hardy, D. H. Lawrence, E. M. Forster, and J.R.R. Tolkien, and American writers from Mark Twain through the muckrakers and after—all attacked the human waste caused by technology and Big Business. Like the best of these writers, Vonnegut goes beyond speculation and, like most of them, describes both the atmosphere of the corporation and the ethos and values it promulgated based upon careful observation. "It was a genuine concern that drove me to write my first book," he claims ("Two Conversations" 4).

While working at General Electric, he recalls

One day I came across an engineer who had developed a milling machine that could be run by punch cards. Now at the time, milling machine operators were among the best paid machinists in the world, and yet this damned machine was able to do as good a job as most of the machinists ever could. I looked around, then, and found looms and spinning machines and a number of textile devices all being run the same way and, well, the implications were sensational. ("Two Conversations" 200; compare *Wampeters, Foma & Granfalloons* 261)

These sensational implications are realized in *Player Piano* as this future electronically run society places the good of the corporation and the *full employment of machines* ahead of human needs and desires, including the human necessity for meaningful work. "[T]he only safeguard of order and discipline in the modern world is a standardized worker with interchangeable parts. That would solve the entire problem of management," says The President in *The Madwoman of Chaillot* by Jean Giraudoux (17)—a sentiment echoed and re-echoed throughout this novel. In *The Sirens of Titan* (1959) Vonnegut explores this issue further through the ultimate machine-run civilization of Tralfamadore whose people originally made machines in order to free human beings from work:

> This left the creatures free to serve higher purposes. But whenever they found a higher purpose, the purpose still wasn't high enough.
>
> So machines were made to serve higher purposes, too.
>
> And the machines did everything so expertly that they were finally given the job of finding out what the highest purpose of the creatures [humans] could be.
>
> The machines reported in all honesty that the creatures couldn't really be said to have any purpose at all.
>
> The creatures thereupon began slaying each other. . . . And they discovered that they weren't even very good at slaying. So they turned that job over to the machines, too. And the machines finished up the job in less time than it takes to say, "Tralfamadore." (274–275)

As Zoltán Abádi-Nagy notes, "Tralfamadore turns out to be a dehumanized planet with a machine civilization: what they can teach man is that man should not learn from them" ("Ironic Historicism" 87).

Against nineteenth-century popular belief, Ralph Waldo Emerson vigorously and correctly maintained that "society never advances" (279), yet there are always those, such as the twentieth-century behavioral psychologist B. F. Skinner, who promised societal advancement in return for merely surrendering unwanted human dignity and unneeded individual freedoms. As the Shah of Bratpuhr keenly observes in *Player Piano*, surrendering such freedoms in the name of "progress" or comfort or efficiency reduces people from their once proud status as free citizens in a democracy to "takaru," or slaves. But those who believe and belong to the Skinnerian utopia, *Walden Two* (1948), "entertain no nonsense about democracy." "This is a totally planned society, structured so that a self-perpetuating elite shapes to their specifications the inhabitants of the world they control" (Elliott 150), and those inhabitants should be grateful.

John Pierce invented an excellent term for this kind of thinking. He called it "the hubris of altruism"; that is, the "blind pride in seemingly benevolent ideals," which must be imposed on humanity "for its own good" (168). From a wealth of historical examples of this kind of utopia Pierce selects John Calvin's Geneva and Pol Pot's Democratic Kampuchea as two places where "the practical consequences of the hubris of altruism" were much in evidence. "It is important," Pierce adds, "to remember that both might still be regarded as noble ideas had they not succeeded so thoroughly" (168). Hence the imposition of Skinnerian values and techniques on a population essentially not consulted either about the values themselves or about participating in such a noble experiment. Had they been so consulted, there might have appeared that lone individual or even a group who like Bartleby would "prefer not to"

participate in the noble experiment. It is against this kind of planned society dedicated to a certain set of values, however benign or well meaning, that anti-utopian literature, such as *Player Piano* is often written. Vonnegut, in contrast to Skinner but much like Emerson, remains a nonbeliever when it comes to societal progress or the necessity for controlling society.

If Vonnegut continues very much aware of the almost absolute centrality of machines for late twentieth-century American society, he also insists on their right use. In his view, machines are both a proper and a necessary subject for the contemporary American writer. "Machinery is important. We must write about it," he affirmed in one of many interviews ("Kurt Vonnegut, Jr." 157). But Vonnegut's point in *Player Piano* so familiar from American history, philosophy, theology, politics, and literature is that machines and technology are or should be the means by which humans gain—not lose—their freedom. Machines are not now nor should they ever become simply ends in themselves. Ralph Barton Perry argued that "even ideas and skills do not suffice unless they are linked with the purposes for which they are used, or the feelings which give them value." He continues, "It is necessary, furthermore, that these purposes and feelings should be shared, in order that they may afford a basis of reciprocal action. When thus socialized and charged with emotion, durable ideas constitute the essence of culture and of civilization" (Perry 27). Machines, therefore, do not need to be "preserved from dissolution"; only their "essential formulas and aptitudes should be remembered, in order to be re-embodied in new machines" (Perry 27). Not any specific machine itself then but the *idea* of that machine should remain paramount. At the end of *Player Piano*, for instance, bitter irony resides in Bud Calhoun's immediate repairing of the orange soda machine. Those repairs, made as the revolution has barely concluded, become Vonnegut's sharply etched image of the failure of this individual and all like him to distinguish between the means and ends for which this machine and every machine were invented. He is about to do himself out of a job once more by preserving this specific machine rather than internalizing his knowledge of it. Bud has become a true *takaru* or the slave of the machine. As such, he exemplifies Lewis Mumford's contention that Europe and America became unlike other cultures that "had machines; but . . . did not develop 'the machine.' It remained for the peoples of Western Europe to carry the physical sciences and the exact arts to a point no other culture had reached, and to adapt the whole mode of life to the pace and capacities of the machine" (4). In Ilium this process reached its zenith in the machine-run society.

The novel's title, *Player Piano*, derives appropriately from a machine, the player piano, invented in the nineteenth century and perfected in the twentieth. The late Tony Tanner most succinctly summarized the ominous quality of this symbol for the novel. "A piano player is a man consciously using a machine to produce aesthetically pleasing patterns of his own making. A player piano is a machine which has been programmed to produce music on its own, thus making the human presence redundant" (182). In an early chapter of the novel someone observes that "watching them keys go up and down . . . [y]ou can almost see a ghost sitting there playing his heart out" (28). David Hughes, in developing the player piano as an ideal image and symbol for Vonnegut's satire, discovered that "the heart of a player piano, the perforated music sheet, was invented in 1842 . . .

and by about 1890 it was brought to perfection in the United States." He concludes that this image "affords Vonnegut the blend he wants of nostalgia, technical proficiency, and corporealization of the spiritual world" (114n20). This blend will reappear even more poignantly in *Galápagos* (1985) when Zenji Hiroguchi programs Mandrax, the super computer, to reproduce the intricacies of ikebana, the Japanese art of flower arranging which his wife, Hisako, teaches. Hisako loses not only her pride but also her very reason for existence. "Her self-respect has been severely crippled by the discovery that a little black box could not only teach what she taught, but could do so in a thousand different tongues . . . ikebana turned out to be as easily codified as the practice of modern medicine" (68–69). Vonnegut thus makes crucial to *Galápagos* his argument and its consequences about the uselessness of human beings first outlined in *Player Piano* and which later became central to several short stories as well as *God Bless You, Mr. Rosewater* (see especially 21–22).

The Shah in *Player Piano* wishes to pose a simple question to the giant computer, "What people are for?" (277). What indeed are humans for if machines can duplicate not only their music and work, but also their arts and sports? (*Galápagos* 71). This question haunts all of Vonnegut's fiction from *Player Piano* to *Timequake* (1997). But for Vonnegut there is no going back on technology, unless nature itself, deciding it has had enough of human destruction should enter the picture as it does in *Galápagos*. In *Player Piano*, perhaps more acutely than elsewhere in Vonnegut's fiction, this issue of the right role of machines and their right relation to people illustrates the difficulty American society has often shown in identifying clearly right means to achieve good ends. *Player Piano* as a mid-century anti-utopia illustrates, albeit negatively, the right role of technology and machinery within the goals and values of human civilization while at the same time arguing passionately for the sacredness of human beings.

Robert Elliott contends that after World War II, the Bomb, and the holocaust "we will never again be able to create imaginative utopias with the easy confidence of the nineteenth century; the terror to which the eschatological vision applied to human affairs has led in our time forecloses that possibility" (101). Yet at the end of the twentieth century the American public and its leaders still fall prey to imagining that society or its organization can be perfected. Many still believe naively in that recurring human delusion called progress. "[T]he dystopia in *Player Piano* looks much more ominous to us in the 1990s than the ones in Huxley and Orwell" (Rampton 24–25).

In the last half of the twentieth as in the first years of the new twenty-first century American society appears dominated by the multinational corporation, "the only social unit of which our age is capable" (Giraudoux) and clearly needs to heed the warning imbedded in *Player Piano*'s extrapolation from current trends and values. Not to do so may well mean being condemned to live in a city much like Vonnegut's Ilium—something that appears an all-too-real prospect for millions of Americans. *Player Piano* thus remains Vonnegut's plea for bringing into being an American society composed of individuals who have discovered shared purposes and feelings, who distinguish clearly between means and ends, who affirm the truth that American culture is neither true nor utopian but partial and imperfect. Above all, this society must be run not by corporations or by machines but by and for free citizens.[9] These themes emerge again and again in

Vonnegut's later novels and stories as they will preoccupy Vonnegut for the rest of his writing career.

## NOTES

1. Krishan Kumar maintains that utopias are in decline in the twentieth century, but as Barbara Goodwin points out "he does this only by discounting a healthy number of recent science fiction and feminist utopias" (786). Vonnegut's book is one of dozens within the science fiction and/or fantastic mode.

2. Vanderbilt lists the typical elements of a utopian novel—all, of which, he claims, are present in *Player Piano*. "The new post-industrial civilization will be, customarily, a socialistic commonwealth of rational men and women, with wisely planned urban communities, maximum individual freedom, socially oriented education, material abundance (with wise conservation of natural resources), non-alienating and non-competitive day labor and professional life, self-transcending leisure time for recreation and the arts, effortless virtue, dynamic social stability, permanent peace, and gratifying love" (140).

3. The computer's name, EPICAC, is awfully close to Ipecac, the children's medicine used to induce vomiting, as several commentators have noted.

4. Vonnegut's economics in *Player Piano* are intriguing. He postulates private socialism where the corporations, not needing to compete because of being monopolies, nevertheless are government regulated. Although there are no taxes on things, there is a heavy tax on machine labor.

5. Vonnegut was well aware of Wiener's work borrowing his first name for the "crass medical genius," Dr. Norbert Frankenstein in his play *Fortitude* (*Wampeters, Foma & Granfalloons* 43–64) and quoting from his work both in interviews and in *Player Piano* (13). Hughes believes that "Vonnegut appears indebted not to Wiener's 1948 monograph *Cybernetics*, but to its popularization, *The Human Use of Human Beings* (Cambridge, MA: Riverside Press, 1950). The latter was revised and toned down in the second edition (1954) after *Player Piano* was published. No mere catalog of borrowings can reveal Vonnegut's assimilation of the 1950 edition." (113n4).

6. Vonnegut "borrowed" the familiar utopian plot from Aldous Huxley's *Brave New World* (1932), as Huxley, Vonnegut claims, had in his turn "ripped [it] from Eugene Zamiatin's *We*" (1923) (*Wampeters, Foma & Granfalloons* 261). The publishing history of *Player Piano* reflects Vonnegut's fortunes as an author since of the original hardcover edition "less than a third of its first printing of 7600 copies was purchased (and most of these, Vonnegut insists, in Schenectady). The next year, however, the Doubleday Book Club prepared a cheap edition of 15,000 copies, which sold very quickly to its subscribers; a second printing of 5000 [*sic*] was soon ordered. And in 1954 came the book's greatest success. . . .. Outfitted with a luridly futuristic cover and retitled *Utopia-14*, the Bantam paperback [. . . ] hit the stands in numbers exceeding 248,000" (Klinkowitz 40).

7. Vonnegut was chosen Man of the Year on the 25th anniversary of the GE Alumni Association which is composed of people like himself who worked for GE then went on to other professions (Vonnegut, "Skull Session" 247). Paul Keating, *Lamps for a Brighter America* (New York: McGraw Hill, 1954) claims that General Electric's Association Island, the model for Vonnegut's The Meadows, was used extensively between 1910 and 1930 but by the 1950s was no longer in use (see Hughes 110). Whatever the historical facts, Vonnegut's satire on corporate culture and its excesses succeeds admirably.

8. While there is no evidence Vonnegut is echoing Emily Dickinson in using "Homestead" ironically as the name for a lost Eden, their use is strikingly similar:

> The Bible is an antique Volume—
> Written by faded Men
> At the suggestion of Holy Spectres—
> Subjects--Bethlehem—

Eden--the ancient Homestead—
(1545, ll 1–5)

9. Yet, as his introduction to *Slaughterhouse-Five* some fifteen years after *Player Piano* makes abundantly clear, Vonnegut cannot be overly optimistic about the prospects for American society and culture. "I crossed the Delaware River where George Washington had crossed it . . . went to the New York World's Fair, saw what the past had been like, according to the Ford Motor Car Company and Walt Disney, saw what the future would be like, according to General Motors" (18).

## REFERENCES

Abádi-Nagy, Zoltán. "Ironic Historicism in the American Novel of the Sixties." *John O'Hara Journal* 5.1&2: 83–89.
Allen, William Rodney. *Conversations with Kurt Vonnegut.* Jackson, MS: University Press of Mississippi, 1981.
Attebery, Brian. "Fantasy as an Anti-Utopian Mode." *Reflections on the Fantastic.* Ed. Michael Collings. Westport, CT: Greenwood Press, 1986. 3-8.
Boon, Kevin Alexander. *Chaos Theory and the Interpretation of Literary Texts: The Case of Kurt Vonnegut.* Lewiston, NY: Mellen Press, 1997.
Dickinson, Emily. "The Bible is an antique Volume—." *The Poems of Emily Dickinson.* Ed. Thomas H. Johnson. Vol. 1-3. Cambridge MA: Harvard University Press, 1958. 1: 1065–1067.
Elliott, Robert C. *The Shape of Utopia: Studies in a Literary Genre.* Chicago: University of Chicago Press, 1970.
Emerson, Ralph Waldo. "Self-Reliance." *Ralph Waldo Emerson: Essays & Lectures.* New York: Library of America, 1983. 257–282.
Giraudoux, Jean. *The Madwoman of Chaillot.* Trans. Maurice Valency. In *Jean Giraudoux: Four Plays, Adapted, and with an Introduction by Maurice Valency.* New York: Hill and Wang, 1958.
Goodwin, Barbara. "The Perfect and the Perfected." Review of Krishan Kumar, *Utopia and Anti-Utopia in Modern Times* n.d. Oxford: Blackwell. *Times Literary Supplement.* 24 July 1987: 786.
Hughes, David Y. "The Ghost in the Machine: The Theme of *Player Piano*." *America as Utopia.* Ed. Kenneth M. Roemer. New York: Burt Franklin, 1981. 108–14.
Huxley, Aldous. *Brave New World.* 1932. Harmondsworth, Middlesex, UK: Penguin, 1955.
Kenner, Hugh. *Dublin's Joyce.* Bloomington, IN: Indiana University Press, 1956.
Klinkowitz, Jerome. *Kurt Vonnegut.* New York: Methuen, 1982.
Mumford, Lewis. *Technics and Civilization.* New York: Harcourt, Brace, 1934.
Perry, Ralph Barton. *Puritanism and Democracy.* New York: Harper, 1944.
Pierce, John J. *Foundations of Science Fiction: A Study in Imagination and Evolution.* Westport, CT: Greenwood Press, 1987.
Rampton, David. "Into the Secret Chamber: Art and the Artist in Kurt Vonnegut's *Bluebeard*." *Critique.* 35 (1993): 16–26.
Sheppeard, Sallye J. "Kurt Vonnegut and the Myth of Scientific Progress." *Journal of the American Studies Association of Texas* 16 (1985): 14–19.
———. "Signposts in a Chaotic World: Naming Devices in Kurt Vonnegut's Dresden Books." *The McNeese Review* 312 (1986): 14–-22.
Skinner, B. F. *Walden Two.* New York: Macmillan, 1948.
Stuart, Francis. *The Abandoned Snail Shell.* Dublin: The Raven Arts Press, 1987.
Tanner, Tony. *City of Words: American Fiction, 1950-1970.* New York: Harper & Row, 1971.

Tillich, Paul. "Critique and Justification of Utopia." *Utopias and Utopian Thought*. Ed. Frank Manuel. Boston: Houghton Mifflin, 1966. 296–309.

Vanderbilt, Kermit. "Kurt Vonnegut's American Nightmares and Utopias." *The Utopian Vision: Seven Essays on the Quincentenniel of Sir Thomas More*. San Diego: San Diego State University Press, 1983. 137–173.

Vonnegut, Kurt. *Galápagos*. New York: Dell, 1985.

———. *God Bless You, Mr. Rosewater*. 1965. New York: Dell, 1970.

———. *Palm Sunday: An Autobiographical Collage*. 1981. New York: Dell, 1984.

———. *Player Piano*. 1952. New York: Dell, 1980.

———. *The Sirens of Titan*. New York: Dell, 1959.

———. *Slaughterhouse-Five*. New York: Dell, 1969.

———. *Timequake*. New York: Putnam, 1997.

———. *Wampeters, Foma & Granfalloons*. New York: Delacorte Press, 1976.

———. "Kurt Vonnegut, Jr." Interview with John Casey and Joe David Bellamy. *The New Fiction: Interviews with Innovative American Writers*. Ed. Joe David Bellamy. Urbana: University of Illinois Press, 1974. 194–207. Reprinted in Allen. 156–65.

———. "A Skull Session with Kurt Vonnegut." Interview with Hank Nuwer. *South Carolina Review*. 19 (1987): 2–23. Reprinted in Allen. 240–264.

———. "A Talk with Kurt Vonnegut, Jr." with Robert Scholes. *The Vonnegut Statement*, ed. Jerome Klinkowitz and John Somer. New York: Dell Publishing, 1973. 90-118. Reprinted in Allen. 111-32.

———. "Two Conversations with Kurt Vonnegut" with Charlie Reilly, *College Literature*. 7 (1980): 1–29. Reprinted in Allen. 196–229.

Wiener, Norbert. *Cybernetics, or the Control and Communications in the Animal and the Machine*. 1948. New York: MIT Press and Wiley, 1961.

———. *The Human Use of Human Beings*. Cambridge, MA: Riverside Press, 1950.

# 5

# David Mamet's *The Water Engine*: The Utopian Ideal as Social Control

## Jeanne Beckwith

Although David Mamet's 1977 play *The Water Engine* is not often produced, it is one of his most penetrating and powerful theatrical works. It is also the only work of Mamet's that overtly incorporates elements of the fantastic and, indeed, could be considered a form of science fiction. Perhaps not coincidentally, it is also a play that heavily utilizes both unrealistic staging and unconventional framing devices. The end result of this double layer of the fantastic is an articulation of the human desire for a future full of hope and utopian promise that is subverted by a terrifying stage representation of a civilization built on chaos. In *The Water Engine*, the dream of utopia becomes a nightmare in which all ideologies are only social constructs that serve the practical needs of the system within which they function, in which both the idea of progress and the possibility of utopia are used by those in power to disguise base motivations of greed and self-promotion. In his presentation of a classic science-fictional situation—the lone inventor and his marvelous machine—in the form of non-realistic theatre, Mamet challenges the audience's perceptions of linearity and causality even as he exposes the rotten underside of a false utopia.

Framing devices in the "real world" are ways of establishing parameters or boundaries for the action that is being played out. In his book *Frame Analysis*, Erving Goffman contends that even the most ordinary everyday activity is dependent on a "closed, finite set of rules," the explications of which provide a basis for understanding the whole of social life (5–7). When we know the "frame" of a social encounter, we know how to act and react within the "rules" that are inherent in the situation. At a funeral, we behave differently than we do at a birthday party. On the stage, we understand the action because we understand the frames of the social world portrayed and the theatrical *frames* which form the conventions of the stage. Theatrical frames are the conditions of theatrical action. They are usually the means by which we establish closure—the beginning, middle, and end of action by which the world of the play

expresses itself. These frames can be as simple as the dimming of lights before the program begins or the blackout at the end of a scene. Such conventions result from the artist's choice of what boundaries will divide the physical world of the audience from the fictional world of the play. Frames also result from the way that a character is presented either realistically or unrealistically. Dialogue may be naturalistic or stylized. The means of conventional representation which are employed are the means by which the playwright or director privileges the audience's interpretation of what is valid experience in the theatrical world. The way in which a theatrical event positions the audience forces that audience to view the action through a certain frame, thus implicating the audience in a certain kind of world for the duration of the performance.

Sociologist Lucien Goldmann defined the theatrical event as a means of finding and imposing coherence upon the external world by expressing social knowledge through a living narrative. Humans need such coherence in order to give meaning to a random world which might otherwise drive them mad (112–116). In this sense, whatever their official designation—comedy, tragedy, tragicomedy—all stage plays are morality plays. The stories told on the stage or in our fiction tell us who we are and what we desire to be at a particular point in history. The ways in which we choose to tell those stories are just as revealing. Each generation, each culture has its own style—its own set of conventions. So-called avant-garde performances are often immediately rejected by the masses for this very reason. Audiences are conditioned to see stage presentations framed in particular ways and are resistant to seeing the possibilities for living inherent in a play if its frames are not familiar. The audience brings with it the rules and frameworks it uses to guide its understanding of the actual world. We have rules about the way things should be, and this extends to our perception of the way plays should be. Over time, if the artistic attempt defined as avant-garde persists, it will become "conventional." What may have once been hooted off the stage becomes "old school."

In *The Water Engine*, Mamet makes staging choices that tend to distort the audience's frame of reference by disrupting the theatrical frame. Mamet does not appear to be seeking to reassure his audience that the world is a coherent place and humans have a significant role to play in it. Instead, the play displays a world that is just the opposite: a world where the "rules" are skewed, and humans are more likely to be victims rather than heroes. Mamet wants to shake the audience up, but at the same time he does not want to lose them. He has to tell a coherent enough story so that the audience will stay with the action, but he also wants the audience to understand that coherence may sometimes be a tool that those in power use to oppress those who are not. The story Mamet presents to us in *The Water Engine* is all too coherent as it unfolds in a stage world where convention gradually loses its ability to mask an unremitting horror. The play's disrupted frame of action and identity assaults the invisible world of assumed reality.

As he tells us this story, Mamet further undermines the audience's expectation of a rational world through his reversal of a time-honored device from "popular genre" science fiction. Like the theatre, science fiction novels, stories, and films have evolved conventions and tropes which bind them to their readers by framing universes which may be incredible but always maintain

credibility, or at least familiarity. One of the most familiar of these conventions is what critic John Clute has termed the "edisonade," after the U.S. inventor Thomas Edison. According to Clute, an edisonade describes "any story which features a young U.S. male inventor hero who uses his ingenuity to extricate himself from tight spots and who, by so doing, saves himself from defeat and corruption and his friends and neighbors from foreign oppressors" (308). The same audiences that are conditioned to expect certain ways of framing a drama on the stage are also conditioned to expect the lone scientist to triumph over "defeat and corruption." But, as we shall see, Mamet's "U.S. male inventor hero" is utterly unable to do so.

Based upon the urban fantasy of an engine that would run on water but is kept from us by the evil emperors of Detroit—a myth that seems to have more truth than fantasy to it in the present time—*The Water Engine* is set in 1934 during the Chicago "Century of Progress Exposition." The action centers upon Charles Lang, a young man with an invention. He has developed an engine which literally runs on water—an engine which will put an end to factories as we know them. His name, "Lang," reminds us of Fritz Lang, the creator of the 1926 film *Metropolis*. Lang's film was a vision of future possibility, but that future world had a grim and terrifying side to it, and so does the world that this Lang stumbles into. Charles Lang's dream of a better future world is not *Metropolis*. It is not a complicated vision at all. Like most of Mamet's characters, especially his good guys, Lang is not a very articulate man, as he demonstrates when he grasps for a way to describe his invention and the world he hopes to help create:

LANG: . . .What you're going to see is like a sailboat. My sister says. There are no more factories. This engine. (*Pause.*) This engine, Mr. Gross, draws from the Earth. (22)

Lang's vision of utopia is not complicated. He and his sister, Rita, share a vague vision of a world where things are *better*. That is the promise of the water engine—a world that is better, a world of many cows and horses, with sunshine and proper food and no cars making excessive noise (33). Both Lang and his sister share a childlike idea of paradise down on the farm: a place where you could raise dogs (24). To achieve "paradise," Lang has gone to a patent law firm to acquire a patent and share his knowledge with the world. However, the dark figures Lang encounters at the law firm perceive his desire to benefit all of humankind and create a world where "things work" as a threat to the really important matters: profit, control, and power. Lang and his sister are aware that there are dangers. Rita repeatedly warns her brother that he must "watch these people," but despite her warnings, Lang goes ahead and attempts to share his device with the world. It is a matter of trust and belief. He believes in "trust"; he believes in contracts. In his first encounter with Gross, the patent lawyer, he tries to get the lawyer to enter into a formal bond with him—a contract. Lang is as yet unshaken in his belief that there should be protection in a person's word and that there are rules of action. If a person follows these rules, everything will be all right. Gross, the lawyer he is consulting, responds:

GROSS: Fine. Well then, give me a dollar. (*Pause.* LANG *hands* GROSS *a dollar.*) Thank you. Do you trust me now? (*Pause.*) And if you couldn't trust me what good would your contract be? (14)

What Mamet demonstrates in his play is just what Gross is saying—the rules are ephemeral, and they will not protect you. The people to whom he has gone for help will accuse him of theft, wreck his lab, and threaten his sister all to *save* him from harm. What we believe must or should be so is often not real. People are not what they seem. Lang's failure initially to understand this results in the loss of everything that he cares for and, ultimately, both his sister's and his own life.

Correctly or not, Mamet is often called a naturalistic playwright, but this play is not presented in a naturalistic or realistic style at all. Rather, the characters and scenes are presented much like a morality play in the medieval tradition. The characters in the play are representative rather than realistic. Many of them are identified by their function or the character traits they represent: Gross, Oberman, Radio Announcer, Worker, Soapbox Speaker, Knife Grinder. Lang and his sister, while they have conventional names, are representative characters themselves. They are all of us. Lang is a kind of "everyman," a less-than-ideal individual who nevertheless has an idea of what utopia would be—what a better world would look like. He longs for heaven here on earth, but such a vision does not appeal to the darker forces in the play whose primary questions are asked by a reappearing, anonymous Soapbox Speaker: "Where are the benefits? . . . where's the wealth?" (31). This character and others in the play represent the power structure which would crumble under Lang's utopian vision. These characters speak quite glibly of utopian ideals, but an ideal universe as Lang would define it is the farthest thing from their minds.

Also like a medieval morality play, the action of *The Water Engine* moves constantly from locale to locale. To tell Lang's story on the stage, Mamet could have written a realistic, straightforward, "well-made" play. Instead, what we see on the stage is a chaotic vision of a world that is only marginally fending off collapse. The story of the young inventor, which is presented in a straight-line action narrative, remains clear and coherent, but it is framed by at least eight separate stage devices. By itself, each frame is fairly conventional, but there is a continual shifting back and forth. Each of these frames reflects upon the action in its own distinct way while, at the same time, each frame redefines the other frames both individually and collectively. For example, the play opens with all the cast members gathered around a microphone singing the state song of Illinois when the announcer's voice breaks in and proudly welcomes us to the Century of Progress Exposition in Chicago. The action moves immediately to Lang in his laboratory. He, too, believes in progress as the product of perseverance and correct thinking and describes this belief to the audience through an analogy to chemistry:

LANG: . . .We are made of molecules. We all are made of light. We are the world in this respect. (11)

Quickly, the action jumps, this time to the newspaper office of the Chicago *Daily News* for about ten lines of seemingly unrelated dialogue about the relationship of the government and the press. Now, a voiceover begins reading aloud a chain letter which overlaps with a dialogue at the candy store between Mr. Wallace and the boy Bernie about the way things are done. The chain letter continues into the next scene in Gross's office (12–13).

Although staying in a linear mode, with such rapid movements between scenes Mamet escapes the constraints of simple real time narrative. He emphasizes the individual unit of meaning depicted by each shift. It is not narrative which dominates the play, but the reflexive quality of individual stage moments as they create a sensual as well as intellectual impact on the spectator. Such a strategy realizes the full potential of drama as both a poetic and a plastic art form: a form that involves words spoken in time which must be experienced in time, but a form which is also a sequence of visual and kinetic images, each of which is a unit of meaning communicated through shape and color moving in space. To achieve a shift in perception, Mamet uses a kind of simultaneous staging technique. There is rarely only a single line of action going on at any given time. Instead there are layers of separate activities. The sequencing of events from one beat to the next or from one scene to the next is not as important as the way in which each unit of action, each image, each voice either refers to previous units or anticipates stage moments and events to come. Individual units become completely meaningful only as we are able to think of them in reference to the entire play as a unified experience. Not only do individual beats, images, and scenes comment back and forth on one another, but within any given scene, there are always at least two, and sometimes more, simultaneous lines of action going on. The separate lines of action serve to explicate, justify, undermine, mystify, or contradict one another in a complex process which continually forces the audience's active involvement in the action. They must not only continually struggle to figure out what is coming; they must also make an effort to figure out exactly what has just been. It is a multiple framing technique that works to achieve this effect.

From the very start of the action, the frames are disruptive. The first frame of the play the audience encounters is that it is presented as a "radio" play. However, it is not a real radio play. It is a stage play about a radio play. It is meant to be done on a stage and presented to a theatre audience—sort of. In an introductory note to the play, Mamet tells the actors and directors that they should "feel free" to use this staging device "as much or as little as they wish." (5) He goes on to describe performances of the play where the action went back and forth between being done as a radio drama and being done as a traditional realistic play with a resulting "third reality, a scenic truth. . . . (5) So, we have a frame which is not a frame, not a clear boundary.

The chain letter is a second framing device. Throughout the play there is a voice-over reading out the contents of a chain letter—of a very long chain letter which seems at times to be nothing more than a conventional chain letter that anyone might receive and probably has received. There will be great rewards if you follow the directions; there will be trouble if you do not. It refers to great men such as Sanford White and Charles Lindbergh who broke the chain with disastrous results. The letter presents a prevailing point of view found in

much of Mamet's work.  People want to believe in magic; they want to believe that there are ways to control fate.  If one doesn't break the chain, if one keeps faith, success is possible.  The chain letter says that human beings can make things right, but the rules to be followed are part of an overall fantastic vision of fate.  At certain points in the action, the letter overlaps with the action of the play and comments upon Lang's situation.  As Rita and Lang discuss their fears about Gross and his associates, and the radio announcer wishes the audience a pleasant evening, the chain letter speaks of a world where humans are saved from demons and fears by the "watchmen of the modern order.  We are characters within a dream of industry.  Within a dream of toil".(24).  The chain letter is the agent of commerce, of industry and order.  It orders the reader to send a dollar to the name at the top of the list in order to salvage a desperate life in need of some kind of magic intervention.  Otherwise the world presents little in the way of utopian possibility.

A third element framing the action is the Century of Progress Exposition itself and, specifically, the Hall of Science.  Shaping this frame are several voices:  the announcer who is part of the radio play, a lecturer who seems to be the voice of science, and a kind of carnival barker from the Exposition with the main function of seducing visitors into embracing the promise of science. His ironic pronouncements about the utopian world that lies ahead in the twentieth century serve to illuminate the dystopic realities of the world we actually inhabit.

BARKER:. . . . Science, yes, the greatest force for Good and Evil we possess.  The Concrete Poetry of Humankind.  Our thoughts, our dreams, our aspirations rendered into practical and useful forms.  Our science is our self. (47)

In addition to these three voices defining the Century of Progress, there are other anonymous voices that interrupt the flow of action and jar the audience with new pieces of the puzzle that is this play.  It is sometimes difficult to identify the space these voices inhabit.  Yet, each time they speak, they comment upon or undercut the action that is underway.  Throughout the play, there are these momentary interruptions by characters that never appear again. When Gross introduces Lang to Oberman, another instrument of the dark world of commerce and power, he urges Oberman to take good care of the young scientist.  Oberman, of course, smiles and agrees.  At that point the Knife Grinder walks past singing, "Knives to grind.  I've got your knives to grind" (28).  His song fades beneath the ensuing dialogue where Oberman begins the process of intimidation and betrayal that will end in Lang's death.  Interjections such as this occur throughout the play and comprise a separate powerful framing device.

A fifth frame is the elevator Lang rides early in each act.  The people who ride the elevator with him carry on conversations which seem to be unrelated to Lang's situation but oddly reflect both the action passing and the action to come.  Early in the play, just after Lang has first contacted the patent lawyer, Gross, two women discuss a rumor that Lindbergh had been allowed into Hauptmann's cell before he was executed (17).  At the end of the second act, Lang angrily accuses Oberman and Gross of wrecking his lab.  They in turn threaten to bring suit against him for stealing materials from his employer (38).

As the second act begins, Lang is riding down in the elevator. A man and a woman coming down with him are discussing whether humans could die of loneliness. The man is sure that there must be a disease involved, but she has read it somewhere (40). Lang is certainly all alone in this world. When the elevator stops, two cops attempt to arrest him. Once again, Mamet uses a theatrical device to undercut the audience's sense of what is the reality of the play, to articulate an oblique sense of something strange and menacing that surrounds even the most banal of our encounters in the world.

A sixth frame is that of a political rally that is going on in the park called Bughouse Square where hecklers, bums, watchers, soapbox speakers, Lang, and the patent lawyer, Gross, speak at the same time, undercutting or underlining what each has said while at the same time creating a sense of surrounding chaos (26–27). They cannot hear one another; they cannot communicate. Yet, to the audience, the message is one of threat and impending doom: Patriotism serves the cause of death. The Bum knows what the speaker means. Pomp-filled ceremonies support the torture of the ages. Gross manipulates. Lang worries. The audience worries as well, and the Watcher sends the speaker back to Russia.

Yet another layer of framing action revolves around a newspaper reporter named Murray. Lang contacts him to expose what Gross and Oberman are trying to do to him. Murray is supposedly the guardian of the truth, but Murray is a man who writes to the numbers. He needs two hundred words? He comes up with two hundred words (54). Lang contacts Murray to tell him about his water engine. Reluctantly, Murray agrees to meet him at the Zoo. When Lang does not show for their meeting, he hops on the next available story which he calls in to the paper. His offhand use of newspaper shorthand to give the facts underscores the dreadful ending of the story that only the audience knows:

MURRAY: . . .The mutilated bodies of a man and woman were discovered in the early morning hours on a stretch of industrial lake frontage five miles north of Waukegan today, period. The man and woman both were white and in their early thirties, period.
  The cause of death in both cases appears to have been drowning, comma, but both bodies bear signs of quite extensive injury, period. (58)

An eighth frame of action is an ongoing dialogue between a little boy named Bernie and Mr. Wallace, or "Pop," at the candy store. Lang has helped Bernie with his science projects, and both are friends of Lang's and when he is in trouble with the cops in the second act, they help him escape. Bernie and Pop represent innocence and naïveté in the world. Pop is a believer in utopian dreams. He is excited about the Exposition. "Some of the things there, I cannot believe what they've got in the Future" (19). For Pop, the future is a real and tangible place where things like rocket ships already exist. Bernie keeps trying to tell him that they exist already even in 1934, but Pop believes wholeheartedly in the myth of Progress. Early in the play, he urges Lang to go to the Exposition—to the future, but Lang has gone last year. Pop agrees that the *Future* was better last year. There is an oddness in the dialogue. It isn't clear whether Pop is referring the Exposition or to the future itself. Is there a limit on the number of times you can visit the future? Or can the future be better this

year than it was last year? Or will it be worse?

The final moments of the play juxtapose three frames—Pop and Bernie, the Barker at the "Fair" and the chain letter: Science, Flim-flam, and Fate come together. At the end of the play, Pop sees something in the paper that shocks him. The audience may think that it will be news about Lang's murder, but it is much more important than that. Pop is delighted to see that *they* are offering free passes to the Exposition. Bernie gets something in the mail, and the audience knows that Lang has mailed Bernie, who has a gift for science, the plans for the water engine. The boy tries to tell Pop what has he has received, but the old man can only plan their next excursion to the fair. He warns Bernie to "watch the cash" (60) if he wants to go because there is a way that things are done. The chain letter breaks in to detail another casualty of the broken chain, and the Barker ends the play:

BARKER:  The Fair is closing.  Those who wish re-entry to the Hall at half-price, see me for a ticket.  This is our last tour tonight.  They're good tomorrow, though. (61)

The Fair is closing, but a half-price future still waits.

In *The Water Engine*, David Mamet reveals a less-than-ideal ideo-logical framework of utopia by attacking the prevailing system of business and capitalism which uses such a utopian vision to hide its own degeneration and corruption. In the world that Mamet describes, the false dream of a utopia is a way of justifying the accumulation of power and money. But in creating a utopian facade, the traditional values of the pioneering spirit of America are rejected or destroyed. Using the 1934 Century of Progress Exposition in Chicago and its vision of a marvelous future as a backdrop, he gradually demonstrates to us through various frames of reference that we are being lied to and manipulated by people who would sell our future in a heartbeat if there was a fast buck to be made.

The conventional trope of the edisonade that Mamet subverts in *The Water Engine* is, in itself, an advertisement for traditional values and the pioneering spirit of America. In the conventional telling of the story, John Clute notes that the edisonade hero not only maintains control of his invention, but also finds that "it will serve as a certificate of ownership" as he is "made CEO of a compliant world" (369). But at the end of *The Water Engine*, the only "CEO of a compliant world" is the corrupting force that has robbed the inventor—and the world—of his invention. Mamet thus creates in his play a dark and ugly world where the audience, trained in the myths of right action, honesty, loyalty, family values, free enterprise, and fair play, feels lost and alone. These values, these utopian ideals with which capitalism likes to align itself, are corrupted in the name of profit. In their place, the play presents a chaotic vision of a social world bent on destroying all the things that it claims make life worth living. The Century of Progress comes to represent something close to what Mamet has, in his essay "A Party for Mickey Mouse," deplored in Disneyland and all the various theme parks of America today—no more than an open manipulation and control of the human perception of authority (80–82). In *The Water Engine*, David Mamet shows a civilization so blinded by fantasy that it has forgotten its dreams.

## REFERENCES

Clute, John. "Edisonade." In *The Encyclopedia of Science Fiction*. Eds. John Clute and Peter Nichols. New York: St. Martin's, 1993.

Goffman, Erving. *Frame Analysis: An Essay on the Organization of Experience*. Cambridge, MA: Harvard University Press, 1974.

Goldmann, Lucien. "The Subject of Cultural Creation." In *Essays on Method in the Sociology of Literature*. Ed. and Trans. William Boelhowes. St. Louis: Telos Press, 1980.

Mamet, David. "A Party for Mickey Mouse." In Mamet, *Some Freaks*. New York: Penguin Books,. 1989.

———. *The Water Engine*. New York: Samuel French, Inc., 1977.

# 6

# Kim Stanley Robinson's Martian Vision

## Carl Swidorski

Many intellectuals and contemporary commentators have argued that the disintegration of the Soviet Union and the destruction of the Berlin Wall symbolize not only the end of the socialist project but also of the socialist vision. As Francis Fukuyama notes, the globalization of capitalism supposedly marks the boundaries of current political possibility and signifies the "end of history."[1] In its more vulgar forms, this critique has argued two contradictory positions. On the one hand it suggests that the socialist vision offers a picture of a future, gray bureaucratic society which would stifle human freedom and creativity for the sake of some form of mindless equality. On the other hand, Gordon Beauchamp claims that it suggests that the socialist vision is "utopian," a somewhat romantic, impossible-to-realize future society.

The "end of socialism" as activity and dream is part of a larger development dating back to the 1970s: as Ellen Meiksins Wood argues, we are living in a new historical epoch, the "postmodern world." While many people celebrate life in this new information age/global economy/era of consumer capitalism, others, including many liberals and leftists, are disenchanted with the postmodern world but see few alternatives. Ironically, this pessimism about, and often hostility to, the idea of general human progress and liberation historically has been an intrinsic element of conservative thought. Now it has become associated with the thinking of a substantial part of the intellectual left.

The failure of communist regimes as a model for human progress; the incorporation of labor unions and social democratic parties into the normal operation of capitalist societies; the failure of the promise of 1968; the apparent resilience of capitalism, both as practice and as ideology; and the rise of the New Right all have contributed to the erosion of the belief in an alternative. But in accepting the idea that there is no alternative to the existing social order of corporate capitalism, that human emancipation is an illusory and dangerous idea, these contemporary intellectuals often fail to appreciate the resilience of the

human dream of a better world and the socialist context in which ideas develop or fade away. Furthermore, as William K. Tabb argues, the idea that change is impossible, this "sense of inevitability, is an ideological construction and the product of political forces acting through powerful mechanisms in the realms of government and media," not merely the intellectual product of autonomous academics (Tabb, 2). This paper argues that the socialist vision is alive and well in the science fiction of Kim Stanley Robinson.

Kim Stanley Robinson presents a sophisticated vision in his Martian trilogy which integrates socialist content and Marxist theory within the science fiction genre. I will examine two levels of his vision. The first, a fairly conventional approach, involves a narrative dealing with economics, politics, social relations, and human thought. The second, and more creative level, involves what appears to be Robinson's use of two key elements of Marxist theory, dialectical analysis and historical materialism. To my surprise, few of the reviews of his trilogy pay much attention to his politics or discuss the socialism in his vision.[2]

At the first level, Robinson uses a fairly traditional socialist argument about the development of the Martian revolutions. However, and very significantly, he engenders his socialist analysis. Not only are a majority of his major actors women, but also an essential element of his socialist vision is the end of patriarchy. I will not make this aspect a major focus of this chapter, although it certainly deserves an extended treatment elsewhere.[3]  Robinson locates the source of the problems which lead to the transformation of Mars in the struggle for control over the Earth's (and Mars's) resources and the accompanying social relations and ideological beliefs associated with this struggle. A significant element is the argument that capitalism and democracy are inherently incompatible. In *Red Mars* dominant power belongs to the wealthy nations of the world and transnational corporations. Rich nations are involved in struggle with poor nations and both are facing the growing power of the transnationals. This economic power is used to influence national policies, and nations' attempts to resist the power of the transnationals was "like the Lilliputians trying to tie down Gulliver" (*RM* 394).

The attempts by transnationals to control the Earth's resources become an explicit political issue on Mars within twenty years of the arrival of the First Hundred. The key events initially center around the renewal of the Martian treaty. New countries are creating scientific stations on Mars so that they can become treaty members, then break the existing treaty at renewal time. Their goal is to open up Mars to individual governments outside the United Nations' control. As Arkady Bogdanov explains to John Boone, the initial scientific expedition is part of the transnational order: "there is never a case of truly pure research. Because the people who pay for the scientist islands will eventually want a return on their investment" (*RM* 342).

By the time of the treaty conference, immigration to Mars has become a major issue, partly due to new longevity treatments. In the advanced countries, millions are marching in the streets protesting new draconian birth reduction acts passed in response to the treatments. In the developing countries, people are rioting over inadequate access to the treatments, creating what Robinson terms a

physicalization of class. As usual, transnational corporations play a key role in the struggle. As Frank Chalmers points out to the Indian and Chinese treaty conference delegates, "That's what transnational capitalism means—we're all colonies now. And there's tremendous pressure on us here to alter the treaty so that most of the profits from local mining become the property of the transnationals" (*RM* 392).

Chalmer's clever maneuvering at the treaty conference around the issues of immigration and payments to developing nations temporarily reasserts national power over transnationals, but this merely buys time. At the same time, the forces that will revolt have been laying the groundwork for an extended period. When John Boone, at Arkady's urging, travels around Mars he discovers that "there was a whole movement down here, a little group in every town!" (*RM* 403). The movement is laying the groundwork, both physically and ideologically, for revolution.

When the revolution occurs, the extent of it takes the forces of the U. N. Office for Martian Affairs (UNOMA) and the transnationals by surprise. More than sixty towns and stations declare independence. But as is often the case in revolutions, those with power soon regroup and indicate their willingness to use all the power at their command to suppress the revolution. When Arkady tries to convince Phyllis that her "masters" should be realistic and understand that the revolutionary forces will destroy everything on Mars if there is an attempt made to subdue the newly declared free cities, Phyllis replies, "Do you think that matters?" (*RM* 475).

The United Nations and the transnationals in particular, given a free hand by the United Nations, move rapidly to suppress the revolution. In their view, Mars "is not a nation but a world resource" (*RM* 516). The First Hundred become a central focus of the repression. Twenty-one of them die early in the revolt, and another forty are missing (*RM* 521). Even Frank Chalmers, who spends much of the time during the revolutionary outbreak in playing his usual middleman brokering role, is no longer safe. On Earth, the revolution fosters revolt by the have-not nations against transnational control and a broader series of conflicts that plunge Earth into chaos for six to eight months. Over 100 million people die in the wars and their aftermath (*Green Mars* 224). Eventually, however, the Group of Seven use their giant militaries to reassert control and protect transnational interests.

Within a short period the first Martian revolution is suppressed and the revolutionary forces who haven't been killed or captured, including the remaining members of the First Hundred, go into hiding. But the revolutionary ideal is not crushed. *Red Mars* ends with Hiroko's assertion, "This is where we start again" (*RM* 572).

Over the next sixty years transnational control grows on Earth and Mars, and the underground reconstructs itself. The transnationals consolidate into a couple of dozen large organizations which become known as metanationals, the major world powers. They also are literally buying countries, taking over their foreign debt and internal economy. The bought country becomes the enforcer of the metanational's economic policies. Austerity

measures are imposed on the masses while government employees are paid handsomely for their work (*GM* 384).

The metanationals also become the effective rulers of Mars, intertwined in a single, yet at the same time Balkanized, power structure:

UNOMA had been shattered in 2061 like one of the domed cities, and the agency that had taken its place, the United Nations Transitional Authority, was an administrative group staffed by transnat executives, its decrees enforced by transnat security forces. "The UN is just as dead on Earth as UNOMA is here." (*GM* 154)

Because of the revolution, developments on Mars were put on hold as rebuilding occurred. But by the beginning of the twenty-second century, stockpiled materials are ready to enter the Terran market and more investment in Mars and immigration of labor are anticipated.

This centralization of power and planning to further develop Mars fosters the growth and organization of the resistance. And, by this time, more effective resistance is growing on Earth. These developments also foster the growth of a revolutionary consciousness among people who "had no real power over their own lives. Decisions were made for them a hundred million kilometers away. Their home was being chopped up into metal bits and shipped away" (*GM* 482). They need freedom—not from Earth, but from the meta-nationals. This heightened consciousness begins to be put into action at the Dorsa Brevia conference. Amid a wide-ranging discussion of economic and social principles and of revolutionary strategy and tactics, a tentative agreement is worked out. This declaration serves as a rallying point and a benchmark for future activities of the resistance. Those activities include the beginning of sabotage against metanational resources and security forces, activities hotly debated within the resistance movement.

Meanwhile, on Earth people denied longevity treatment engage in "riots, arson, and sabotage" (*GM* 509). The Group of Eleven are still titularly in charge but the metanats are trying to take over countries in the Group. And on Mars, United Nations Transitional Authority (UNTA) police are moving against the underground in their traditional southern strongholds, helping to precipitate the next revolution: "The idea of another revolution seemed to be gaining a life of its own now, a momentum independent of any real logic; it was just something they were doing, were always going to have done" (*GM* 535).

The trigger turns out to be a natural disaster on Earth, the breakoff of the West Antarctica ice sheet and the subsequent dramatic rise in sea levels. This event, and the subsequent chaos it created on Earth, provide the "space" for the second Martian revolution. The revolution, which begins on October 12, 2127, reminds Nadia of previous ones on Earth, but they determine to make it different this time: "It was not power that corrupted people, but fools who corrupted power" (*GM* 582).

The successful Martian revolution interacts with events on Earth. Some client countries in the Southern Club begin to nationalize metanat holdings, a new effort by governments against the metanats. Switzerland, India, and Praxis establish diplomatic relations with the new Martian government. The World Court brokers a cease-fire among the metanationals and some look like they will

follow the lead of Praxis and put their resources into food relief. And on Mars, they also realize their delicate, dialectical relationship with Earth will continue.

In *Blue Mars*, Robinson principally deals with the process of institutionalizing the second Martian revolution and future developments which pose more contradictions for those living on Mars and Earth. There has been a shift from one kind of global socioeconomic system to another. On Mars, at least, people are living in a new democratic age which has replaced the capitalist one. As in all previous periods, the new democratic age includes within itself a clash between the "contentious, competitive residuals of the capitalist system, and some emergent aspects of an order beyond democracy—one that could not be fully characterized yet, as it had never existed" (*BM* 483). The most notable institutional residuals of the capitalist age are the metanationals. Still powers on Earth, they have partially transformed themselves into the Praxis model in order to survive. However, they still have power and want to continue doing business. They continue to have Martian programs; the ideological residuals of the capitalist age, including various forms of hierarchical and noncooperative values, are particularly embedded in newer immigrants to Mars.

The third Martian revolution is precipitated by the meta's takeover of the elevator and the invasion of Terran military. But this revolution is "so complex and nonviolent that it was hard to see it as a revolution at all, at the time" (*BM* 743). And one more time, a massive response by Martians going into the streets led to another set of negotiations. "People in the streets, that's the only thing governments are afraid of" (*BM* 746–747).

Robinson's elaborate, moving, yet somewhat conventional narrative of the contradictions of capitalist development and transformation is supplemented by the alternative visions which live on in the lives and minds of the new Martians. The visions are varied and often in conflict with each other. They range from those who wish to "humanize" the modern capitalist age to those who want to retreat into small, isolated communities which will insulate themselves from a world they find intolerable. Yet throughout all three books, Robinson's principal alternative vision is a socialist one. This is the vision most encapsulated in the third Martian revolution and the one he leaves us with. I will choose three main examples of the socialist alternative articulated by Robinson, one from each book of the trilogy.

In *Red Mars*, the main example of a socialist critique of existing society and articulation of a socialist alternative shows in the words and actions of Arkady Bogdanov, named after one of the original Bolsheviks, Alexander Bogdanov, also the author of a science fiction novel about Mars.[4] Bogdanov's views are those of a clear minority at this point but his vision will eventually become dominant. He is an early proponent of terraforming (making Mars resemble Terra), but for reasons having more to do with politics than science. "We need to terraform in order to make the planet ours, so that we will have the material basis for independence" (*RM* 172). Nadia is critical of his actions which she sees as precipitating a needless, violent reaction. "You damned liberals," he responds, "too soft-hearted to ever actually do anything." In response to her critique that liberalism works he states, "Earth is a perfectly liberal world. But

half of it is starving, and always has been, and always will be. Very liberally" (*RM* 174).

Arkady's critique and analysis of capitalism remain grounded in materialism, yet his vision is in the best traditions of socialist humanism. In a conversation with John Boone, Arkady argues that the economic basis of life on Mars is changing. While the early years of the scientific mission on Mars was lived outside of a money economy, immigration, investment, and the importation of labor have changed the situation dramatically. And Bogdanov is among the increasing number of people who will fight to keep things on Mars the way they were before the multinational presence. Yet his vision of an alternative, life, while grounded in material necessity, is one of spirit. The ultimate realist and pragmatist, Frank Chalmers is befuddled by Arkady's views. Arkady argues:

Why then we will make a human life, Frank. We will work to support our needs, and do science, and perhaps terraform a bit more. We will sing and dance and walk around in the sun, and work like maniacs for food and curiosity." (*RM* 457)[5]

In *Green Mars*, the socialist alternative becomes stronger and is most dramatically illustrated by the conference at Dorsa Brevia and the declaration that emerges from it. The emerging alternative economic vision is articulated by Vlad and Marina with their concept of eco-economics, a more rationalized economic system than the gift system used in much of the underground. They see an economy operating on two planes, one of necessity and one of the gift. In response to criticism that their views are another version of the "socialist catastrophe," Vlad responds:

We must not throw the baby socialism out with the Stalinist bathwater, or we lose many concepts of obvious fairness that we need. Earth is in the grip of the system that defeated socialism, and it is clearly an irrational and destructive hierarchy. So how can we deal with it without being crushed? We have to look everywhere for answers to this, including the systems that the current world defeated. (*GM* 373)

The declaration that emerges from the Dorsa Brevia conference includes provisions that guarantee rights to all, including the means of existence, in a combination of individual and communal enterprise. It recognizes the impossibility of any metanational supporting such a system: "The goal of Martian economics is not 'sustainable' development but a sustainable prosperity for its entire biosphere. . . . The Martian landscape itself has certain 'rights of place' which must be honored" (*GM* 389). Although many of these provisions can be, and are, in Robinson's Mars, subject to some variation in interpretation, their explicit renunciation of the metanational order of earth and advocacy of common ownership of the resources of the earth, including land, make them part of a socialist vision. This is made clear in a discussion of inheritance and whether a person's "possessions" should be passed on to her relatives or to the Martian community. Vlad points out, "No one will own any of the land, water, air, the infrastructure, the gene stock, the information pool—what's left to pass on?" (*GM* 371).

And in *Green Mars*, the humanism of the socialist vision remains. The young generation of Martians is depicted as wanting a Mars that was "truly independent, egalitarian, just, and joyous" (*GM* 514). They also are seen as already having enacted some of their dreams with the communalism, alternative economy, and independence from the metanats and Transitional Authority. The hardened Maya looks at the laughing young Martians at the end of the conference, their shock at cruelty and injustice, their beliefs in collective harmony, and feels pulled in opposite directions. She knows that the path to revolution will not be easy and many will suffer yet she ends the conference with a belief that she has found one of the keys to revolution. "What use was utopia without joy, after all?" (*GM* 515).

The socialist vision in *Blue Mars* is explicitly articulated at the convention writing the new constitution for the postrevolutionary society. Criticism is directed at those provisions of the Dorsa Brevia declaration that now appear to be too radical. Some are complaining that the new economic principles will impinge on local autonomy, while others assert they have more faith in a traditional, capitalist economic system. Vlad, one of the most enigmatic yet brilliant members of the First Hundred, delivers a passionate defense of the new postcapitalist, socio-economic system. Capitalism is incompatible with democracy, he argues, which is why the system on Earth was so easily turned into a metanational system in which the democratic elements grew increasingly weaker. In response to the charge that Mars now has a planned economy, he points out that all economies are plans—that capitalism "planned just as much as this, and metanationalism tried to plan everything." When some charge that this is socialism, he states, in the best tradition of Marxism, "Mars is a new totality. Names from earlier totalities are deceptive. They become little more than theological terms" (*BM* 146). The new Martian economy contains elements of what used to be called socialism in order to remove injustice from the economy. It retains elements of a market structure that many inherently associate with capitalism but, he points out, a crucial difference is that workers will hire capital. The objective is to create a more democratic and just and free system. Freedom under an unjust system such as capitalism is "no freedom at all" (*BM* 147).

Years later, Sax despondently says to Michel that he feels as if there has not been any real progress at all. Michel's response points out the dramatic change that Robinson has envisioned in his history of the Martian future: "But Sax, right here on Mars we have seen both patriarchy and property brought to an end. It's one of the greatest achievements in human history" (*BM* 426).

While this extensive presentation demonstrates the radical, socialist vision underlying Robinson's narrative, I want to suggest that the method of his argument is even more impressive, revealing a relationship among vision, form, process, and narrative. I believe that Robinson's work is an outstanding example of the use of dialectics and historical materialism, in the best traditions of Marxism (whether Robinson is a "Marxist" is not of major consequence to me). Robinson's narrative poses the issue at the center of the best Marxist history, the dialectic between freedom and necessity. Garbriel Kolko, in his superb history of the U. S. intervention in Vietnam, states:

The role of freedom and constraint in historical processes and great events intrudes per-
petually into mankind's ideas. The real question in this search for primary explanations is
the extent to which both choice and necessity operate over time, and, above all, how,
when and why one becomes more important than the other. The significance of these
issues, fundamental for understanding the modern historical experience, resists
simplifications and does not permit the evasion of contingent conclusions, for living with
the tensions of complexity and partial insight is superior to the false security of
pretentious final solutions to the inherent, but creative, dilemmas of knowledge. (555)

Dialectical thinking focuses on the process of whatever it is trying to
understand. It argues that we must study how something developed, its history,
context, and possible future, to more fully understand it. To do this we must
focus on relations and totality. Dialectics helps us to see the present as a moment
through which society is passing. It encourages us to examine where the present
has come from and where it is heading. It allows us to see people acting in
history not just as objects or victims of historical forces. Marxist dialectics
places class struggle at the center of historical development and suggests that
people don't choose to participate in class struggle because they are already
involved in it. What people can choose is which side to take and how to
participate. One's knowledge of necessity can usher in the beginning of real, not
apparent, freedom. Dialectics does not claim to be some infallible formula but
argues that dialectical thinking can increase our understanding of the instability
and impermanence of social relations, revealing ways in which they are one-
sided, partial, and finite.[6]

At the center of Marxist dialectics is the concept of contradiction which
involves examining the incompatible development of different elements within
the same relation. These incompatible elements block, undermine, interfere
with, and in time transform each other. The future becomes the likely and
possible outcome of the interaction of opposing tendencies in the present.
Nondialectical thinkers characterize these elements as strains, tensions, or
paradoxes and tend not to see them as evolving toward some historical
"resolution" (Ollman 15–17).

Robinson's trilogy is organized around the central element of
contradiction. Near the end of *Blue Mars* Robinson explains that many
historians, sociologists, and other analysts had tried to explain the historical
evolution on Mars. But the individual who offers the most compelling
explanation is the Martian historian, Charlotte Brevia, whose multivolumed
metahistory locates the foundation of the vast, sweeping changes in the shift
from one kind of global socioeconomic system to another. Brevia's history is
fundamentally a Marxist analysis, rooted in the dialectical choice humans make
as the act on the world they live in. Robinson is offering us a literary version of
Charlotte Brevia's approach.

The major contradiction that Robinson addresses in his trilogy is that
between the old, Terran capitalist world and the new, socialist world that human
beings slowly create on Mars. My preceding argument outlines the major
developments in this story. But Robinson does not merely provide some simple,
linear narrative. He uses his major characters and a series of other contradictions

to weave a complex, multifaceted story of human beings making choices within the context of a world they have both inherited and remade.

One of the major contradictions he poses is between the "greens," who want to terraform Mars, and the "reds," who oppose such efforts. The two central characters in this part of the drama are Saxifrage Russell and Ann Clayborne. Sax is initially portrayed as an apolitical scientist who is willing to act unilaterally, and illegally, to move the terraforming project forward. Science is creation and because scientists can change Mars they will change Mars. Ann Clayborne, in contrast, has the scientific vision of the "pure" researcher who believes they should study the planet without changing it. She accuses Sax of treating Mars like a giant playground sandbox where he can build his castles. "You find your justifications where you can, but it's bad faith, and it's not *science*" (*RM* 177). Yet by the end of the trilogy both characters have developed and changed significantly as they react to the world they have helped to remake. Sax, in particular, changes in interesting ways. He not only becomes a major revolutionary, but his views of science also undergo change. In *Blue Mars*, he is describing science as a dialogic process, a communal effort extending back to prehistory. While he still loves science for itself, as a mathematical edifice occupying its own space, he now recognizes the degree to which it is at the same time a social construct which is shaped by and in turn shapes the material world.

Robinson uses Sax and Ann to express symbolically a dialectical understanding of historical development. Near the end of the trilogy, Sax and Ann appear to speak in each other's voices. Ann now argues that Mars must be open to Terran immigration to deal with the population surge caused by the longevity treatments while Sax speaks for the protection of Mars from overdevelopment. Characters who were initially presented as almost dichotomous opposites have evolved, through their thought and activity. They have not switched positions but have become new beings. The red and the green have been resolved into the blue:

So she was a new Ann now. Not the Counter-Ann, not even that shadowy third person who had haunted her for so long. A new Ann. A fully Martian Ann at last. On a brown Mars of some new kind, red, green, blue, all swirled together. (*BM* 754)

Robinson poses numerous other contradictions, using his characters effectively to express them. They include the contradiction of the material world versus the spiritual one; the old versus the young; reform versus revolution; rationality versus spirit; aerophany versus viriditas; and theory versus practice. In posing these and many other issues, Robinson continually refuses to fold such issues into dichotomous categories or inevitable choices. He approaches each dialectically, uses his characters and narrative to advance his story and the story of historical development, and leaves us with no final solution.

The other major category of Marxist analysis Robinson uses is historical materialism. His human beings are agents of history and are shaped by material, historical forces. Historical materialism is a theory of history which holds that the way people act and think is grounded in the way they make their living *and* the social relations and organizations that follow from this. It argues

that if human action is shaped and constrained by human-made conditions, then social explanation should be historical and historically specific. Historical materialism rejects explanations of development based on abstract general principles such as "human nature" or "society." Similarly, it rejects attempts to explain human action as shaped by forces beyond human control, such as technology. These approaches, not grounded in specific historical developments or particular historical situations, are characterized as ideology.[7]

In this philosophy of history, stages of human development are associated with certain forms of property, certain productive conditions, and certain relations among human beings. This approach requires that social conditions and relations be studied in each particular historical setting. Humans make history but not as a mere act of will. Their actions are conditioned by the particular class relations and divisions of labor which characterize their world.

Just as our opinion of an individual is not based on what he thinks of himself, so can we not judge of such a period of transformation by its own consciousness; on the contrary, this consciousness must be explained rather from the contradictions of material life, from the existing conflict between the social productive forces and the relations of production. (Marx and Engels, *Critique*, 328–329)

This emphasis on the nature of labor, the division of labor, productive forces, and relations of production have led many to caricature historical materialism as deterministic or materialistic. Such misreadings, whether unintentional or not, fail to understand that Marx emphasized that humans make history.

*History* does nothing, it "possesses *no* immense wealth," it "wages *no* battles." It is *man*, real living man, that does all that, that possesses and fights; "history" is not a person apart, using man as means for its own particular aims; history is *nothing but* the activity of man pursuing his aims. (Marx, *The Holy Family*, 125)

Robinson's narrative is one in which human beings, acting on their new environment on Mars, and reacting to political-economic developments on Earth, make a new world—one grounded in different relations of production and different human associations. The significance of historical consciousness is evident early in the trilogy. Maya, on the initial flight out to Mars, reflects on the power of historical forces: "History too has an inertia." What kind of force would be necessary to "escape history, to escape an inertia that powerful and carve a new course?" (*RM* 50). Similarly, John Boone, a less sophisticated political animal than Maya, yet the supposedly central character of the initial colonization, knows how necessity shapes freedom of choice.

Robinson also uses Sax as an example of this dialectical tension. When Sax has left the underground and is working under an assumed identity in Burroughs, before he has evolved into Sax the revolutionary, he is thinking about the superiority of "real science" in comparison to the social sciences and humanities. He sees the latter as a "huge compendium of meaningless analogies," a kind of "conceptual drunkenness." In contrast, science knows. He sees the historical situation as determinate, results following from causes yet never neat or predictable (*GM* 185). This historical development mirrored

evolution; yet humans "would have to intervene continuously in the act of evolution itself" (*GM* 186).

And in *Blue Mars*, Art serves as a vehicle for regular reflections on this central point. Art recognizes the significance of the congress which has created the institutions and processes of the first Martian postrevolutionary government.

All the dead, it suddenly seemed, and all the unborn all there in the warehouse with them, to witness this moment. As if history were a tapestry, and the congress the loom where everything was coming together, the present moment. . . Looking back at the past, able to see it all, a single long braided tapestry of events; looking forward at the future, able to see none of it, though presumably it branched out in an explosion of threads of potentiality, and could become anything. (*BM* 152)

Finally, Robinson concludes his discussion of the third Martian revolution by making this point again. It is a time of "history in the making," "history labile right there in their hands—and so they seized the moment and wrenched it in a new direction" (*BM* 746).

Furthermore, human beings make history, and themselves, by acting on the material world they live in. Arkady initially points out this relationship. He states that they have come to Mars for good, to make a new life. They have the technology to make their homes, their food and even water and the air they breathe. Yet some people, he points out, think they can terraform the entire planet without changing themselves. He argues: "We must terraform not only Mars, but ourselves" (*RM* 89).

Initially, others are skeptical. Sax, in his great terraforming debate with Ann Clayborne, states that humans will terraform Mars because they are humans; they must act on the material world they live in. But at this point, he does not yet understand how that process will transform humans, particularly the scientist Saxifrage Russell. Nadia also does not agree with Arkady at this point. Yet it is Nadia, the apolitical engineer who simply must act on the world she inhabits, who becomes the central character of the trilogy. She evolves, by acting and reflecting both on the world she helps to make and on forces she comes to understand she cannot fully control, into the major revolutionary leader of the successful Martian revolution. She becomes almost universally accepted as the symbolic representation of the new Mars. She also has to act after the second revolution, but now politically instead of as the engineer she still longs to be. But she is aware by this point that she "must" act in this new way because that is how history has "evolved." Her choice occurs within a realm of necessity that she has helped to create.

Fittingly, Robinson concludes his grand narrative of transformation by returning to the simple realities of life, the starting point for our acting in the world. Maya, a consummate political animal from the beginning, and Ann, the scientist who wanted to live in her own particular world of pure science, take children to the beach. They do the ordinary things that adults do when they take children to the beach, keep an eye on the kids and reflect on the meaning of it all.

Yet in setting his grand narrative within the theoretical framework of historical materialism, Robinson appears to downplay the central element of

Marx's view of historical transformation, class struggle. Robinson's central characters are professionals, not workers in the "traditional" sense. The major historical institutions of the working class, trade unions and labor or socialist political parties, are not part of his narrative. However, class is not absent from Robinson's story. In fact, the concept of the "physicalization of class" is a major element in his entire narrative. Yet when people act on this issue on Earth, they are portrayed in the more abstract sense of the "masses" or "the people," not as a working class. On the other hand, the capitalist class figures more prominently in the story, although primarily not through central characters but through their institutions, the transnationals and metanationals. I do not know if this emphasis reflects strands of post- or neo-Marxist theory or of postmodernism. Perhaps Robinson is suggesting that such a transformation is no longer possible on Earth alone and can only occur under the unique circumstances that would characterize a "new world," such as interplanetary colonization. Perhaps Mars is merely metaphor for possibilities on Earth. Or perhaps, in the best sense of Marx, Robinson is asking us to think about new kinds of class formations in the future, ones based on new ways of thinking about gender, production, and association, not grounded in the nineteenth-century world that Marx lived in. Yet, even if he is urging us to think in new ways, he constantly reminds us of the historical connection to the past—of 1789 and 1917; of Bologna and Keral; of Spanish anarchism and the Diggers and Levellers. And, once again, the primary issue is not exactly what Robinson thinks or intends, but how people who read his work react—and act.

Robinson's vision responds to the question asked by de Toqueville: "Does anyone imagine that democracy, which has destroyed the feudal system and vanquished kinds, will fall back before the middle classes and the rich?" (5–6). Robinson's response is no. He envisions a socialism that is

the name of the struggle to make it [democracy] come true. Thus conceived, socialism is part of the struggle for the deepening and extension of democracy in all areas of life. Its advance is not inscribed in some preordained historical process, but is the result of a constant pressure from below for the enlargement of democratic rights; . . .

This, however, is not enough. Socialism seeks, not only the limitation of power, but *its eventual abolition as the organizing principle of social life.* This, incidentally, or not so incidentally, is ultimately what Marx was about (Miliband 4).

## NOTES

1. Earlier versions of this "end of ideology" argument have been proposed by Daniel Bell, Edward Shils, Seymour Martin Lipset, and Daniel Boorstin.
2. John Newsinger makes this point in his review. See "The Martian Trilogy," *Monthly Review* 52 (December 1997): 53-55. For a sampling of these largely apolitical reviews see Roz Kaveny, Gene LaFaille, John Gribben, David Barrett, Edward James, and Ryder W. Miller.
3. For some of the socialist-feminist literature, see Sheila Rowbotham, Julie Mitchell, Heidi Hartmann, Zillah Eisenstein, Batya Weinbaum, Ann Ferguson, Iris Marion Young, Nancy Fraser, and Anne Phillips.

4. Alexander Bogdanov, *Red Star: A Utopia*, 1908. Bogdanov also wrote a sequel, *Engineer Menni*, included in the volume edited by Loren R. Graham and Richard Stites, 1984. The editors also provide useful essays on Bogdanov. For further information on Soviet science fiction, see Patrick L. McGuire, *Red Stars: Political Aspects of Soviet Science Fiction*.

5. For an early version of this socialist humanism, see Leon Trotsky, *Literature and Revolution* (Ann Arbor, 1960).

6. See, e.g., Bertell Ollmann, *Dialectical Investigations*, especially Chapter 1; Ernst Fischer, *How to Read Karl Marx*; and Bertell Ollman and Tony Smith, eds., "Dialectics: The New Frontier." *Science and Society* (entire issue) 62 (Fall 1998).

7. See, e.g., Karl Marx and Friedrich Engels, *The German Ideology* and *The Communist Manifesto*; Ernst Fischer, *How to Read Karl Marx*; David Riazonov, *Karl Marx and Friedrich Engels: An Introduction to Their Lives and Work*. For an attempt to formulate a theory of "cultural materialism," see Raymond Williams, *Marxism and Literature*.

## REFERENCES

Barrett, David. "Return to the Red Planet." *New Scientist*, January 30, 1993.

Beauchamp, Gordon. "Utopia and Its Discontents." *Midwest Quarterly* 16 (Winter 1975): 161–79.

Bell, Daniel. *The End of Ideology: On the Exhaustion of Political Ideas in the Fifties*. New York: The Free Press, 1960.

Bogdanov, Alexander. *Red Star: A Utopia* (1908). Ed. Loren R. Graham and Richard Stites. Bloomington: Indiana University Press, 1984.

Boorstin, Daniel. *The Genius of American Politics*. Chicago: Chicago University Press, 1953.

Eisenstein, Zillah. *Capitalist Patriarchy and the Case for Socialist Feminism*. New York: Monthly Review Press, 1979.

Ferguson, Ann. "Sex and Work: Women as a New Revolutionary Class in the United States" in *An Anthology of Western Marxism: From Lukacs and Gramsci to Socialist Feminism*. Ed. Roger S. Gottlieb. New York: Oxford University Press, 1989: 348–372.

Fischer, Ernst. *How to Read Karl Marx*. New York: Monthly Review Press, 1996. Revised edition of *Marx in His Own Words*, 1970.

Fraser, Nancy. *Justice Interruptus: Critical Reflections on the "Postsocialist" Condition*. London: Routledge, 1997.

Fukuyama, Francis. *The End of History and the Last Man*. New York: The Free Press, 1992.

———. "The End of History?" *The National Interest* 16 (Summer 1989): 3–18.

Gribben, John. "Prizes for the Imagination," *New Scientist*, March 13, 1993: 47.

Hartmann, Heidi. "The Unhappy Marriage of Marxism and Feminism: Towards a More Progressive Union" in Lydia Sargent, ed. *Women and Revolution*. Boston: Sound End, 1981: 2–41.

James, Edward. "The Landscape of Mars." *Times Literary Supplement*, May 3, 1996: 23.

Kaveny, Roz. "Taking Advantage of Genre." *Times Literary Supplement*, October 2, 1992: 20.

Kolko, Gabriel. *Anatomy of War: Vietnam, the United States, and the Modern Historical Experience*. New York: Pantheon, 1985.

LaFaille, Gene. "Science Fiction Universe." *Wilson Library Bulletin*, February 1993: 90–91.

Lipset, Seymour Martin. *Political Man: The Social Bases of Politics*. Garden City, NY: Doubleday, 1960.

Marx, Karl, and Friedrich Engels. Preface to *A Contribution to the Critique of Political Economy*. In *Karl Marx and Frederick Engels: Selected Works* Vol. 1. New York: International Publishers, 1968.

———. *The Communist Manifesto*. New York: Monthly Review Press, 1968.

———. *The German Ideology*. Ed. C. J. Arthur. New York: International Publishers, 1984.

———. *The Holy Family*. Moscow: Foreign Languages Publishing House, 1956.

McGuire, Patrick L. *Red Stars: Political Aspects of Soviet Science Fiction*. Ann Arbor: Michigan University Press, 1985.

Miliband, Ralph. "The Plausibility of Socialism." *New Left Review* 206 (July/August 1994).

Miller, Ryder W. "Reflections of the 100-Year Anniversary of *The War of the Worlds*: A Frontier and Literary History of Mars." *Mercury: The Journal of the Astronomical Society of the Pacific* 27 (May–June 1998): 13–16.

Mitchell, Julie. *Women's Estate*. New York: Pantheon, 1971.

Newsinger, John. "The Martian Trilogy." *Monthly Review* 52 (December 1997): 53–55.

Ollman, Bertell. *Dialectical Investigations*. New York: Routledge, 1993.

Ollman, Bertell, and Tony Smith, eds. "Dialectics: The New Frontier." *Science and Society* 62 (Fall 1998).

Phillips, Anne. "From Inequality to Difference: A Severe Case of Displacement?" *New Left Review* 224 (July–August 1997): 143–153.

Riazonov, David. *Karl Marx and Friedrich Engels: An Introduction to Their Lives and Work*. New York: Monthly Review Press, 1973.

Robinson, Kim Stanley. *Blue Mars*. New York: Bantam, 1997. (*BM* in text)

———. *Green Mars*. New York: Bantam, 1995. (*GM* in text)

———. *Red Mars*. New York: Bantam, 1993. (*RM* in text)

Rowbotham, Sheila. *Woman's Consciousness, Man's World*. New York: Penguin, 1973.

Shils, Edward. "The End of Ideology?" *Encounter* Nov. 1955: 52–58.

Tabb, William K. "Progressive Globalism: Challenging the Audacity of Capital." *Monthly Review* 50 (February 1999): 2.

Toqueville, Alexis de. *Democracy in America*. New York: Harper Row, 1966.

Trotsky, Leon. *Literature and Revolution*. Ann Arbor: Michigan University Press, 1960.

Weinbaum, Batya. *The Curious Courtship of Women's Liberation and Socialism*. Boston; South End, 1980.

Williams, Raymond. *Marxism and Literature*. Oxford: Oxford University Press, 1977.

Wood, Ellen Meiksins. "Capitalist Change and Generational Shifts." *Monthly Review* 50 (October 1998): 1–18.

———. *Democracy Against Capitalism: Renewing Historical Materialism*. Cambridge, UK: Cambridge University Press, 1995.

Young, Iris Marion. *Justice and the Politics of Difference*. Princeton: Princeton University Press, 1990.

# 7

# Women and Mad Science: Women as Witnesses to the Scientific Re-creation of Humanity

## Cherilyn Lacy

In "The Beginning," which was the premiere episode for season six of *The X-Files*, the protagonists—FBI Agents Mulder and Scully—were told by a review board that "the FBI is not a school for science." And yet, as a science fiction program which has developed an elaborate story line centered on the genetic engineering of alien-human hybrids, *The X-Files* nonetheless reflects popular anxieties about the pervasive influence of science and technology in society—especially the potential for their abuse. Thus, while it may not be "a school for science," as Roslynn Haynes noted in her study of popular stereotypes of the scientist, *The X-Files* serves as an "ideological indicator" of contemporary perceptions of science and its potential effects of society (2). In this, it continues the tradition of Mary Shelley's *Frankenstein*, which has been the subject of numerous references during the evolution of the series.[1]

Women are central to the underlying critique of the misuse of technology in both *Frankenstein* and *The X-Files*. Although the activities of scientists are portrayed as sinister and menacing, in both cases what is condemned is not necessarily scientific investigation itself, but rather the degree of power that the resulting knowledge and technology confer upon those who control them. The appropriation of female reproductive functions by male scientists who are not held accountable for their mistreatment of other human beings serves as an allegory for the threat posed to society when the results of scientific research are employed for selfish reasons rather than collective benefit.

This is unsurprising, given that since the very outset of the Scientific Revolution, Western conceptions of science have frequently relied upon gendered metaphors that characterize science as a masculine enterprise that manipulates Nature and coerces *her* secrets out of *her*.[2] It is indeed possible to contrast science, as a cognitive activity involving the rational, systematic investigation of material phenomena through observation or controlled experimentation, with technology, conceived of as mechanisms which result

from *applied science* and enable human beings to manipulate or control their environment. However, because many of the earliest proponents of scientific research employed a sexualized vocabulary of domination when they conveyed their visions of science, the distinction has effectively been obscured, if not thoroughly transgressed, in the minds of the public. When Francis Bacon, whose utopian *New Atlantis* would be the inspiration for a plethora of scientific societies in the seventeenth and eighteenth centuries, proclaimed: "I am come in very truth leading to you Nature with all her children to bring her to your service and make her your slave" (Bacon, 197), he helped foster a specific sociopolitical context for scientific investigation which would have long-term consequences for the kind of research that would be promoted up through the twentieth century. His message was intended to appeal to heads of state, who would be instrumental in authorizing and financing the new scientific institutions, yet he also set the tone that would shape *perceptions* of science for centuries to come.[3]

Thus, although Mary Shelley's *Frankenstein* can be seen as a protest against the Baconian tradition, which valorized an aggressive manipulation of nature,[4] Shelly reproduces the same binary oppositions (male/female, science/nature) that were employed by male scientists and have been so pervasive in Western culture. In the case of *The X-Files*, this critique is rendered even more complex by the fact that the female agent, Dana Scully, is at once a scientist and an involuntary participant in a covert experiment to engineer an alien-human hybrid, commonly referred to as The Project. She simultaneously represents science as a mode of inquiry, and the ominous consequences of science misused. How, then, do the narratives in *Frankenstein* and *The X-Files* both evoke and subvert prevailing stereotypes of science and women in order to voice contemporary anxieties about the power of technology to reinvent humanity itself?

By the nineteenth century the prevailing optimism about the power of science and technology to bring about greater human happiness had been replaced by a growing realization that technology—especially in England's rapidly developing industrial sphere—was being used to advance the wealth and prestige of a minority at the expense of the laboring poor. Moreover, the confidence of the Enlightenment *philosophes*—who had believed that the same, objective scientific method which revealed so much about the physical world could also arrive at the blueprint for a more just, egalitarian society—was severely shaken after the events of 1789. As a political experiment which sought to establish liberty and equality by reinventing society according to rational principles, the French Revolution ended by producing the exact opposite. The sobering lesson, learned at the price of all too much bloodshed during the Terror, was that reason alone could not promise Utopia for it was ultimately no more than a tool—a tool no more perfect than the humans who presumed to wield it.

Mary Shelley's *Frankenstein* appeared just a few years after the British defeat of Napoleon, and well into the industrial era in England. Her novel can thus be seen as a gauge of contemporary anxieties about the dehumanizing consequences of technology when employed in the self-interest of those who controlled it. Numerous scholars have observed that Victor Frankenstein's tragic flaw was his self-absorbed pride—pride in the thought that "many happy and

excellent natures would owe their being" to him (49). An idealistic yet ambitious youth, he preferred "chimeras of boundless grandeur" to the "realities of little worth" (41). The image of Frankenstein as a solitary student of science working feverishly in his isolated laboratory reflects Shelley's criticism of those who placed their faith in scientific, objective rationalism. Far from being able to claim humanitarian motives for his work, Victor, who sought to appropriate the powers of creation from Nature and bestow life, had fully withdrawn from all contact with the natural world and the company of other human beings.[5]

Much has been said of the gendered imagery of "masculine" science ravaging "feminine" nature that is implicit in Victor Frankenstein's attempt to create life independently of any female contribution. Yet Shelley also develops her female characters to suggest that *all* of humanity is undermined by the unrestrained emphasis on rationality that many of the English Romantics associated with science (Haynes, 79). Enlightenment thinkers devoted considerable attention to the question of what makes a human being, and in particular, what shapes the mind. Many were persuaded, along with John Locke, to "suppose the mind to be . . . white paper, void of all characters, without any ideas" (Locke, Bk II Ch 1). Whereas in the twentieth century emphasis has been placed on genetics, the *philosophes* placed their faith in a different kind of code: legislation and education. Gayatri Spivak has already argued that *Frankenstein* is a commentary on the danger inherent in a social system founded exclusively on "pure, theoretical, or natural-scientific reason" (256). The result is dehumanization, for the perpetration of injustices or violence against real, living human beings can be justified in the name of creating the Ideal Man. Justine was not simply an unhappy servant whose condemnation for William's murder highlights the tragedy inherent in Frankenstein's disregard for the potential consequences of his research. Her fate—to be executed for a crime committed by another—illustrates how a society presumably founded on rational, impartial legislation could nonetheless perpetrate injustice against one of its own citizens. Frankenstein's creature was aided in transferring responsibility for his crimes to Justine by the complicity of the legal system. For Shelley, this cold sacrifice of an innocent to the rational logic of impersonal laws extends beyond the suffering of one woman to menace all people equally.

No doubt fresh in her mind was the attempt of the French revolutionaries to create virtuous citizens and her own mother's criticism of any effort to give birth to a new social order that willfully excluded women from the creative process. In her *Vindication of the Rights of Woman*, Mary Wollstonecraft argued that excluding women from any concept of natural rights was not just an attack on the female half of the population, but was detrimental to all of society, "for truth must be common to all, or it will be inefficacious with respect to its influence on general practice" (86). Mary Shelley echoed this warning when Victor's cousin and future bride, Elizabeth, lamented circumstances which caused Justine to suffer for the consequences of Frankenstein's experimentation: "Alas! Victor, when falsehood can look so like the truth, who can assure themselves of certain happiness?" (88).

Shelley's *Frankenstein* is thus not simply an expression of popular anxieties about the misuse of technology. She cautioned against the idea, common to both Enlightenment political philosophy and the science of her day,

that humanity could be "engineered" more perfectly simply through a rational analysis of the component elements of a human being.[6] Moreover, it is not merely Frankenstein's silence about his own role in William's death that deprives Justine of her freedom and ultimately her life. The complicity of the general public and the courts in this miscarriage of justice bears a potent message. Science in itself does not generate monsters—they are *cultivated* by a social and political context that values research chiefly for its practical applications.

In many ways, *The X-Files* has become both an extension and the antithesis of *Frankenstein*. Numerous episodes have made playful reference to Mary Shelley's creation. Moreover, the elaborate plans to engineer an alien-human hybrid, which have served as a continuing story line in the series, underscore the same tensions about identity that lurk behind any interplay between "human" and "monster." Indeed, in both cases the scientific endeavor to create a new species raises greater questions about the humanity of the would-be engineers than it does about their creations.[7] It is the willingness of certain men to manipulate life, regardless of the consequences for other people, that is revealed as monstrous.

At the same time, *The X-Files* builds a critique of the misuse of technology that is the antithesis of *Frankenstein*. The anxieties evoked no longer center around the megalomaniacal designs of an individual who, through technology, possesses greater power than he is capable of wielding. Rather, as The Project has evolved in *The X-Files*, the greatest source of unease arises from the fact that it is never clear who is in control—if, indeed, anyone is at all. The illicit scientific experiments are conducted in laboratories across the globe by anonymous researchers, almost as if to suggest that like Frankenstein's creature, whose body was horrifying because of its dismembered origins, science has become fragmented. Most disturbing of all, however, is that there is not even a megalomaniac overseeing the sum of all the experiments. It is repeatedly implied that there are competing factions among those who direct The Project, and that its *own creations*, such as the multiple alien-human hybrids who shared the single name, Kurt Crawford, were involved in an effort to subvert it. This is more than simply a case of technology escaping from the control of its creator— it is as if the monster's creator has completely vanished, as if there never even was an original "creator." The Project to engineer an alien-human hybrid thus manifests certain features of the Foucauldian Panopticon, in which the very invisibility of the Powers at the center enhances their ability to control and manipulate others.[8]

If any allusions are made about responsibility for The Project in *The X-Files*, it is most frequently through references to the Department of Defense. That the relationship between scientific research and the military is so often written into the show's narrative suggests one of the prevailing anxieties about science and technology in the 1990s: the detrimental impact on human life caused by much of the technology that was developed during the Cold War. Yet government funding for scientific research grew so closely tied to potential military applications between 1947 and 1989 that an urgent debate arose in the early 1990s over the issue of *defense conversion*, or the shift in research from military to commercial purposes.[9] Indeed, one observer has likened the close

interaction between military funding and scientific research to "a cancer in the organism of science" (Bóhme 75).

This striking metaphor about the insidious and invasive influence of the military on scientific research and technological innovation was incorporated into the character of Dana Scully. Originally assigned to disprove her partner's theories about extra-terrestrials and paranormal phenomena, she approached each investigation with skepticism and a refusal to draw conclusions without the support of verifiable physical data. In this, and in her disinterested pursuit of factual evidence, she represents most closely the image of ideal, value-neutral science. Yet, in addition to being herself a scientist, she has also been an unwilling test subject in an effort to produce an alien-human hybrid—a secret and exploitative experiment that evokes the spectre of science "gone awry." As a result of a procedure which amounted to nothing less than a medical rape of her body, Scully developed a rare, inoperable cancer and was rendered infertile.

At one level, one could interpret this as a perpetuation of the stereotype that casts women as victims: that in spite of a woman's professional status and her independent contributions to society, she is always a potential victim. Moreover, in spite of the entry of more and more women into scientific fields, Dana Scully has violated the gendered distinction between "masculine" science and "feminine" nature which has not been fully excised from Western cultural norms. As a scientist she is an interloper because she is not male, and thus must be reduced to the status of experimental subject in order for an archaic trope to be sustained.

Moreover, as if in homage to the biological determinism so prevalent in the nineteenth century, which men had employed to restrict women's social roles to their biological functions of reproduction, the experiments to which Scully is subjected resolve the tension by removing those features of womanhood from her body. Rather than exorcising the view that women's sexuality is incompatible with scientific endeavors, through the elimination of Scully's reproductive abilities the narrative in *The X-Files* perpetuates it.

However, the character of Dana Scully defies such a simplistic categorization or reduction to the status of "victim." Far from succumbing to a fatal disease, she emerged from the experience determined to uncover the facts behind it, resolutely confirmed in her identity as scientific investigator. This suggests a more subtle commentary about science and technology than the simple distinction between a masculine, invasive, manipulative science and a feminine, victimized Nature. Indeed, her character not only exposes this distinction as artificial, but also subverts it in such a way as to produce a very subtle critique of the damage that is done to the practice of science itself by the emphasis that has been placed on controlling or manipulating the environment. The cancer inflicted upon Dana Scully by the directors of The Project serves as metaphor. Their ties to the Department of Defense were highlighted when Agent Mulder discovered the microchip which cured Scully in the bowels of the Pentagon. This metaphor suggests that the Cold War, by linking much of the funding for scientific research to the development of technology with potential military applications, seriously damaged the ideal of "pure science"—or, at least, the public's ability to believe in this ideal.

However, the fact that Dana Scully is both a woman and a scientist does more than simply demonstrate that the ideal of pure science—like the stereotyped Woman-as-Victim—suffers from the misuse of technology. Rather, it highlights the dilemma for a public that has become fully dependent on technology. Although the connection between military funding and scientific research during the Cold War era raises troubling ethical issues, technology developed in this climate has also become integral to the rhythms of daily life. Notorious for clouding the distinction between villains and protagonists, *The X-Files* plays upon this ambiguity, suggesting that separating "good" science from "bad" might be not only impossible, but also undesirable. To evoke once again Dana Scully's cancer, she was ultimately cured by a microchip—technology developed as part of the same, insidious Project that had jeopardized her life. It was the removal of a similar chip, implanted at the base of her neck when she was subjected to the hybridization experiments, which had triggered the onset of the cancer. Thus, the attempt to excise the "bad" from the "good" proved nearly fatal. Her survival dependent upon the reintroduction of the microchip into her body, Dana Scully effectively became a cyborg—a hybrid of human flesh and alien technology.[10] And, as Donna Haraway has noted, it is the cyborg which challenges the binary distinctions so pervasive in Western culture—male/female, science/nature—that have fostered a climate of domination in which technology has played such a pivotal role.[11]

*The X-Files* is a parable for the post–Cold War era, in which scientific discoveries about the most intimate workings of the human body provoke considerable anxiety because many important questions, such as who controls that knowledge and what risk it poses to the integrity of each individual body, remain unresolved.[12] Like its frequent source of inspiration, *Frankenstein*, *The X-Files* suggests that the paradox is that the closer scientists get to "the truth" of human nature, the greater the danger becomes for the human species as we know it.

Thus, perhaps the greatest source of anxiety in *The X-Files*, as in Mary Shelley's *Frankenstein*, is not science itself but rather the widespread pre-disposition in Western societies against challenging or questioning the uses of scientific research.[13] In *Frankenstein*, nobody within human society confronted Victor about his research. Though he silently lamented his culpability in the death of William, his family and friends adored him as the pillar upon whom they placed their hopes for the future. Only his creation admonished him to take responsibility for his work, saying, "Do your duty towards me, and I will do mine towards you and the rest of mankind" (94). The creature defended himself as neither inherently good nor bad, and ascribed the miserable and murderous trajectory of his life to his creator's refusal to nurture his progeny: "Once my fancy was soothed with dreams of virtue. . . . But now vice has degraded me beneath the meanest animal. . . . I, the miserable and the abandoned, am an abortion, to be spurned at, and kicked, and trampled on" (219). Paradoxically, Victor Frankenstein was blind to the creative process itself. So focused was he on the end result of producing a new species that would bless him as its creator and source that he believed he could circumvent the developmental stages of infancy and youth in which his creation would require devoted guidance (49).

A similar reproach is woven through *The X-Files*. The directors of The Project oversee a vast array of technology that they did not create themselves through painstaking research, but rather salvaged from alien spacecraft just as Dr. Frankenstein salvaged body parts from human corpses. However, in *The X-Files* the challenge is not just leveled at the scientists conducting research and the powers who control technology. In the episode most closely based on *Frankenstein*, "Post-Modern Prometheus," the exaggerated stereotypes of ignorant, small-town residents serve to indict the modern culture of expertise in which the general population is all too eager to absolve itself of responsibility for the consequences of advanced technology, and is aided in this evasion by a social division of labor which accepts widespread scientific illiteracy as unproblematic.

## NOTES

1. Among the episodes that have played upon the theme of *Frankenstein* are "Post-Modern Prometheus" (30 Nov. 97), "Young at Heart" (2 Nov. 94), and "The Beginning" (9 May 99).

2. See Londa Schiebinger (1989), Sandra Harding (1991), and Anne K. Mellor (1989). Of Mary Shelley, Mellor says, "Perhaps because she was a woman, she perceived that inherent in most scientific thought was a potent gender identification. . . . Many seventeenth-century natural philosophers and their successors viewed the scientific quest as a virile masculine penetration into a passive female nature, a penetration that would, in Bacon's words, not merely exert 'gentle guidance over nature's course' but rather 'conquer and subdue her' and even 'shake her to her foundations.' "

3. "Scientific rationality certainly is not as monolithic or determinist as many think... Nor is it all 'bad.' It has been versatile and flexible enough throughout its history to permit constant reinterpretation of what should count as legitimate objects and processes of scientific research; it is itself shaped by cultural transformations and must struggle within them; and it is inherently no better or worse than other widespread social assumptions that have appealed to groups with different and sometimes conflicting agendas" (Harding 3).

4. See Roberts, 59–73; Badley, 90–91; Mellor, 40; Homans, 100–119; and Haynes, who notes, "By extension, the suggested rape and subsequent death of the beautiful and vivacious Elizabeth by the Monster created by science can also be seen as a figurative enactment of Bacon's perception of science as penetrating the secrets of a symbolically female Nature, laid inert on the rack" (100).

5. Shelley shows Victor musing: "My eyes were insensible to the charms of nature. And the same feelings which made me neglect the scenes around me caused me also to forget those friends who were so many miles absent, and whom I had not seen for a long time. . . . I wished, as it were, to procrastinate all that related to my feelings of affection until the great object, which swallowed up every habit of my nature, should be completed" (50).

6. "By representing in her creature both the originating ideals and the brutal consequences of the French Revolution, Mary Shelley offered a powerful critique of the ideology of revolution. An abstract idea or cause (e.g. the perfecting of mankind), if not carefully developed within a supportive environment, can become an end that justifies any means, however cruel" (Mellor 84).

7. As Judith Halberstam indicates in *Skin Shows*, "Monster seeps into the category of man as justice miscarries and misery comes home. It is the human that falls into doubt at this crucial moment; it is the human that seems to be a patchwork of morality, criminality, subterfuge, and domesticity, and one which barely holds together" (37–38).

8. Foucault argues: "Hence the major effect of the Panopticon: to induce the inmate to a state of conscious and permanent visibility that assures the automatic functioning of power. So to arrange things that the surveillance is permanent in its effects, even it is discontinuous in its action; that the perfection of power should tend to render its actual exercise unnecessary; that this architectural apparatus should be a machine for creating and sustaining a power relation independent of the person who exercises it" (201).

9. For example, on March 1 and 22, June 1, and August 4, 1994, hearings were held before the Research and Technology Subcommittee of the Committee on Armed Services in the House of Representatives to discuss defense technology reinvestment and conversion issues.

10. "A hybrid composed of organism and machine, the cyborg challenges the mythos of a uniquely human identity and disperses sacred distinctions. But erasing these distinctions, as Haraway suggests, opens up new territories. . . . In Haraway's view, high-technology culture challenges the binarism of Western culture, the dualisms that support the domination of nature, women, people of color, animals" (Badley 90).

11. Haraway claims "taking responsibility for the social relations of science and technology means refusing an anti-science metaphysics, a demonology of technology, and so means embracing the skillful task of reconstructing the boundaries of daily life. . . It is not just that science and technology are possible means of great human satisfaction, as well as a matrix of complex dominations. Cyborg imagery can suggest a way out of the maze of dualisms in which we have explained our bodies and our tools to ourselves" (181).

12. "The National Organ Transplantation Act passed by Congress in 1984 prohibited the sale of organs for transplantation, but the real point emerging from discussion was that the body is now viewed as a commodity as well as a person. It has market value. But to whom or what does it—flesh, bone, blood, tissue, genes, eggs, sperm, and all—belong?" (Badley 71).

13. See Restivo, 147; Irwin and Wynne, 215; Böhme, 37. Harding states ironically that "pure science, the theoretical science that wins Nobel Prizes, is not implicated in the misuses and abuses of science and technology in the political realm. As this argument goes, we can have an easy conscience when we teach our students pure theoretical science. We and they are not responsible for what happens to the value-neutral information that is the result of pure scientific inquiry once it leaves the hands of scientists. After it is released into society, how it is used for good or bad purposes becomes others' responsibility" (37).

## REFERENCES

Bacon, Francis. " 'Temporis Partus Masculus': An Untranslated Writing of Francis Bacon." Trans. Benjamin Farrington. *Centaurus* I (1951).

Badley, Linda. *Film, Horror, and the Body Fantastic.* Westport, CT: Greenwood Press, 1993.

Böhme, Gernot. *Coping with Science.* Boulder, CO: Westview Press, 1992.

Foucault, Michel. *Discipline and Punish: The Birth of the Prison.* Trans. Alan Sheridan. New York: Vintage, 1979.

Halberstam, Judith. *Skin Shows: Gothic Horror and the Technology of Monsters.* Durham, NC: Duke University Press, 1995.

Haraway, Donna. *Simians, Cyborgs, and Women: The Reinvention of Nature.* New York: Routledge, 1991.

Harding, Sandra. *Whose Science? Whose Knowledge? Thinking from Women's Lives* Ithaca: Cornell University Press, 1991.

Haynes, Roslynn D. *From Faust to Strangelove: Representations of the Scientist in Western Literature.* Baltimore: Johns Hopkins University Press, 1994.

Homans, Margaret. *Bearing the Word: Language and Female Experience in Nineteenth-century Women's Writing.* Chicago: University of Chicago Press,1986.

Irwin, Alan, and Brian Wynne. *Misunderstanding Science? The Public Reconstruction of Science and Technology.* Cambridge, UK: Cambridge University Press, 1996.

Locke, John. *An Essay Concerning Human Understanding.* ILT Digital Classics, 1995.

Mellor, Anne K. *Mary Shelley: Her Life, Her Fiction, Her Monsters.* New York: Routledge, 1989.

Restivo, Sal. "In the Clutches of Daedalus: Science, Society, and Progress." Ed. Steven L. Goldman. *Science, Technology and Social Progress.* London: Associated University Presses, 1989.

Roberts, Marie Mulvey. "The Male Scientist, Man-Midwife, and Female Monster: Appropriation and Transmutation in *Frankenstein.*" *A Question of Identity: Women, Science and Literature.* Ed. Marina Benjamin. New Brunswick, NJ: Rutgers University Press, 1993.

Schiebinger, Londa. *The Mind Has No Sex? Women in the Origins of Modern Science.* Cambridge, MA.: Harvard University Press, 1989.

Shelley, Mary Wollstonecraft. *Frankenstein, or the Modern Prometheus.* Ed. James Rieger. Chicago: University of Chicago Press, 1982.

Spivak, Gayatri Chakravorty. "Three Women's Texts and a Critique of Imperialism." *Critical Inquiry* 12.1 (Autumn 1985): 256.

Wollstonecraft, Mary. *A Vindication of the Rights of Woman.* Ed. Carol Poston. New York: Norton, 1988.

*The X-Files.* Fox Television, 1993–present. Starring David Duchovny and Gillian Anderson. "Post-Modern Prometheus" (30 Nov. 97), "Young at Heart" (2 Nov. 94), "The Beginning" (9 May 99).

# Digital Ambivalence: Utopia, Dystopia, and the Digital Cosmos

## Dennis M. Weiss

In 1984, during Super Bowl halftime, television watchers were treated to a commercial that initiated a conversation about technology and utopia that continues today. During that commercial, Big Brother is shown glowering down from a monumental television screen, haranguing a pathetic mass of workers. Suddenly from their ranks, a rebellious young woman emerges. Rushing forward she flings a hammer toward the screen, shattering it, freeing the enslaved masses, introducing the halftime crowd to the Apple Macintosh, and, at least symbolically, starting the computer revolution for couch potatoes and football fans all around the world.

By playing off, as it does, the themes of utopia, dystopia, and the digital culture, this commercial nicely illustrates many of the themes I take up in this chapter, which will focus on a central issue being worked out not only in the selling and the marketing of the digital future but in its more, or perhaps less, imaginary moments in science fiction. Central to this debate is the question of what kind of future we are creating and whether we will have a place in it. We can learn a lot about the contours of this debate from a close reading of science fiction, especially the work of William Gibson, who, like that prescient Apple commercial, has done much to initiate and shape this debate, beginning with the publication of *Neuromancer*, also released in 1984, a good year for utopias and dystopias.

Allow me to begin by setting out what I will call the problem of homelessness. It is against the backdrop of this problem that we can deepen our understanding of the issue of our place in the digital cosmos and its treatment in contemporary science fiction.

In 1938, writing about man's place in the cosmos, Martin Buber distinguished between epochs of habitation and epochs of homelessness. "In the former," Buber writes, "man lives in the world as in a house, as in a home. In the latter, man lives in the world as in an open field and at times does not even

have four pegs with which to set up a tent" (126). From Aristotle to the medieval Christians, Buber argues, human beings have lived in the world as in a home. These were periods of habitation in which the human being had a fixed place in the cosmos. The cosmos for Aristotle, and later Aquinas, was "a manifold universe, ordered as an image, in which every thing and every being has its place and the being 'man' feels himself at home in union with them all" (134). This cosmological unity and the certitude with which human beings considered their place in it was shattered by Copernicus. "All the walls of the house were. . . crumbling beneath the blows of Copernicus, the unlimited was pressing in from every side, and man was standing in a universe which in actual fact could no longer be experienced as a house" (131). Following Copernicus, the original contact between the human being and the universe is dissolved and the human being finds his or her self a stranger in the universe. With the introduction of infinite space, we are no longer able to form an image of the universe, no longer able to transform it from a cold and meaningless space into a place, a home, an abode. Our own time, Buber argues, is best characterized by its pervasive homelessness.

Some forty years later, echoing Buber, Robert McDermott observes, "The deepest contemporary ontological problem is that of homelessness. The vast, limitless, perhaps infinite universe does not award us a place. The planet earth is a node in the midst of cosmic unintelligibility" (13). Michael Jackson begins his *At Home in the World* with an epigraph from Susan Sontag: "most serious thought in our time struggles with the feeling of homelessness." Taking up the theme of being-at-home, Jackson too argues that ours is a century of uprootedness. "All over the world, fewer and fewer people live out their lives in the place where they were born. Perhaps at no other time in history has the question of belonging seemed so urgent" (1). Increasingly, our attempts to fashion an abode out of the cosmos has been frustrated. We are thought to be a rootless people. Karl Jaspers points out in "The Spiritual Crisis of Our Times": "man today has been uprooted, having become aware that he exists in what is but a historically determined and changing situation. It is as if the foundations of being had been shattered." William Barrett, too, sees this as a dominant fact for the modern mind. "To be homeless—how well we know it in this age of displaced persons! . . . Homelessness is the destiny of modern man" (133–134).

In "Without Earth There Is No Heaven," Edwin Dobb suggests that contemporary cosmologists have given up on the idea of the cosmos as a home for human beings. The result, he argues, is a sense of abiding ontological solitude. In the cosmologies produced by the likes of Stephen Hawking, Steven Weinberg, and Alan Guth, the cosmos is largely lifeless, a brilliant intellectual edifice, yet utterly vacant. And yet, Dobb contends, judging from the popularity of texts such as Hawking's *A Brief History of Time* and Carl Sagan's television series *Cosmos*, "we still seek from cosmology what we have always sought from it, which is to say, guidance in our attempts to construct a metaphysical map of the world, at a time when cosmology has envisioned a universe that negates such attempts" (35). Dobb argues that a more adequate cosmology would be one that shifts emphasis from trying to discern the structure of the universe to trying to reckon our place within that structure.

The problem of homelessness, of finding a place in the cosmos, certainly predates the advent of digital technologies. Today, though, it is equally clear that our own experience of the problem is shaped by and probably deepened by our increasing reliance on technology. Indeed, the issue of place has been a focus of theorists of technology beginning at least with Marshall McLuhan. In *The Medium Is the Massage*, McLuhan captures the general nature of technology and its impact on our sense of place. He writes,

Electric circuitry has overthrown the regime of "time" and "space" and pours upon us instantly and continuously the concerns of all other men. . . . Its message is Total Change, ending psychic, social, economic, and political parochialism. . . . Nothing can be further from the spirit of the new technology than "a place for everything and everything in its place." You can't *go* home again (16).

Building on and extending McLuhan's insights, Joshua Meyrowitz, in *No Sense of Place*, notes the manner in which electronic media have been deeply implicated in the restructuring of our sense of space, time, and place. Meyrowitz contends that the formerly close connection between one's sense of place and one's access to information has been shattered by the electronic media. One's place is no longer synonymous with who one is or to what information one has access. Place, he contends, has become a meaningless category. Due to the homogenization of place by the electronic mass media, any place is now synonymous with every other place, and no place any longer has significance. Where I am is no longer defined by the place where my body is, but is susceptible to recoding according to the electronic media available to me. The flow of information across boundaries reduces every place to the figure of the same. As places lose their distinctive characteristics we feel increasingly rootless because our roots can no longer be defined in terms of some distinctive location. "Our world may suddenly seem senseless to many people because, for the first time in modern history, it is relatively placeless" (308). Similar arguments have been put forth by David Bolter, in his analysis of the impact of hypertext media on the shift from a hierarchical to a network culture; by Kenneth Gergen, in his discussion of the role of technology in fashioning a saturated self; and in Frederic Jameson's accounts of our feelings of alienation in postmodern hyperspace.

But while there seems to be widespread agreement on this descriptive account of our contemporary situation, there is less agreement on its significance and consequences. Especially in the last ten to fifteen years, we have witnessed a far-reaching, potentially important, but polarizing debate on the role of technology in reshaping and redefining our place in the cosmos, a debate which has been recapitulated in contemporary science fiction. On one side of this issue critics of our technological age decry our growing reliance on technology, show concern over our increasing alienation from nature, and prophesize the loss of authentic subjectivity and true community. Such dystopic visions of the digital cosmos can be seen, for instance, in the work of Sven Birkerts, Neil Postman, and Mark Slouka. In *Technopoly*, for instance, Postman criticizes what he sees as technology's power to bring about total change. Technology alters those deeply embedded habits of thought which give to a culture its sense of what the

world is like—"a sense of what is the natural order to things, of what is reasonable, of what is inevitable, of what is real" (12). On the other side of this issue we have proponents of the digital age and their utopian vision of a more democratic, more individualistic society of progress, plenty, and peace brought to you by the folks at Intel and Microsoft. Howard Rheingold's vision, elaborated in his *The Virtual Community*, provides a representative example of this so-called West Coast line of thinking, which includes the essays of John Perry Barlow and others associated with the founding of the Whole Earth 'Lectronic Link, an early, influential "virtual community." Rheingold, Barlow, and others argue that technology and the world it is fashioning move us away from stifling, hierarchical premodern and modern societies and toward more democratic, open, networked societies. Technology itself may well resolve the problems of rootlessness and homelessness by bringing people together, creating new communities, and empowering democracy. As Rheingold suggests in *The Virtual Community*, "perhaps cyberspace is one of the informal public places where people can rebuild the aspects of community that were lost when the malt shop became a mall" (26). Similar visions of what Rob Kling has called *technological utopianism* can be found in Nicholas Negroponte's *Being Digital,* William Mitchell's *City of Bits*, and Raymond Kurzweil's *The Age of Spiritual Machines*, among other works.

This debate over the nature of the digital cosmos we are creating for ourselves and our place in it is obviously important. Yet, the polarizing and fractious nature of the debate has obscured more thoughtful and cautious positions. We might get clearer on the proper contours of the problem of homelessness and technology by looking at science fiction, where this problem is the focus of a significant body of literature, exploring the place of human beings in a technological cosmos. Contemporary science fiction has been central to shaping our vision of the digital future and cyberspace and because it foregrounds technology it provides us with a readymade laboratory for examining and testing our intuitions about technology and the human lifeworld. In his essay "Global Ethnoscapes," Arjun Appadurai notes that in our current period of deterritorialization, where specific territorial boundaries and identities are transcended and individuals move about the world in uprooted groups of tourists, immigrants, exiles, and guest-workers, the imagination acquires a singular new power in social life (197). "More persons throughout the world see their lives through the prisms of the possible lives offered by mass media in all their forms. That is, fantasy is now a social practice; it enters, in a host of ways, into the fabrication of social lives for many people in many societies" (198). Examining contemporary science fiction might disclose a particular imaginary construction of the digital cosmos available to today's homeless masses.

For the purposes of this chapter I will concentrate on William Gibson, for several reasons. First, it is widely recognized that Gibson's work has been influential, highly regarded, and paradigmatic of cyberpunk science fiction. Veronica Hollinger has noted that cyberpunk has been especially fascinated with technology and its effects upon human being-in-the-world (31), and Peter Fitting contends that people read cyberpunk as a "poetic evocation of life in the late eighties. . . a fictional evocation of the feeling or experience of technoculture in the late 1980s" (296). Claire Sponsler, too, argues that cyberpunk developed as

an exploration of human experience within the context of media-dominated, postindustrial, late capitalist society (626). Gibson's trilogy, *Neuromancer* (N), *Count Zero* (CZ), and *Mona Lisa Overdrive* (MLO), together with his short story collection *Burning Chrome* (BC) and the scripts to *Johnny Mnemonic* and *The X-Files* episode "Kill Switch" (co-written with Tom Maddox) provide a large body of work that ranges over several media, offering us plenty to consider. *Neuromancer* is thought by many to be the quintessential cyberpunk novel (Hollinger 30). Sterling suggests that in Gibson's sprawl stories ("Johnny Mnemonic," "Burning Chrome," and "New Rose Hotel,"), which form the back-drop to his cyberspace trilogy, "we see a future that is recognizably and pains-takingly drawn from the modern condition" (x). Allucquere Rosanne Stone argues that Gibson's first novel *Neuromancer* was the dividing line between epochs:

*Neuromancer* reached the hackers who had been radicalized by Lucas' powerful cinematic evocation of humanity and technology. . . and it reached the technologically literate and socially disaffected who were searching for social forms that could transform the fragmented anomie that characterized life in Silicon Valley and all electronic industrial ghettos. In a single stroke, Gibson's powerful vision provided for them the imaginal public sphere and refigured discursive community that established the grounding for the possibility of a new kind of social interaction. . . . *Neuromancer* is a massive intertextual presence. (95)

Equally clear is Gibson's focus on the problem of placelessness in the digital cosmos. Most of the central characters of Gibson's fiction seem to have no place or home, are disconnected from others, transient, and rootless. At the beginning of *Neuromancer*, Case is initially cut off from the only place he feels at home, cyberspace. We learn next to nothing of the backgrounds of any of the main protagonists of the novel. Molly, who appears in both *Neuromancer* and *Mona Lisa Overdrive* as well as the short story "Johnny Mnemonic," is muscle for hire who seems to move about the landscape from job to job, calling no place home nor staying very long in any one place. Corto/Armitage is a mere semblance of a personality, having been constructed by the AI Wintermute. The main protagonists of both *Count Zero* and *Mona Lisa Overdrive*, Angie Mitchell and Bobby Newmark, are, we're told, "well matched . . . born out of vacuums, Angie from the clean blank kingdom of Maas Biolabs and Bobby from the boredom of Barrytown" (MLO 22). Angie is orphaned when her father is killed during her escape from Maas Biolabs and Bobby's home is destroyed early in *Count Zero* and he assumes that his mother is dead. Turner has fled his boyhood home and is now a mercenary who moves around a lot. "Home was the next airport Hyatt. And the next. And ever was" (CZ 2). As Turner helps Angie escape, he comments, " 'It's okay. . . we're half way home.' It was a meaningless thing to say, he thought, helping her out of the seat; neither of them had homes at all" (CZ 200). At the opening of *Mona Lisa Overdrive*, Kumiko's mother is dead and her father is sending her away from her homeland, Japan, to the strange country of England. Cherry Chesterfield's life is described as surrounded by a "sad ragged scrawl" (MLO 44), and Slick Henry has induced Korsakov's, "something they did to your neurons so that short-term memories wouldn't stick" (MLO 77). Mona is truly lost in place, having grown up on the

outside of most official systems (MLO 56). She is manipulated by the men in her life as she is moved from one squat to another, ultimately having her identity taken from her as she is cosmetically transformed into the twin of Angie Mitchell, never fully comprehending what's happening to her.

While Gibson's fiction exhibits a fascination with technology and its impact on human being-in-the-world, and while he is recognized for having created cyberspace and his dystopic novels have shaped our vision of the digital future, his work presents a very cautious and ambivalent attitude toward his creation. Gibson himself suggests his own ambivalence toward technology in an interview with Larry McCaffery. "My feelings about technology are *totally* ambivalent—which seems to me to be the only way to relate to what's happening today. When I write about technology, I write about how it has already affected our lives. . . . My aim isn't to provide specific predictions or judgments so much as to find a suitable fictional context in which to examine the very mixed blessings of technology" (274). Gibson's ambivalence toward technology is reflected in his approach to the question of place in the digital cosmos. It is this ambivalence that I think strikes the right chord in our own evolving relation to the digital cosmos. Allow me to bring out this ambivalent attitude by first contrasting the short story "Johnny Mnemonic" with the film by the same name and then examining cyberspace as a place for human beings in Gibson's trilogy *Neuromancer, Count Zero,* and *Mona Lisa Overdrive.*

The short story "Johnny Mnemonic" presents us with what by now would be recognized as a standard dystopic, cyberpunk vision of our digital future, featuring criminals and gangsters, hucksters and pimps, freelance muscle and other assorted misfits and miscreants. But it is not presented as an especially bleak or forbidding future. By the time the movie is released, however, one important addition has been made: the introduction of NAS, nerve attenuation syndrome, a fatal, epidemic disease that we are told is caused by information overload: "all the electrons polluting the airwaves. Technological civilization is causing it. But we can't live without it." We are presented with hospitals full of victims of NAS dying rather painful deaths. The information environment has turned deadly and begun to attack its inhabitants. This notion of technology polluting the environment and sickening people is completely missing from Gibson's short story and from his cyberspace trilogy. While the short story Johnny seems perfectly at home in his digital environment, Gibson's screenplay, written some ten years after the short story, seemingly rethinks the relationship between human beings and the digital environment and presents us with a digital cosmos that has turned deadly against human life and doesn't afford us a place or home.

This contrast is further underscored in the different treatments of the central character Johnny Mnemonic. Consider the opening scenes of the short story and the movie. The short story opens with Johnny, having surgically altered himself and adopted the name of Eddie Bax, doing the dance of biz, playing the game, boasting about being a very technical boy. The movie, however, opens with Johnny in a hotel, following a one-night stand. As a nameless woman makes for the door, she asks, "So, where is home Johnny?" to which he replies, "Home. . . home. . . would you believe I don't even know?" Our mnemonic courier, who is paid to remember things, can't recall his own

home. It seems that in order to make room for his mnemonic implant, Johnny has excised some of his long-term memory, specifically his memory of his childhood. Johnny then proceeds to get in touch with his agent and makes clear his desire to get out of the courier business, have his cranial implant removed, and have his long-term memory fully restored. In just one of many pointed contrasts, while our short story Johnny is engaged in doing the dance of biz, our movie version is trying to extricate himself from the biz. Throughout the rest of the movie he is subject to flashbacks of a sunny suburban life that contrasts with the dark urban decay by which he is surrounded. In recovering his long-term memory it is this childhood home and suburban fantasy that Johnny is attempting to recover.

Meanwhile, our short story Johnny is not plagued by childhood memories of home. Indeed, he has found his place in the digital cosmos, taking up residence in the Pit of Nighttown, remaking himself to fit in with the canine-inspired look of the Lo Teks, and conspiring with the cybernetic dolphin Jones to decode the technological data left as traces in his implant. Our cinematic Johnny, however, is a different story altogether. He wants to recover his place, his home, by way of recovering his memories. The end of the movie has Johnny hacking his own brain to release the information stored in him. This in turn releases the memories of his childhood and we see a bright, green, suburban lawn, a birthday party with cake and candles. What Johnny is trying to recover, the place he is trying to reconstruct, if only in memory, is clearly an entirely different world than the world he must occupy. He is not at home in the real world. Indeed, he spends the entire movie trying to recover home and when he does it is clear that that home has no place in the digital environment in which he currently resides.

The character of Johnny Mnemonic returns in *Neuromancer* and ultimately serves as counterpoint to both cinematic Johnny and Case, the cyberspace cowboy of *Neuromancer*. Molly, who is working with Case in *Neuromancer* and also appears in "Johnny Mnemonic," tells us that Case reminds her of Johnny. In *Neuromancer* she picks up the narrative where the short story ends. Molly explains that in the time following the events related in the short story, she was happy, a rare instance for any of Gibson's characters. She wonders if Case has ever been happy. "Tight, sweet, just ticking along, we were. Like nobody could ever touch us. . . . we were living fat, Swiss orbital accounts and a crib full of toys and furniture" (N 176–177). But before Johnny and Molly have a chance to get out of the business, a Yakuza assassin murders him. After that, Molly says she "never much found anybody I gave a damn about" (N 178). Later, in *Mona Lisa Overdrive*, Sally learns that Case got out of the biz some years after the Villa Straylight run and now has four kids, a point to which I will return later. Cinematic Johnny similarly opts out of the biz and achieves some kind of wholeness following the recovery of his memories at the end of the movie. In the short story, Johnny is most at home in the digital environment, and yet he is the one who ends up dead at the hands of an assassin. Both Case and cinematic Johnny leave cyberspace behind and go on to live happy lives.

In looking at these two iterations of Johnny Mnemonic, we see dramatically different views of being-at-home in the digital future. While there

are roughly similar environments in both stories, the central characters have very different relationships to their environments. Where our short story Johnny finds a place in this digital world, cinematic Johnny's place can be guaranteed only by reconstituting his memories of his childhood home. Between the short story and the screenplay, Gibson turns more ambivalent toward the digital cosmos his work has created. We have no place, he now implicitly suggests, in an environment that pollutes and sickens us and requires we forget home.

A similar ambivalence can be seen in Gibson's treatment of cyberspace. While Gibson is often celebrated for his portrayal of life in the consensual hallucination that is cyberspace, it's worth noting just how ambivalently Gibson portrays his creation. Much is made, for instance, of his account of cyberspace cowboys as body-loathing, living for the disembodied exultation of jacking into cyberspace, and indeed, this is a remarkable feature of much of the digital culture. But it is a mistake to think that *Neuromancer* unequivocally endorses this aspect of the digital future. True, the opening of *Neuromancer* focuses on Case's contempt for his body and his almost addictive need for cyberspace. Equally central, though, to understanding Case is his relationship to his girlfriend Linda Lee. That relationship is complex and I must simplify things a bit by concentrating on two particular points. First, Case's motivation as he tries to break through the ice surrounding the AIs Wintermute and Neuromancer is born when Wintermute initially presents Case with a simulation of his dead girlfriend. When Wintermute rescinds that simulation, however, Case experiences rage, a rage which impels him through the rest of the novel. Gibson writes, "He knew then: the rage had come in the arcade, when Wintermute rescinded the simstim ghost of Linda Lee, yanking away the simple animal promise of food, warmth, a place to sleep" (N 152). That animal promise, as Gibson refers to it, is what wakes Case up from the long period of numbness he had been experiencing in the first part of the novel. Case's body is literally speaking to him: "*Meat*, some part of him said. *It's the meat talking, ignore it*" (N 152). Later on, though, he can't ignore it. Neuromancer offers him the chance to turn his back on the real world, on the world of flesh and meat, and take up life in cyberspace with a virtual Linda Lee. Case refuses. While Neuromancer argues that, "to live here is to live. There is no difference" (N 258), Case has come to realize there is a difference. He cannot leave his flesh behind, even if it is to be with the woman he loves. Far from being a tale about the escape from the prison-house of the flesh, *Neuromancer* ends with the realization that human nature is embodied and our home may not be in cyberspace. But once again Gibson's ambivalence reveals itself. The very last scene of the novel has Case jacked into cyberspace once again when he sees "at the very edge of one of the vast steps of data" three figures: Neuromancer, Linda Lee, and "close behind her, arm across her shoulders, was himself" (N 271). Neuromancer has apparently generated a cyberspace doppelganger of Case that remains with Linda, taking up life in cyberspace. In one further reversal, we're told in *Mona Lisa Overdrive* that Case opted out of life as a cyberspace cowboy shortly after the events depicted in *Neuromancer*. When Sally, known as Molly in *Neuromancer*, looks up Finn, fourteen years after the events in *Neuromancer*, he tells her in response to a question about Case, "Case got out of it. Rolled up a few good scores after you split, then he kicked it in the head and quit clean. . . .

Last I heard, he had four kids" (MLO 165). Initially portrayed as the exemplar of the cyberspace cowboy, Case ends his life by building a home in the real rather than the virtual world.

While Case opts out of cyberspace, in *Count Zero* and *Mona Lisa Overdrive* Bobby Newmark and Angela Mitchell ultimately choose to leave their bodies behind and are united in a rapturous, cyberspace wedding. In *Mona Lisa Overdrive*, Bobby has given up on living in his body and has taken up life in the biosoft built by Lady 3Jane. He is portrayed as living the good life. His environments are castles and country estates with fresh mown grass and poolside retreats. He has turned his back on the real world and his own body. At the end of the novel, his true love, Angela, has projected her disembodied consciousness into cyberspace, her body and Bobby's physically die, and they marry and take up residence in the simulated castle of the simstim star Tally Isham. As Gibson describes it in the last chapter of the final installment of the trilogy: "They have come to live in this house: walls of gray stone, roof of slate, in a season of early summer. The grounds are bright and wild, though the long grass does not grow and the wildflowers do not fade" (MLO 305). Following the events portrayed in *Neuromancer*, Gibson's trilogy ends with cyberspace as the ideal habitable realm, the perfect home.

Once again, though, things are not so clear. *Count Zero* and *Mona Lisa Overdrive* complicate the relationship of individuals to cyberspace and question the implied claim that cyberspace constitutes a place for human beings. Consider, for instance, how the presentation of cyberspace is complicated in *Mona Lisa Overdrive*. By the third novel in Gibson's cyberspace trilogy, cyberspace has seemingly been "captured" or delimited. Cyberspace is often described as an infinite nonspace. In *Neuromancer* Gibson describes it as a "graphic representation of data abstracted from the banks of every computer in the human system. Unthinkable complexity. Lines of light ranged in the nonspace of the mind, clusters and constellations of data" (N 51). When Case is finally able to jack in, he describes cyberspace as "his country, transparent three-dimensional chessboard, extending to infinity" (N 51), an "infinite blue space ranged with color-coded spheres strung on a tight grid of pale blue neon" (N 63), "the infinite neuroelectronic void of the matrix" (N 115). In "Burning Chrome," it is described as a "3-D chessboard, infinite and perfectly transparent" (BC 168). The matrix created the "illusion of infinite space" (BC 177). Again in *Mona Lisa Overdrive* cyberspace is described as a nonspace: "There's no there, there. They taught to children, explaining cyberspace. . . . No there, there" (MLO 48). By the third novel, however, cyberspace, this infinite nonplace of the mind, is literally enframed through the device of the Aleph, a small, black slab of biosoft purchased by Lady 3Jane for the purpose of downloading personality constructs. The character of Gentry is obsessed with apprehending the overall shape of cyberspace and he believes he has found it in the Aleph, which is thought to contain the sum total of data constituting cyberspace (MLO 210). "The Aleph is an approximation of the matrix. . . a sort of model of cyberspace" (MLO 307). The Aleph is like a microcosm of the macrocosm, containing worlds within worlds (MLO 154). And it is in the Aleph, and not cyberspace itself, that Bobby, Angie, 3Jane, and other characters come to live. By the end of the trilogy, the Aleph, described by Slick Henry as a fairy

tale place (MLO 180) and by Colin as a toy universe (MLO 267), is marooned in the desolation of Dog Solitude, where not even rats dare to live. It is in this fairy tale place, in their virtual castle in the middle of Dog Solitude that Bobby, Angie, and company live out their days.

Adding another layer of ambivalence to this mix, we might also take note of the story that frames *Count Zero*. The novel both begins and ends not with the Count but with the mercenary Turner. At the opening of the novel he is in New Delhi running for his life. We're told later that Turner is always running, mostly away from home. It has been years since he's been home. He's estranged from his only brother and he couldn't bring himself to go home when, near death, his mother called for him. Yet, by the end of the novel, he has achieved a kind of happiness by returning to his childhood home, settling down, and raising his own son as he was raised. Indeed, the last chapter of *Count Zero* doesn't focus on Bobby and Angela, whose story will be picked up in the subsequent novel, *Mona Lisa Overdrive*. The last chapter is called "The Squirrel Wood" and focuses on Turner and his son exploring the woods in which Turner and his brother grew up. The backdrop of the chapter is one of the few if not only scenes in the trilogy of human beings interacting with animals in a natural environment. In the woods is a clearing, a "special place," where nature asserts itself by slowly swallowing up the plane that originally brought Turner home (CZ 245). Turner has seemingly made a home for himself by following Johnny Mnemonic's example, recovering his childhood home and reestablishing contact with nature and domesticity.

Finally we would do well to remember the large cast of characters surrounding Case and Bobby and Angela for whom cyberspace plays no integral part. Indeed, the characters most at home in cyberspace are either constructs or otherwise presented as flawed, suffering from obsessions or psychopathologies of various sorts. 3Jane is portrayed as a sad and pathetic figure for wanting to live forever in her biosoft construct. Virek mutates into a cancerous mass of flesh who obsesses over the next stage in his evolution. Gentry is obsessed with his search for the shape of cyberspace. Even Angie is portrayed as wracked with self-doubt, chemically dependent, possibly schizophrenic, the result of her father's experiments on her brain.

While Gibson's stories often revolve around central characters who have a vital relationship to cyberspace, the vast majority of the people populating his digital future do not. Case, for instance, is puzzled by the Zionites who live outside the official system and seemingly don't understand cyberspace.

Case didn't understand the Zionites. . . . The Zionites always touched you when they were talking, hands on your shoulders. He didn't like that. . . . "Try it," Case said [holding out the electrodes of the cyberspace deck]. The Zionite Aerol took the bank, put it on, and Case adjusted the trodes. He closed his eyes. Case hit the power stud. Aerol shuddered. Case jacked him back out. "What did you see, man?" "Babylon," Aerol said, sadly, handing him the trodes and kicking off down the corridor. (N 106)

Michael Heim suggests that the Zionites are the "body people" who remain rooted in the energies of the earth, a "human remnant in the environmental desolation of *Neuromancer*" (80). Such "remnants" appear throughout Gibson's cyberspace trilogy. The title character of the third novel,

for instance, is Mona, about whom it is never intimated that she enters cyberspace. Indeed, we are told that Angela feels a particular tenderness toward Mona because "Mona's life has left virtually no trace on the fabric of things, and represents, in Legba's system, the nearest thing to innocence" (MLO 285). While Bobby is looking for transcendence in cyberspace, Cherry Chesterfield is shown as disgusted by his desire to leave his body behind: "Hear that, motherfucker?" Cherry yelled. "You're dying! Your lungs are filling up with fluid, your kidneys aren't working, your heart's fucked. . . . You make me wanna puke" (MLO 272).

Turner too has a very physical reaction to the kind of digital cosmos Gibson describes in his cyberspace trilogy. While working security for the media conglomerate Sense/Net, a media star is killed. Her eyes, which had been replaced with artificial cameras, are described by Turner as "inhumanly perfect optical instruments. . . worth several million New Yen" (CZ 91). Immediately following her death, those inhuman eyes are removed to be reused by the corporation. When Turner recalls this incident, some nine years later, it leads to a very physical response.

And he'd turned away, his guts knotted around eight glasses of straight Scotch, and fought the nausea. And he'd continued to fight it, held it off for nine years, until, in his flight from the Dutchman, all the memory of it had come down on him, had fallen on him in London, in Heathrow, and he'd leaned forward, without pausing in his progress down yet another corridor, and vomited into a blue plastic waste canister (CZ 94).

Turner then drops out of the traveling life, changing his plans, and flies to Mexico. Turner literally reacts physically to the nature of the digital cosmos, where human beings have been transformed into cyborgs whose parts are owned by multinational corporations, recoverable upon death. His response is to move back to his boyhood home and recover a sense of nature.

In 1984, a series of texts were introduced that, while not creating the debate over technology, place, and utopia out of whole cloth, introduced a few new wrinkles into the fabric of that debate. Apple's Super Bowl commercial ultimately holds out a vision of technology that frees us from Orwell's dystopic vision and promises a coming technological utopia. Gibson's contribution to 1984 initiated a more ambivalent approach to these issues and represents an advance over this. His portrayal of the digital cosmos, of our own abode, if not now then in the future, is a richly textured vision that reveals the complex cultural and social issues tied up with technology. Central to this vision is a measure of ambivalence. It is this ambivalence that we would do well to adopt in our own increasingly technological lives. As we adopt and adapt to this technology, as it further transforms our world, we need to interrogate what it may be doing to us and to our place in the world. We can look to science fiction to offer us some guidance in this task. To the question, is technology creating a utopia or a dystopia, we should answer along with William Gibson, maybe.

## REFERENCES

Appadurai, Arjun. "Global Ethnoscapes." *Recapturing Anthropology: Working in the Present.* Ed. Richard G. Fox. Santa Fe, NM: School of American Research Press, 1991. 191–210.

Barlow, John Perry. "A Cyberspace Independence Declaration." Electronic manuscript available at: http://www.eff.org/pub/Publications/John_Perry_Barlow.

Barrett, William. *The Illusion of Technique.* Garden City, NY: Anchor Press, 1978.

Birkerts, Sven. *The Gutenberg Elegies.* New York: Fawcett Columbine, 1994.

Bolter, J. David. *Electronic Writing.* Hillsdale, NJ : L. Erlbaum Associates, 1991.

Buber, Martin. *Between Man and Man.* Trans. R. G. Smith. New York: Macmillan, 1965.

Dobb, Edwin. "Without Earth There Is No Heaven." *Harper's Magazine.* February 1995. 33–41.

Fitting, Peter. "The Lessons of Cyberpunk." *Technoculture.* Ed. Constance Penley and Andrew Ross. Minneapolis: University of Minnesota Press, 1991. 295–315.

Gergen, Kenneth. *The Saturated Self: Dilemmas of Identity in Contemporary Life.* New York: Basic Books, 1991.

Gibson, William. *Neuromancer.* New York: Ace Books, 1984. (N in text)

———. *Burning Chrome.* New York: Ace Books, 1986. (BC in text)

———. *Count Zero.* New York: Ace Books, 1986. (CZ in text)

———. *Mona Lisa Overdrive.* New York: Bantam Books, 1988. (MLO in text)

———. *Johnny Mnemonic.* Dir. Robert Longo. Tri-Star, 1995.

Heim, Michael. "The Erotic Ontology of Cyberspace." *Cyberspace: First Steps.* Ed. Michael Benedikt. Cambridge, MA: The MIT Press, 1991. 59–80.

Hollinger, Veronica. "Cybernetic Deconstructions: Cyberpunk and Postmodernism." *Mosaic* 23.2 (1990): 29–44.

Jackson, Michael. *At Home in the World.* Durham, NC: Duke University Press, 1995.

Jameson, Frederic. *Postmodernism or, The Cultural Logic of Late Capitalism.* Durham, NC: Duke University Press, 1991.

Jaspers, Karl. "The Spiritual Crisis of Our Times." *Die geistige Situation der Zeit,* 1931, usually translated as *Man in the Modern World.* Tr. Eden and Cedar Paul. Garden City, NY: Doubleday, 1957.

Kling, Rob. "Hopes and Horrors: Technological Utopianism and Anti-Utopianism in Narratives of Computerization." *Computerization and Controversy,* Second Edition. Ed. Rob Kling. San Diego: Academic Press, 1996. 40–58.

Kurzweil, Ray. *The Age of Spiritual Machines.* New York: Penguin Books, 1999.

McCaffery, Larry. "An Interview with William Gibson." *Storming the Reality Studio.* Ed. Larry McCaffery. Durham, NC: Duke University Press, 1991. 263–285.

McDermott, Robert. *Streams of Experience.* Amherst : University of Massachusetts Press, 1986.

McLuhan, Marshall, and Quentin Fiore. *The Medium Is the Massage: An Inventory of Effects.* New York: Bantam Books, 1967.

Meyrowitz, Joshua. *No Sense of Place: The Impact of Electronic Media on Social Behavior.* New York: Oxford University Press, 1985.

Mitchell, William. *City of Bits: Space, Place and the Infobahn.* Cambridge, MA: The MIT Press, 1995.

Negroponte, Nicholas. *Being Digital.* New York: Vintage Books, 1995.

Postman, Neil. *Technopoly.* New York: Knopf, 1992.

Rheingold, Howard. *The Virtual Community: Homesteading on the Electronic Frontier.* Reading, MA: Addison-Wesley, 1993.

Slouka, Mark. *War of the Worlds: Cyberspace and the High-Tech Assault on Reality.* New York: Basic Books, 1995.

Sponsler, Claire. "Cyberpunk and the Dilemmas of Postmodern Narrative."

*Contemporary Literature* 33.4 (1992): 625–645.

Sterling, Bruce. "Preface." *Burning Chrome*. By William Gibson. New York: Ace Books, 1986. ix–xii.

Stone, Allucquere Rosanne. "Will the Real Body Please Stand Up?" *Cyberspace: First Steps*. Ed. Michael Benedikt. Cambridge, MA: The MIT Press, 1991. 81–118.

# 9

# Apprehending Identity in the Alldera Novels of Suzy McKee Charnas

## Bill Clemente

Set initially in a post-holocaust world and increasingly in a postcolonial context, the Alldera cycle chronicles the protagonist's affirmation of self bolstered by her dream to create a radically new society. The novels witness Alldera's rise from slave to leader in a world split by gender, rent by war, roiled by faction, and yet sustained by hope despite the grim reality depicted.

Writing convincingly about *Walk to the End of the World* (1974) and *Motherlines* (1978), novels for which Suzy McKee Charnas won a Retrospective Tiptree Award,[1] Sarah Lefanu notes that the writing is "fired by a political vision coming from the heart of the women's liberation movement," adding that this acute perception is hardly "presented to the reader to be passively consumed." Lefanu emphasizes, moreover, that both novels "explore possibilities, but offer no solutions" (165).

The third and fourth novels in the Alldera cycle, *Furies* (1994) and *The Conqueror's Child* (1999), boldly build on the complex currents charted in the earlier books.[2] And Charnas, with the rigor readers rightly expect of her, confronts with energy and insight the vexing problems at the core of the narratives, of which this analysis concentrates on two: self-affirmation and the acquisition of power in the context of the concomitant responsibilities these reciprocal processes demand of slaves who would be free.

These latter two texts in particular focus considerable energy on the violence and terror, both psychological and physical, required of the women— many of whom fail—to throw off the yoke of the patriarchal Holdfast systems formerly and viciously imposed on them. While clearly addressing feminist concerns, the narratives' equal attention to the often traumatic but potential realization of a free society also brings the entire cycle into the orbit of conflicts at the core of much postcolonial literature, especially as the conclusion of the final novel holds hope for an emerging multicultural, feminist society. This potential world aspires to the antithesis of that to which the former

patriarchal/colonial system sought to reduce the enslaved women at the conclusion of *Walk to the End of the World:* to the ultimate commodity, slavery's lowest common denominator.    Of his modest proposal, Raff Maggomas, the Engineer of Troi, explains to his son, Eykar Bek, who the father hopes will eventually assume Holdfast's throne: "We're going to rationalize society into a small group of superior men subsisting primarily on the meat, skins and muscle power of a mass of down-bred fems. . . Eating femflesh seems bizarre to you now, but believe me, you'll get used to it."[3]

One area of shared concern with postcolonial literature parallels in general what Wole Soyinka describes as 'self-apprehension', and another bears interestingly on certain matters at the heart of Ngugi wa Thiong'o's discussions of the necessity to 'decolonize the mind'.    The former informs Alldera's growing self-awareness as well as her evolution from slave to leader while the latter establishes the often brutal context in which change occurs, one that precludes escape from hateful experience but that also promises hope even as it demands sacrifice.

As the authors of *The Empire Writes Back* note, the Nigerian Wole Soyinka argues that the essential problems for Africans concern avoiding the "two extremes of a national or racial essentialism (such as Négritude) and an international posture which denies 'self apprehension' " (164). With respect to this imperative, Soyinka writes, "To refuse to participate in the creation of a new cult of the self's daily apprehended reality is one thing; to have that reality contemptuously denied or undermined by other cultic adherents is far more dangerous and arouses extreme reactions" (xi). For Charnas's novels, patriarchy defines the outside force imposed on the fem society; and the separatist feminist eutopia detailed in *Motherlines* describes "*eu*topia" inasmuch as the Mother- lines' community offers, in Joanna Russ's formulation, better alternatives for the free fems.    It avoids, in some important respects, the national or racial essentialism that the protagonist Alldera struggles to transcend but to which she ultimately accedes at the conclusion of *The Conqueror's Child* to ensure the continued evolution of the society the free women seek to mold in the now- greening world of the old Holdfast.[4]

I refer to Ngugi in particular because of his urgent call to give voice to the traditionally silent, especially as numerous women in the novels have had their tongues removed to punish them and to preclude quite literally these subalterns from speaking.    The myths the rulers fabricate and perpetuate to legitimize their horror likewise and strategically deny women their history, casting them as demons responsible for the Wasting, an ecological disaster that reduced much of the world to near sterility: "Females themselves brought on the Wasting of the World!"; "Those were the rebels who caused the downfall and their young remain:    men call them 'unmen'.    Of all the unmen, only females and their young remain, still the enemies of men" (*Walk* 4, 5).    What Ngugi argues in general about African literature obtains for Charnas's novels, particularly as the former slave Alldera fights for identity and for the formation of a new society.    His book, *Decolonising the Mind*, Ngugi argues, is about "national, democratic and human liberation" and the continued struggle:

Struggle makes history. Struggle makes us. In struggle is our history, our language and our being. That struggle begins wherever we are; in whatever we do: then we become part of those millions whom Martin Carter once saw sleeping not to dream but dreaming to change the world (108).

These words from the Guyanese poet Carter register an impulse that informs Alldera's new-epic quest to re-create herself and in many ways to pursue Carter's literary imperative of giving voice to the traditionally voiceless: "and I bent down / listening to the land / and all I heard was tongueless whispering / as if some buried slave wanted to speak again."[5]

Prior to her escape from the Holdfast, Alldera witnesses Troi's destruction, for the Juniors, those men held in subservient positions by the paranoid Seniors, revolt. The Juniors eventually conquer, in part because of Bek's patricide, and his aiding the slave he has raped plays an important role in Alldera's securing the Holdfast with her army in *Furies*. The child of that sexual violence, the conqueror's daughter, is Sorrel, who, raised in freedom by the "Mares" in the Grasslands, gives hope in *The Conqueror's Child* for a brighter future, for she dreams of creating a more egalitarian society, one in which men need not be kept in chains. (Sorrel, in fact, might just as easily be the child of the wicked Servan d'Layo, who also raped Alldera; that the daughter reflects Bek's essential goodness in that case argues for nurture over nature as motivating men's behavior.) Charnas, as Marleen Barr writes, does not simply portray men as the enemy, for she takes care "to illustrate that women are not the only victims of patriarchal repression" (18). Centered in Troi, the Holdfast, in varying degrees of brutality, victimizes all its members.

The significance of Troi points in two related directions. On the one hand, the name identifies a center for industry, Detroit, the epitome of the rational thought that Bek's father evokes to legitimize by farming women's flesh. As suggested earlier, the men who survive the world-wide devastation blame the Wasting that engulfs all society on minorities in general and all women in particular: "It is their male descendants who emerge from the Refuge to find the world scoured of animal life and beggared of resources. They continue the *heroic, pioneering tradition* of their kind" (*Walk* 4, my emphasis). These new colonists pursue traditions established by "pioneers," who in David Diop's fitting characterization of colonial conquerors, "knew all the books but did not know love."[6] The ancestors of the Holdfast's tenants ultimately destroyed society with their poison power, just as their offspring subjugate the remaining women. The old industry underscored by the Engineer's plans, moreover, continues to pollute, though without the physical machinery that formally propelled it.

That part of Troi's significance concerns texts found there, and battles fought there also evoke Homer's heroic Troy, the narrative pattern and the hero it posits as exemplary, the warrior kin—a narrative whose expectations the Alldera cycle manipulates. Through Alldera's experiences, Charnas experiments with not simple gender reversal but, in Sarah Lefanu's words, offers "a subversion of the narrative structure that holds a protagonist in place" (35). Alldera the Conqueror is not Odysseus, who seeks immortality of reputation both through war and, on his homecoming, the harsh reimposition of

the preexisting order, for she has no such pretensions: only eventually to lie in the arms of her former lover, the Grasslander Nenisi. And in the process, she will give women back their history and lay the foundation for a possible future. In any case, Charnas challenges both versions of Troi, both the power and the narrative structure the city's name implies.

The Holdfast's Troi embodies a powerful industrial complex, a selfish and all-consuming patriarchy that dehumanizes men, who subsequently demonize the women they allow to survive and to serve. The free fems, women who manage to escape from the Holdfast to the Grasslands, know no other system, for the Matris, women who maintain order among the fems, generally kill youngsters whose rebellious acts threaten to bring further violence on the women; one Matri did, however, send Alldera on her mission to find the free fems and return with them to the Holdfast. As a result of their previous experience at the Tea Camps described in *Motherlines*, the fems subordinate themselves to the neocolonial leadership of Elona, who imposes an order familiar to the women: they know only the system that enchained them. Justly though impetuously—for as she will admit later, she wanted them to be perfect—Alldera chastises them all: "I don't want to wear a slave smock as if I were still somebody's property in the Holdfast. . . . I can't believe this. It's as if I'd never left the Holdfast at all" (321). In Franz Fanon's terms, these wretched of the earth are indeed "Affranchized slaves, or slaves who [imagine themselves] individually free" but who perpetuate the very system that initially enslaved them (Fanon, 60). Alldera will eventually win them over by activating both the dream to which Elnoa pays only lip service and the promise of what they actually desire, to paraphrase Fanon: "What they demand is not the [men's] position or status, but the [men's] place" (62).

But as Charnas clearly emphasizes, the patterns of power their history taught them weave a tight web of behavior not easily unraveled. When in *The Furies* the free fems eventually invade the Holdfast, for example, they find themselves confronting a Matri who murders beloved Tua and argues for compromise: " 'Is this what you came for?' called a voice, quavering but edged with scorn. 'To be our masters in the men's place?' " (100).

Though in her mind the Matri murders Tua because she fears men's reprisals, in actuality she hopes to ensure her privileged position. But her own violence and that for which she berates Alldera raise issues of special significance. In Soyinka's apt words, this particular Matri mirrors the problems at the old tea camp, where the people continue to "suffer from externally induced fantasies of redemptive transformation in the image of alien masters" (Soyinka, 54). Thus, motivated by the pet fem Daya's manipulative tales that malign Alldera, women eventually try to kill their leader, whose army crushed the crumbled society to which the Holdfast had reduced itself. Such is often the plight of those who lead the newly free, who elevate their leader to superhuman status but who, Franz Fanon reminds us, have learned about and therefore fear those who they believe would be gods. As Charnas notes in "Of Women and Wonder,"

Alldera is not only leader but sacrificial figure, and she senses this terrible truth: it's one of the reasons she dislikes being singled out this way. The other is that she knows that

acting in ways that a master might act leads to being seen as a master, and maybe even becoming one inwardly, however unwittingly and unwillingly. She distrusts power as it has been constructed by men, and rightly (Clemente 78).

In *Black Skin, White Mask* and *The Wretched of the Earth*, Franz Fanon argues that the struggle for liberation demands violence; that violence, he insists, will not end until the oppressed have usurped the colonizer completely. *Furies* confronts directly the need to purge the women's hatred and the requisite role of violence against the men. When Alldera berates a woman for what strikes her as excessive violence, for example, she is warned: "We killed some of the masters who used to brutalize us. We needed to do this. We all need to do it, each of us; even you" (62). Many readers have found the resulting terror and revenge disturbing, including Alldera, who comes nonetheless to appreciate its necessity. Her daughter, however, will underscore an imperative behind the special rebellion: the women simply cannot eradicate these colonizers, for unlike the women of the Motherlines who do not need men for procreation (they, in fact, represent a new species), the fems need their former conquerors.

Although in *The Conqueror's Child* the liberated women create a council to help order their lives, the problems Alldera lists to Sheel, a Grasslander and member of the fem army, at the end of *Furies* continue to plague: "The problem is men and fems, masters and slaves" (272). Before she leaves for the Grasslands at the close of the Holdfast Series, "taking the Holdfast's future further and further away from herself" (411), Alldera tells her daughter, who dreams of a future society where gender no longer divides men and women, that

"If the men's place really does change, it's not going to happen for a while. . . . When they learn to carry their honor for themselves. That's the most heroic task there is, if they could only see it. Then Eykar and Setteo and a few others, not to mention us women, wouldn't have to break our backs trying to carry it for them." (405–406)

Alldera's influence and, just as important, the impact of stories attributed to her mitigate the preceding concerns. Bitter experience has taught, however, that, in Sorrel's words, "Liberty doesn't heal every wound" (419), and the process of decolonizing the mind scars everyone, just as affirming identity demands sacrifice.

Experience teaches Alldera to accept limitations and, in part because of Bek's rebellions against his father in the first novel, how to resist power's corrupting influence. In fact, Alldera eventually turns her back on the throne that could easily be hers and retires to live in the Grasslands with the Motherlines and her beloved Nenisi, eventually leaving with this culture beyond the present reach of the fem society. Alldera quickly becomes a mythic figure; and as narrative she will continue to influence the emerging society now in the hands of youth. To this end, Charnas suggests that progress is the work of generations, epitomized, for example, by Sorrel, who, raised by the eutopian Grasslanders, brings to the new Holdfast ideas and ideals from her past that help secure a better future. Among other things, nurtured with love but alienated because she cannot conceive as Grasslanders do (by copulating with horses, whose semen activates parthogenesis), Sorrel identifies with Veree, a male baby

ostracized by the Motherlines.  Sorrel knows love but does not hate men. Equally important is Beyarra, a New Free, who, like Sorrel, hopes to lift "mucks" and "sticks" from bondage and make them both men and human.  In addition, Beyarra admires Bek and realizes the importance of the written word he teaches her.

Put in another way, the problems facing the New Holdfast concern not only fear, fear of the future, of change, of those very things that challenge a society, but also power:  how a group either focuses its energy on inventing and transforming or reverts to learned methods and manners that cause division and reinstate tyrannies.  The one approach is reactionary and regressive; it creates new Holdfasts in which a Servan D'Layo finds familiar and fertile ground for his particular brand of selfish consumption and vicious repression.  This perspective mimics and results in neocolonial systems.  As Sorrel and Beyarra attest, however, innocence and naïveté create wonderful dreams of a hopeful future, but they likewise fail to admit the reality of nightmares, as Servan D'Layo and, to a lesser degree, Daya emphasize.

To this end, a short story by the Botswanan author Bessie Head, "A Power Struggle," is instructive.  Of leadership, Head notes that the aim must be "to make evil inconsequential" (72).  Many aspire to productive leadership, Head notes, but only a few "saints" attain that goal.  The manner in which Daya manipulates Beyarra and in which Servan D'Layo treats Sorrel teach both that evil exists.  This realization that tempers their dreams at the conclusion of the novel, a fact of considerable importance, for as the strange nets that wash up on the shore and which no one in Bayo or the Holdfast identifies attest, other people and societies populate the world of challenges that awaits them.  Power, the novels additionally argue, describes always a perspective.  In "A Power Struggle," an evil brother attempts to secure the throne from his older brother and rightful heir, known as "the Beautiful One," a man who naturally merits the titles people reserve conventionally for kings.  Although a good man, he remains vulnerable to his younger brother's machinations, for he, to a degree like Sorrel and Beyarra, has yet to experience evil's reality; as do characters in the Holdfast Series, he learns to view the world not with paranoid suspicion but with healthy circumspection.

Grappling with postcolonial issues, Head's narrative also argues further points that bear on Charnas's work.  At a loss to comprehend his evil brother's assertion of power, the Beautiful One escapes into his memory, dreaming of youthful innocence until he meets a wise man who insists that the only wisdom in this particular situation is "kill or be killed," for so history and tradition dictate.  After the younger brother tries to assassinate him, the Beautiful One refuses to attack, however, reasoning that if securing the throne requires that he become like his enemy, he wants no part of the system.  Instead he leaves, taking up life as an exile in another tribe.  And yet, learning of the good man's location, the people eventually follow.  Such is the power of an extraordinary leader, for, as Head indicates, that courageous person forces people to choose and knows when and why to break with tradition's grip.

Alldera accomplishes much the same, insisting that the women not abdicate responsibility for their actions by allowing a ruler too much influence, thereby surrendering their freedom to the comfort of discipline.  Charnas,

moreover, implies that making leadership a tremendous burden lessens the chance for a D'Layo to assert his influence. In *The Conqueror's Child*, for example, Alldera complains about infinite discussions and an endless chain of meetings the Council requires: "But it meant that every decision had to be weighed and considered, often more than once, twice, or three times. While she had been gone she knew that there had been no pause in the endless palaver that it took to keep the New Holdfast running" (212); but she also acknowledges the dreadful alternatives the recent past recalls.

Head also notes that with colonization came slavery, which silenced the story of the Beautiful One and many others. "A Power Struggle" asserts that these ancient tales bear on the future because, although the stories reinstate a lost history, they do not posit an idealized past. To forget the past, Charnas's novels argue, is to relive it because, as the preceding pages argue, power describes a perspective and the women, who know only tyranny, must find new ways in which to order society. The Grasslanders, to be sure, provide only a partial solution, one that works for them but which bears only partially on the fem world's very different experiences and needs. To this end, Troi, the center of the women's former grief, assumes an important position in their life.

There, the liberated quite literally mine history, for ores and for ideas. In many respects, they mimic the past, though hardly in the manner for which V.S. Naipaul berates the Caribbeans, who he fears slavishly imitate and therefore subordinate themselves to what enslaved them, reducing their culture to a dim shadow of what they mistakenly make essential. Instead, the free fems practice emulation, a productive mimicry of the sort described by Derek Walcott:

Sophistication is human wisdom and we [West Indians or free fems], who are the dregs of that old history, its victims, its transients, its dispossessed, know what the old wisdom brought. What is called mimicry is the painful, new, laborious utterings that come out of belief, not out of doubt. . . . In the indication of the slightest necessary gesture of ordering the world around him, of losing his old name and rechristening himself, in the arduous enunciation of a dimmed alphabet, in the shaping of tools, pen or spade, is the whole, profound sign of human optimism, of what we in the archipelago still believe in: work and hope. . . . The New World originated in hypocrisy and genocide, so it is not a question for us, of returning to an Eden or of creating Utopia; out of the sordid and degrading beginning of the West Indies [the Holdfast], we could only go further in decency and regret. Poets and satirists are afflicted with the superior stupidity which believes that societies can be renewed.[7]

The New Holdfast undertakes to put the past to new use, from planting wheat to manufacturing guns, both for the general good, the antithesis of patriarchal greed, and for further growth.

The tempered optimism for which both Head and Walcott argue finds wonderful reflection in the ambivalent role stories play throughout the narrative the Alldera cycle describes. The tragic pet fem Daya resembles the African Griot, as she is an oral repository of history whose stories of slavery keep memory fresh; her imaginative narratives relate the terror the women survived and keep alive the dream to which Alldera aspires as well as the struggles they all endure. Indeed, Daya's continued treachery teaches Alldera the power of the

word, for cowardly Daya never appreciates the storyteller's necessary role and exquisite might.    She wants instead to become what she creates and consequently uses her stories to manipulate, a character fault that leads to the attempted murder of Alldera and eventually to her own death.

Daya, for example, witnesses one of Alldera's defining moments of self-affirmation.  When the former slave who, as did all the other women, habitually referred to herself in the third person as "this fem" or some other circumlocution crosses with her army the border into the Holdfast in *The Furies,* she somewhat awkwardly proclaims, "I, Alldera, I am here" (32); the pet fem quickly and enthusiastically adds, "I, Daya, I too am here!" (32).   And in response to Alldera's complaint that the storyteller makes her "a myth instead of a person," Daya asserts, "I dress you in myth with the hands of love" (39).  This affection turns soon to envy, which poisons her words that eventually seduce others to undertake an unsuccessful attempt on Alldera's life near the conclusion of *The Furies.*  For this act, the storyteller, caught up in her own myth making, refuses to acknowledge responsibility: "Daya would remember only how when the tide had turned against her, she had turned with it.  She would tell it and tell it and tell it her way until people thought that was how it had happened, because she was a gifted storyteller and because she needed them to believe" (364). Ironically, the new historian, Beyerra, who uses the pen and the written word, records all Daya's tales and puts rather a heroic spin on the pet fem's death.  In a sense, Beyerra offers a poetic version of history, for the pet fem's intrigues also resulted in Servan D'Layo's death.  In many respects, Beyerra emphasizes the significance of the results and not simply what happened; she seeks not to articulate the facts but rather to arrive at the truth.

Although uncomfortable with the tales of her own actions, Alldera nevertheless appreciates their function, just as she knows, though she herself is illiterate, the written word's beauty as well as its potential to undermine ideals and to help actualize dreams.  To this end, the mining of the past also uncovers from recent ruins narratives of consequence for the emerging future.   Bek informs Sorrel, for example, that women, too, wrote books in the past; and he mentions one text in particular:  *West with the Night.*  This text is, in fact, an actual book, an autobiography written by Beryl Markham.  The book offers an account of a strong and independent woman who in the early twentieth century lived in British East Africa.  Among other things, despite living in a patriarchal world, she was a pioneer aviator and horse breeder.   Surprisingly enough, therefore, the past provides women with a history, even role models, and a certain continuity the Wasting threatened to erase.

Recasting the past thus resembles listening to the earth and articulating the tongueless whisperings Martin Carter describes.  Markham's buried book also calls to mind Leslie Silko's description in *Ceremony* of reinventing old stories to overcome new obstacles:  she describes these long-forgotten texts as frogs who when the infrequent rains leave and the ground dries encase themselves in mud.  In this stage they often remain for many years unheard and preserved until the rains return.  At this time they emerge reborn to chant songs to a new world.[8]

The storyteller, whether through orature or written word, possesses the power to cast old tales in new forms and affirms, in Trinidadian writer Earl

Lovelace's terms and in words that characterize, I believe, Charnas's project, the "belief that the creative artist can heal the wounds of history."[9] To bridge gaps, to heal wounds, and to actualize dreams are, at heart, acts of the imagination, the power to create worlds from words. This process, as the Alldera cycle underscores, demands struggle, hope, and work. And a literature that addresses forthrightly issues that challenge the world today is science fiction,, for it engages readers, not only by inviting them to dream but also by suggesting ways in which by dreaming they can change the world.

## NOTES

1. The Eighth Annual Tiptree Award was announced at the Twentieth International Conference on the Fantastic in the Arts. This award—named in honor of the significant role Alice Sheldon/James Tiptree, Jr., played in mining science fiction's borders to include feminist concerns—pays homage each year to the work of science fiction or fantasy published that best explores and expands gender roles. Two years ago, Charnas (along with Ursula Le Guin and Joanna Russ) received a Retrospective Tiptree for the groundbreaking feminist novels *Walk to the End of the World* (1974) and *Motherlines* (1978). Charnas won the 1999 Tiptree Award for *The Conqueror's Child*.
2. *The Furies* by Suzy McKee Charnas. New York: Tor, 1994; *The Conqueror's Child* by Suzy McKee Charnas. New York: Tor, 1999. All future references are to these editions.
3. *Walk to the End of the World & Motherlines* by Suzy McKee Charnas. London: The Women's Press, 1995: 205–206. All future references are to this edition.
4. "Although 'utopia' may be a misnomer for some of the works, many of which (like Triton or The Dispossessed) present not perfect societies but only ones better than our own, 'feminist' is not. All these fictions present societies (and in one case, a guild organization) that are conceived by the author as better in explicitly feminist terms and for explicitly feminist reasons" (my emphasis). "Recent Feminist Utopias" in To Write Like a Woman: Essays in Feminism and Science Fiction by Joanna Russ, 134.
5. "Listening to the Land" by Martin Carter. Collected in Whispers from the Caribbean: I Going Away, I Going Home by Wilfred Cartey. Los Angeles: Center for Afro-American Studies, UCLA, 1991.
6. "The Vultures," by David Diop. Collected in The Penguin Book of Modern Poetry edited by Gerald Moore and Ulli Beier.
7. "The Caribbean: Culture or Mimicry?" by Derek Walcott, in Critical Perspectives on Derek Walcott edited by Robert D. Hammer: 57.
8. *Ceremony* by Leslie Marmon Silko. "Everywhere he looked, he saw a world made of stories, the long ago, time immemorial stories, as old Grandma called them" (95).
9. As quoted by Kathy Williams. "Earl Lovelace: The Wine of Astonishment." *A Handbook for Teaching Caribbean Literature* edited by David Dabydeen: 40

## REFERENCES

Ashcroft, Bill, Gary Griffiths, and Helen Tiffin. *The Empire Writes Back: Theory and Practice in Post-Colonial Literatures.* New York: Routledge, 1989
Barr, Marleen S., Ruth Salvaggio, and Richard Law. *Suzy McKee Charnas, Octavia Butler, Joan D. Vinge.* Mercer Island, WA: Starmont House, 1986.
Cartey, Wilfred, ed. *Whispers from the Caribbean: I Going Away, I Going Home.* Los Angeles: Center for Afro-American Studies, UCLA, 1991.
Charnas, Suzy McKee. *The Conqueror's Child.* New York: Tor, 1999.

————. *The Furies*. New York: Tor, 1994

————. *Walk to the End of the World & Motherlines*. London: The Women's Press, 1995.

Clemente, Bill. "Of Women and Wonder: a Conversation with Suzy McKee Charnas" in *Women of Other Worlds: Excursions Through Science Fiction and Feminism*. Nedlands: University of Western Australia Press, 1999: 62–81.

Dabydeen, David, ed. *A Handbook for Teaching Caribbean Literature*. London: Heinemann, 1988.

Fanon, Franz. *Black Skin, White Masks*. Tr. Charles Lam Markmann. New York: Grove Press, 1968.

————. *The Wretched of the Earth*. New York: Grove Press, 1963.

Hammer, Robert D., ed. *Critical Perspectives on Derek Walcott*. Washington, DC: Three Continents Press, 1993.

Head, Bessie. *The Collector of Treasures and Other Botswana Village Tales*. Portsmouth: Heinemann, 1977.

Lefanu, Sarah. *In the Chinks of the World Machine: Feminism and Science Fiction*. London: Women's Press Ltd, 1988.

Moore, Gerald, and Ulli Beier, eds. *The Penguin Book of Modern Poetry*. London: Penguin, 1963.

Ngugi wa Thiong'o. *Decolonising the Mind: The Politics of Language in African Literature*. London: J. Currey, 1986.

Russ, Joanna. *To Write Like a Woman: Essays in Feminism and Science Fiction*. Bloomington: Indiana UP, 1995.

Silko, Leslie Marmon. *Ceremony*. New York: Viking Press, 1997.

Soyinka, Wole. *Myths, Literature and the African World*. Cambridge, UK: Cambridge University Press, 1976.

# 10

# You Can't Go Home Again: *Kirinyaga* by Mike Resnick

## Lynn F. Williams and Martha Bartter

In his story-cycle, *Kirinyaga: A Fable of Utopia*, Mike Resnick explores several interrelated questions: How might a utopian society get started? What qualities must the initiator of a utopia show? Will these qualities also serve to guide the utopian society after it gets started, as it moves into its utopian dream? Here we encounter an apparent contradiction: "move" implies change; once a society becomes perfect utopia, one might assume that any change must make it less utopian. Yet a society that does not change will stagnate and ultimately disappear.

Many cultures believe that humans once lived in a utopian garden, until human change moved humans out, into a degraded, violent, unpleasant world.[1] They look to the past for their perfect society, seeking to retreat to that perfect garden. Resnick plays extensively with this pattern in his story-cycle, *Kirinyaga*.

Set in the twenty-second century, the first story, "Kirinyaga," was originally intended as a contribution to Orson Scott Card's "shared world" science fiction anthology to be called *Eutopia*.[2] Card imposed some restrictions: the worlds would all be artificial planetoids; discontented citizens would be free to leave if they wished; and the narrator must be an insider in the society. This arrangement is more common in dystopias than in utopias, where the protagonists are usually a visitor and his guide. Resnick had done some traveling in Africa and admired the grand scenery, animal life, and culture of East Africa, especially Kenya; he decided to describe a utopian world in which Kikuyu who found modern Kenya a dystopia could return to the life and customs they followed before the arrival of the Europeans.

Over the next nine years Resnick wrote nine stories which appeared in various science fiction magazines and which continued to win awards. Each narrated by Koriba, Kirinyaga's spiritual leader-dictator, they document the progress of the colony of Kirinyaga, on its utopian asteroid. Collected and framed in *Kirinyaga* (1998), these stories cover fourteen years of the narrator's life, from 2123 to 2137. In the Prologue, "One Perfect Day, with Jackals,"

readers get a very good idea of Koriba's plans, and the personal characteristics that enable him to fulfill them. This provides another unusual feature in a utopian novel; usually the society is firmly in place when the reader gets introduced to it, and the initiator (if any) is long gone. We may compare *Kirinyaga* with Skinner's *Walden Two*, which advocates behavior modification as the basis for a peaceful and cooperative lifestyle. Here, also, the inventor and leader of the society is very much present, allowing readers of *Walden Two* to evaluate T. E. Frazier, the Skinnerian stand-in. He may be well meaning, but his plan and his society sound unpleasantly rigid. This also describes Koriba, and Koriba's version of an ideal Kikuyu society.

Koriba despises the Kenya of the twenty second century: urbanized, technologized, democratic, with crowded cities, skyscrapers, pollution, and traffic. In the Prologue Koriba chides his son Edward for abandoning his Kikuyu heritage and refusing to join him on the artificial asteroid, where he will reconstruct the precontact society he claims is the only appropriate one for *real* Kikuyu. He himself will serve as *mundumugu*, the traditional wisdom keeper or "witch doctor."[3]

Evidence of biological degradation shows in the extinction of all the large African mammals, but jackals still exist. Scavengers, they attempt to colonize urban areas, but Edward, who takes his father to see them as a special treat, explains that they will soon be moved to an artificially created theme park. Koriba sees the soon-to-be-removed jackals as further evidence that "the Kikuyu, who were here before the Kenyans, [must] leave for a new world" (8). In this Prologue, Resnick shows that Koriba has already decided exactly what kind of life his people must lead to be *real* Kikuyu.

The asteroid provides an imitation of precontact Kenya as a tropical paradise, with forests, savannas, and even the sacred mountain, Kirinyaga, where the Kikuyu God Ngai lives. Although there are no more lions and elephants, there are giraffes, buffaloes, gazelles, birds, snakes, and smaller animals as well as predators like vultures and hyenas. As *mundumugu*, Koriba cures illness, settles disputes, blesses and curses. Despite his open scorn for everything "European," he has been educated at Oxford and Yale, speaks several languages, and has a computer hidden in his grass hut to communicate with "Maintenance," the apparently charitable corporation which can regulate temperature and rain on the asteroid, while overseeing the behavior of the settlers. Lacking natural enemies, the villagers cultivate their fields, herd their cattle, and dance at festivities without fear.

Resnick has subtitled his book "A Fable of Utopia," and each story begins with a fable from African folklore which prefigures the events of the story. In particular Koriba uses fables to teach the children, encouraging them to use their own minds to understand the real meaning of each tale. At the end of a story, Koriba usually meditates on the meaning and purpose of utopia and the consequence of his own actions. The primary difficulty he faces becomes clear in the opening tale, in which Koriba, following ancient Kikuyu custom, kills a newborn baby. It was born feet first, and tradition decrees that it was therefore a dangerous demon. Maintenance has not protested when old people are left outside the *boma* for the hyenas; they had the option to leave Kirinyaga if they chose, and therefore can be considered to consent to their deaths. A newborn

cannot. Although Koriba's contract with Maintenance specifies "no inter-
ference," they send a woman to remonstrate with Koriba. Koriba holds his own
with her, arguing that "the first time we betray our traditions this world will
cease to be Kirinyaga, and will become merely another Kenya" (23). But he
realizes that this is only the first skirmish in his battle to preserve precontact
Kikuyu culture.

Even Koinnage, the village chief, expresses dismay at Koriba's action
and worries for his own status with the people. Koriba declares, "Our society is
not a collection of separate people and customs and traditions. No, it is a
complex system. . . . You cannot destroy the part without destroying the whole"
(29). Utopian societies must "overcome problems such as economic scarcity,
political disorder, crime and illness" (Walters 20). Under Koriba's leadership,
Kirinyaga seems economically and politically stable; illness and death were
always present in the precolonial culture Koriba has envisioned. Even the return
to Eden may have natural drawbacks.

Koriba's insistence on maintaining tradition seems admirable at this
point, if somewhat difficult for outsiders to comprehend; killing newborns and
leaving old and dying people out for hyenas to finish off does not fit with
Western customs, but can be argued for as part of a management system that
prevents both overpopulation and magical disasters. In the next stories, however,
Resnick increases readers' doubts about the validity and value of Kikuyu
tradition. Kirinyaga is clearly not utopian for women. In dealing with Kamari,
an exceptionally bright and self-respecting young girl, Koriba blocks all her
attempts to educate herself, declaring that since Kikuyu women can't become
*mundumugus* and only *mundumugus* need education, she must abandon all
attempts at learning. The fable here involves a hawk with a broken wing, which
Koriba sets while warning Kamari that the bird will die if it cannot fly. Her
attempts to nurse it fail, as Koriba predicted, and Kamari's creativity and
intelligence are continually frustrated. The girl commits suicide.

If Kamari cannot learn enough, the next woman, Mwange, knows too
much. She immigrates with her husband, idealistically determined to become a
perfect Kikuyu wife.[4] She is prepared to weave her own cloth, cultivate her
garden, and make friends with the other women, and has practiced speaking
Kikuyu, only to discover that the people speak Swahili on Kirinyaga.[5]
Unfortunately, she tries too hard. Her weavings are prettier than the other
women's, her garden grows better, she decorates her hut with flowers. Although
the younger women admire and learn from her, she incurs the enmity of the
older, more powerful women, because she never learned the proper manners and
modes of address inculcated in Kikuyu children from an early age. All Kikuyu
"boys and girls learn that they have one thing to learn which sums up all the
others, and that is the manners and deportment proper to their station in the
community" (Kenyatta 103). Mwange fails to show proper respect to the older
woman, and even interrupts Koriba. Her example threatens to corrupt the
manners of the entire group. Worse, she angers Koriba. In the end, she and her
husband are forced to leave, while warning Koriba that rigid adherence to
tradition leads eventually to stagnation. Bright young Ndemi notes that Koriba
relied on one of the two fables he told to demonstrate why Mwange could not
join their community when he should have listened more closely to the other

one: " 'Does not the story of the *mundumugu* and the serpent tell us that we cannot be rid of that which Ngai created simply because we find it repugnant or unsettling?' " and Koriba must agree (150).

The next woman to challenge his authority is old Mumbi, one of the settlers who helped Koriba establish Kirinyaga. She leaves her son's *shamba* to build a hut for herself on Koriba's hill, much too near him for comfort. Koriba takes this as a declaration of war. He wins his battle with her only by calling down a drought that brings suffering to the entire country. Mumbi abandons her attempt at independence rather than see her grandchildren suffer, but she defiantly tells Koriba that he has made Kirinyaga as fixed and unproductive as the dried-up river. Koriba replies that its virtue depends upon this. Mumbi retorts, "All *living* things change—even the Kikuyu. . . . They change or they die" (172–173). Like Skinner's T. E. Frazier, Koriba has an answer for every argument, but his responses become more and more mechanical, less and less convincing.

Mumbi apparently knows more about Kikuyu history than does Koriba. Tradition claims that the tribe was once matriarchal, and women still have strong traditional roles (Kenyatta 7–9). Kikuyu clans are named for the daughters of Gikuyu, the first man, and his wife. Although tribal elders are traditionally men, a woman's advisory council oversees the training and well-being of young women, just as the men's advisory council deals with young men. (Kenyatta 107–108). Women and men each have their proper work in their respective areas; in some they work together, as in cultivating and weeding the garden (Kenyatta 12).[6] Thus it seems appropriate that Koriba receives the strongest warnings of the failure of his utopia from women, whose life-fostering role includes not only bearing and raising children but also passing on—and assessing—the culture.

As time passes, it appears that Kirinyaga is not a utopia for all men, either. In the first story, Koriba chooses Ndemi as his apprentice, and thinks *"You are the future. . . . It is you, Ndemi, upon whom Kirinyaga must depend if it is to survive"* (31). But his insistence upon maintaining his concept of a fully traditional culture in a new world makes life intolerable for some of the young men. Several commit suicide, frustrated because they are not needed in their traditional role as defenders of the village, and the old men own all the farms and the wives. Indeed, lacking the traditions that led families to facilitate marriages, the young men clearly see that they will never rise to the status of "elder" at all. An elder must have undergone the appropriate rituals for his age group, married, and sired at least one child; he then becomes one of the decision-makers in his community (Miller). These traditions were abandoned under British rule.

As Murumbi, one of the young bachelors living outside the village, explains, the traditional life of a Kikuyu man as practiced on Kirinyaga does not hold much attraction for him. His wife will do all the work, while he pretends to protect her from nonexistent dangers. He wants *meaning* in his life. The only solution Koriba can find for this disaffection is to exile Murumbi and those who feel as he does. The villagers reluctantly agree, even though Koriba has again removed sources of innovation and creativity lest they alter his utopia.[7]

The extent to which the fabric of utopia has unraveled becomes clear when the young men invite a famous hunter, a Maasai warrior, to visit Kirinyaga. He is to help them kill hyenas, which they think have grown too dangerous. The Maasai does get rid of a lot of hyenas, but he also moves right in, makes the Kikuyu build him a bigger house than the chief's, takes several wives, and demands that he now be called "Bwana" (master). " '*Now*,' he said, 'it is Utopia' " (91). The need to defend his people brings out the best in Koriba, who defeats the arrogant hunter with his "magic" while maintaining Kikuyu traditions. This tale emphasizes the problems of creating a society fair to all members. It also shows that Koriba has not instituted the traditional housing patterns, in which "the male head of the household lived separately in his own large *thingira*, or man's house, at the rear of the compound, with houses for each wife and her children extending in a semicircle on either side of the *thingira* toward the entrance" (Davison 19). These patterns also changed after the British came (Davison 20).

Ndemi, like young Kamari, learns more from the *mundumugu*'s computer than Koriba counted on, and soon he rebels as he learns that many of the teachings he has grown up with are either inexact interpretations or actual falsehoods. Once again, Resnick has shown that Koriba has not really re-created Kikuyu tradition. As Ndemi learns, before the British colonized Kenya, land was held by families, not villages, and family elders settled disputes.[8] Kikuyu villages, tribes, and tribal chiefs were invented by the British to facilitate the process of colonial government ("Highlights"; Kenyatta 33). He learns that Jomo Kenyatta had a European name, that Kirinyaga is a Maasai word, and that the only king who united the Kikuyu was a white man.[9] Moreover, he so informs his young friends. Koriba argues that this knowledge "will destroy their pride in being Kikuyu" meaning, of course, that it will undermine his arguments against adopting European ways (210). As a man educated in European schools, Koriba has created for himself a picture of precolonial life that does not fit reality. In fact, Koriba has made the same mistake the survival anthropologists made in the late nineteenth and early twentieth centuries: he believes that primitive cultures do not and *cannot* change over time.[10] Koriba has not organized the five traditional councils: the councils of junior warriors, senior warriors, junior elders, of peace, and religious practice (Kenyatta 197). He has taken all responsibility (and most of the power) himself. Worse, he fails to take the colony's very different environment into account.

Sadly, Ndemi leaves for Kenya, where he will acquire an education. Among all the remaining boys, Koriba can find none worthy to train in his tradition. And having learned how much more powerful Koriba's computer is than theirs, the village elders now want to use it to learn more about the world and their history. Chief Koinnage argues, "If the *mundumugu* can make a mistake by allowing a young boy to speak with his computer, can he not also make a mistake by not allowing the Elders to speak to it?" (217). Yet Koriba will not allow this.

As several of the more thoughtful and intelligent members of Koriba's "utopia" inform him, the worst problem he has created comes from his desire to hold Kikuyu life in stasis. Surely it will only be a matter of time before the villagers finally rebel against his rigid traditionalism. And indeed this does

happen; while Koriba stamps out European ideas, he finds his people coming up
with non-European inventions. As Koriba describes these innovations—oil
lamps, bows and arrows, a wooden plow—readers begin (for the first time) to
realize just how primitive a culture he has invented on Kirinyaga. Instead of
rejoicing at the creativity of his people, Koriba laments that he does not know
how to stop it.

I spent many long days sitting alone on my hill, staring down at the village and
wondering if a Utopia can evolve and still remain a Utopia.
    And the answer was always the same: Yes, but it will not be the *same* Utopia, and it
was my sacred duty to keep Kirinyaga a Kikuyu Utopia. (226)

That is, a Utopia fitting *his* vision of what Kikuyu life was like in some (mythic)
past.
    The final challenge occurs when a Maintenance ship crashes on
Kirinyaga and a doctor arrives who saves the pilot's life. Despite Koriba's
attempts to intervene, the villagers seek out the doctor to treat their illnesses.[11]
By denying his people both the truth of their history and practical ways of
deciding whether or not to adopt a particular European device, Koriba has put
them in the same condition as that of the earlier Kikuyu who sold Mr. Kenya for
six goats. They have not been allowed to develop their own criteria of
usefulness. Precisely as Koriba predicted, they rapidly accept all kinds of
European labor-saving devices.
    Now that his power has been successfully contested, the people merely
tolerate, even humor their *mundumugu*, instead of fearing and respecting him,
and Koriba returns to Kenya in defeat. Once there, he again drives his son
Edward to distraction by refusing to accept modern life. He admits that
Kirinyaga is a "failed utopia" but that Kenya is still worse. He cannot search for
Ngai on Mt. Kenya because it is now covered with buildings, but he leaves for
another sacred mountain, Mt. Marsabit. This mountain is abandoned, because
radioactive waste which had been stored at its base has begun to leak.
    Throughout the work, animals play a major role both in Koriba's fables
and in the life of the Kikuyu on Kirinyaga. Their cattle and goats provide them
with wealth, gifts to their *mundumugu* and sacrifices to Ngai. The jackals in the
Prologue prefigure the condition of the Kikuyu in Kenya, while the lions and
elephants that Koriba continually uses in his fables recall their precontact life
and add to their cultural pride. In the second story, a pygmy falcon with a
broken wing symbolizes the tragedy of Kamari, who leaves behind a couplet in
her invented language:

I know why the caged birds die—
For, like them, I have touched the sky (61)

This also describes the people on Kirinyaga; deprived of their natural creativity,
locked in Koriba's romantic "ideal" culture, they too have been caged. The ever-
present hyenas set up several aspects of the plot, both as scavengers and as
predators who limit the growth of wild game; as Ndemi comes to realize, it is
the threat of the hyena that defines the impala (192) and living with the wild
defines the Kikuyu. Koriba struggles with his paradox—how can a utopia

change and remain utopia—even in his fables, including the elephant who wished to change and got his wish but perhaps was not happy with it (174–175).

Just as Koriba convinced himself that following the customs he has designated determine whether or not a person really *is* Kikuyu, he has also convinced himself that his vision is not only the correct one, but the *only possible* one for the Kikuyu. The abilities Koriba showed as he invented and created Kirinyaga—leadership, stubbornness, education, invention—become the character traits that drive him away.

The irony of the elephant fable becomes more poignant when connected with Koriba's last adventure. Koriba is literally guided to Mt. Marsabit by the last living elephant, a clone called Ahmed, which seems to accept him as it accepts none of its keepers. The corruption of Kenyan officials, which allowed the improper storage of radioactive waste, erupts again as the scientists who cloned the elephant, having declared their experiment a success, decide to kill it and pocket the rest of their grant money.[12] Daringly, Koriba steals the elephant and follows it up Mt. Marsabit.

I had wasted many years seeking Ngai on the wrong mountain. Men of lesser faith might believe Him dead or disinterested, but I knew that if Ahmed could be reborn after all others of his kind were long dead, then Ngai must be nearby, overseeing the miracle. I would begin searching for Him again on Marsabit. . . .
And this time, I knew I would find Him. (287)

As Koriba leaves Kenya the first time with a vision of jackals making their inventive way back into "civilized" territory, so he leaves the second time following the clone of the long-extinct animal that has always symbolized Africa. Koriba is a wonderful character, as ambiguous as his utopia: idealistic but hard-headed, rigidly traditional yet capable of imaginative solutions to his problems, ultimately tragic, but still seeking God at the end.

The success or failure of any real-world intentional community depends upon the character and ability of the leader who originally inspired and organized it. As Resnick describes Koriba,

the narrator is a fanatic. I don't agree with him; I think he is dead wrong! . . . Is this the logical outcome? No! It's just that he can't see a third alternative. And if you're a fanatic and you can't see one, you don't acknowledge it, and you don't prepare for it. This is why ultimately in *Kirinyaga* the society doesn't fail, Koriba, the narrator, fails and he has to leave. ("Highlights")

*Kirinyaga* is in many ways an original approach to the central problem of utopia: if it is perfect, it should not change, yet without change it becomes rigid, uncreative, and ultimately dystopian. Resnick's novel is impressively symmetrical, opening and closing in Kenya with balanced narratives. The fables give the stories an extra dimension, as they signify the erosion of the utopian dream which cannot remain fixed, no matter how perfect it might (once) have been. While colonization created abrupt (and nonnative) changes in Kikuyu culture, their culture would have changed over time as they exchanged ideas with other groups and tried new solutions to their problems. Resnick's *Kirinyaga* tacitly demonstrates that for utopia ever to become possible, it must

be managed not by a dictator, but by a changing, growing, self-governing society. Returning to an imagined, unchanging past solves nothing; a culture can't go "home" again.

## NOTES

1. This Judeo-Christian belief matches that of many other cultures; see especially the Maha Yuga cycles of the Hindus.

2. *Eutopia* has not appeared, and Resnick chose to continue the series of stories after the surprise success of the first story, "Kirinyaga," published in *The Magazine of Fantasy and Science Fiction* in November 1988, which won a Hugo and several other awards.

3. Kenyatta spells this *mondo mogo*, and translates it as "witch doctor."

4. Mwange is not herself of Kikuyu blood, but this cannot disqualify her, for Koriba has defined being a true Kikuyu as "living as Kikuyu live." But although Mwange is a married woman, she is not circumcised and has determined to remain childless; she is therefore ineligible for the "elder" status that her age would otherwise entitle her to.

5. Koriba claims that "Kikuyu is a dead language" (119), and that most of the people don't know it. Yet the acclaimed Kenyan writer Ngugi wa Thiong'o writes his very popular novels in his native Gikuyu at the same time Resnick writes the *Kirinyaga* stories; this would only be 130 earlier (Ngugi wa Thiong'o). There seems little reason to believe that it was a dying language then or that it would die so rapidly, especially given such radical supporters of the traditional culture as Koriba and his cohorts. The reader may wonder if Koriba knows Kikuyu himself.

6. Kenyatta notes that "The mother is the immediate head of her family set, namely, her hut, her children, her personal ornaments and household utensils, as well as her cultivated fields with the crops thereon and granaries." Moreover, "co-operation in cultivating the land, planting the seeds or harvesting, depends entirely on mutual agreement between the wives and their husband" (12).

7. Koriba realizes that Ndemi, his apprentice, "was a perfect candidate to commit suicide in a few more years" because he "was the boldest and brightest of the village children" (190). Clearly, he recalls the tragedy of Kamari, who was precluded by her sex from serving him as Ndemi has learned to do. When Koriba asks Ndemi what he would have wanted to do when he was grown, Ndemi immediately gives the customary response: "Take a wife, I suppose, and start a *shamba*" but then adds "that is not really what I wanted" because he wanted "Something more" which he could not exactly describe (191).

8. Kenyatta notes that "every family unit had a land right"; the whole tribe would defend their territory, but "every inch of land within it had its owner" (22).

9. Some of Ndemi's "knowledge" seems erroneous, however; he believes that Jomo Kenyatta was born with a European name, while other sources claim that he "was born as Kamau, son Ngengi, at Ichaweri, southwest of Mt. Kenya in the East Africa highlands." Having met white doctors who treated his illness, Kamau ran away from home and studied at a mission school, where he took the name Johnstone Kamau. Leaving the mission for Nairobi, he adopted the name Kenyatta, "the Kikuyu term for a fancy belt that he wore," married, and eventually joined the protest movement against the "white-settler-dominated government" (Encyclopedia Britannica).

10. As Shoemaker explains, anthropologists studying American Indian cultures "relied on paradigms for studying Indian history that have been largely abandoned today." Their models "could not tolerate change" so they described "cultures as single entities with clear boundaries, pure and unsullied by contacts with other peoples. They cast innovations or adaptations, especially any customs or ideas borrowed from Euro-

peans, as cultural degeneration or loss" (5). Consequently, they wrote as though they were documenting the whole history of the tribe they were studying, to "capture" it before it "disappeared." Such "salvage anthropology" gave a very misleading view of actual cultural experience.

      11. Note the resonance between the experience of the villagers and that of Jomo Kenyatta.

      12. Resnick's offhand comments imply that Kenyans feel little surprise or resentment of the widely acknowledged corruption of government officials:

You have a country where the president, Daniel Erevmois [is] paid $17,500 a year and in twenty years he's amassed every DC airplane in the country, every Mercedes taxicab in the country, every Mobil gas station (which is now called Cobil), and two million acres of the best farmland, which means he brown-bagged a lot of lunches. It also means that westerners are shocked by this, but none of the locals are, because the chief is supposed to be the richest guy in the tribe. ("Highlights")

In *Devil on the Cross*, the Gikuyu author Ngugi wa Thiong'o explicitly shows that many "locals" are outraged by corruption (although they might like to share in the proceeds), and Resnick also tacitly condemns it in *Kirinyaga*. Politics seems quite as ambiguous as utopia.

## REFERENCES

Davison, Jean, with the women of Mutira. *Voices from Mutira: Lives of Rural Gikuyu Women*. Boulder, CO: Lynn Reinner, 1989.

Encyclopedia Britannica Online: Kenyatta, Jomo. http://search.eb.com/. Accessed 28 July 2000.

"Highlights of Butler/Delany Conversation." Posted 15 March, 1999. http://media-in-transition.mit.edu/science_fiction/transcripts/ resnick_jablokov.html. Accessed 24 July 2000.

Kenyatta, Jomo. *Facing Mt. Kenya: The Tribal Life of the Gikuyu*. New York:Vintage, 1938, 1962.

Miller, Harold F. "Exploring the Wisdom of Africa: Kikuyu Elderhood as African Oracle." http://www.mennonitecc.ca/occasional/26/oracle.html. Accessed 26 July 2000.

Muriuki, Godfrey. *A History of the Kikuyu, 1500–1900*. Nairobi; Oxford University Press, 1974.

Ngugi wa Thiong'o. http://www.cc.ukans.edu/~asrc/Ngugi~1.htm. Accessed 28 July 2000.

———. *Devil on the Cross*. Tr. From Gikuyu by the author. London: Heinemann, 1987.

Resnick, Mike. *Kirinyaga: A Fable of Utopia*. New York: Ballantine, 1998.

Shoemaker, Nancy, ed. *American Indians*. Malden, MA: Blackwell, 2001.

Skinner, B. F. *Walden Two*. New York: Macmillan, 1948.

Walters, Kerry S. *The Sane Society Ideal in Modern Utopianism*. Lewiston/Queenston, U.K.: Edwin Mellen, 1988.

# "Momutes": Momentary Utopias in Tepper's Trilogies

## Robin Anne Reid

Until recently, discussion of "feminist science fiction" focused primarily on the feminist utopias of the seventies. The feminist utopias most often analyzed include Ursula K. LeGuin's *Left Hand of Darkness*, Joanna Russ's *The Female Man*, Suzy McKee Charnas's *Walk to the End of the World* and *Motherlines*, and Marge Piercy's *Woman on the Edge of Time*. While these works are notable in their exploration of some seventies feminist ideas, "feminism" as a variety of philosophies, ideologies, and plans for political movement has changed since the seventies. One author who began publishing in the eighties is Sheri S. Tepper, who published, among numerous other novels (including two mystery series), four trilogies which appeared between 1985 and 1992. Tepper's feminist position has been linked mainly to *The Gate to Women's Country* (1988). I wish to add to this discussion an examination of the variety of feminist theories embodied in these trilogies.

Lucy Freibert, Sally Miller Gearheart, Natalie M. Rosinsky, Joanna Russ, and Lynn F. Williams have published work on the seventies utopias, and I have drawn from all their essays in the following summary of the feminist utopian characteristics of that time. The seventies utopias tend to share a collective process of governing rather than centralized governments or strict class structures. Communal or tribal societies consisting of non-patriarchal or extended family units were the norm. Ecological values shape ideas of how humans exist within the natural world which results in technology being reduced, destroyed, or advanced enough to be invisible and nonpolluting. Violence may occur between individuals, but what feminists saw as the patriarchy's tendency toward territorial wars is absent. Finally, some but not all of the utopias are separatist and lesbian, excluding men, often by elimination through natural disasters or war. While some of the other utopias did include

males, writers construct both genders as androgynous, valuing egalitarian relationships in nonpatriarchal cultures where childcare is often shared by more people than the biological mother, or parents.

Feminist scholarship has valued, perhaps even valorized, the seventies feminist utopias. I am not arguing that these works are not worthy of such study. But I am concerned that one unintended result might be the creation of critical categories which seem to fall into a false binary of feminist/not feminist in which only feminist utopias count as feminist science fiction. Feminist dystopias, showing futures where women are even more horribly oppressed, also count as feminist in this schema. However, despite the scholarly interest paid the seventies feminist utopias, the women writing science fiction in the eighties seemed to move on to other kinds of narratives rather than continuing to publish feminist utopias.

Recent critical work calls for considering feminist science fiction as another critical category rather than defining feminist science fiction as *only* feminist utopias. Robin Roberts, in *A New Species: Gender and Science in Science Fiction*, Jenny Wolmark, in *Aliens and Others: Science Fiction, Feminism, and Postmodernism*, and Jennifer Burwell, in *Notes on Nowhere: Feminism, Utopian Logic, and Social Transformation*, present critical models which I will draw upon.

Roberts argues for the existence of "feminist science fiction" which draws upon feminist ideas yet differs from feminist utopias by creating more fully developed characters and describing equality of gender and race. Wolmark argues writers can create strong female characters who exist within conventional narratives and can be seen as feminist appropriations which provide a starting point for resistance to patriarchal gender roles. Burwell argues that one important difference between traditional utopias and feminist utopias is their attitudes toward the "past," that is, the author's contemporary culture. Traditional utopias, according to Wolmark, maintain social harmony by repressing the individual subject and suppressing or forgetting the "past" while feminist utopias link contemporary and imagined (utopian) societies to highlight social change and female agency.

I would argue that Tepper's trilogies, specifically the *Marianne*, *Mavin*, and *Jinian* trilogies, as well as *Grass*, *Raising the Stones*, and *Sideshow*, which were all published between 1985 and 1992, fit Roberts's and Wolmark's definition of feminist science fiction and feminist appropriations. While her more utopian novel, *The Gate to Women's Country*, has gained more critical attention, I am interested in examining her earlier novels because this earlier work can be seen as part of the feminist utopian attitude toward the "past," a past that is leading to a utopian future. Tepper's work so far seems to reveal that she believes human's can participate in a utopian future only when they are so changed as to be no longer "human" (genetically). The progress from her earlier, more optimistic, work which focuses on individual change and her later, more pessimistic work which takes on the issue of cultural changes may well reflect the changing perspective of feminist theory meeting the social backlash of the 1980s.

In *Marianne, The Madame, and the Momentary Gods*, Tepper's second novel in the *Marianne* trilogy, Tepper introduces creatures/creations called

momentary gods, or "momegs." Momegs are "basically a wave form with particular aspects," beings who "give material space its reality by giving time its duration" (53–54). An infinite number of momegs exist, each with its own locus, and the momegs describe themselves as both a wave and a particle. I argue that Tepper's trilogies are feminist science fiction and include "momutes," or momentary visions of utopian possibilities (my neologism). However, a reading of the trilogies in order of publication reveals that the momutes change over the course of the novels and that the changes in the nature of these momutes correlates with the development of a more complicated narrative structure and with a decreasing trust in human beings' ability to create feminist/utopian societies. The correlation between the nature of the momutes and narrative structures reveals a change in emphasis from Tepper's focus upon the feminist empowerment of an individual woman within a patriarchal and oppressive culture to the problem of how cultural change on a larger level occurs. This may reflect changes in feminist theory. Cultures are rarely if ever changed by the actions of single individuals who call for such change. Instead, systemic changes beyond the agency of any single individual, involving demographics, technology, and economics, are what lead to cultural changes. Considering the change in culture, the subject of feminist utopias is a more complex task than the changes in a single individual.

The first three trilogies share a great deal in common, despite genre differences. The *Marianne* trilogy is closely related to the urban fantasy genre, and the *Mavin* and *Jinian* trilogies are set on what first appears to be an alternate fantasy world but which is revealed to be a world colonized by human settlers. But all the trilogies explore the situations of individual women who are born into patriarchal families and oppressive male-dominated cultures. Sexual abuse of female children, restriction of education or choices outside marriage, forced pregnancies, and other feminist concerns inform these "fantasies." Yet all three protagonists prove strong enough to escape their oppressive situations and to change some aspects of their families or cultures, although the scope of changes differ in each trilogy.

Marianne changes her own situation and that of her family, and ends in a happy and more than egalitarian marriage in another country. From the start, strong indications show that her spiritual/magical powers are stronger than her older husband's. The momutes in Marianne's life and story are all individual and limited to a small circle of people as she changes the oppressive conditions of her life by changing the time-line, but not by changing social expectations. In fact, she meets the expectations of her traditional father by marrying an upper-class male from her parents' country of origin, Alpenlicht, and having a child. Marianne achieves full agency—pregnancy and marriage do not interfere with her agency—but her power apparently comes at least in part from being a Kavi, a member of the hereditary ruling class in Alpenlicht. And while Alpenlicht is described as being as close to utopia as a country on a fairly realistic twentieth-century earth can be (with an apparently egalitarian, spiritually aware culture using reduced technology, and therefore connected to many of the seventies feminist utopias), little or no narrative time is spent there.

Mavin is also born into an oppressive extended family, a group of Shapeshifters in the "Land of the True Game." Rather than change the family,

as Marianne does, Mavin escapes, rescuing her younger brother, her older sister, and others along the way.  Mavin's momutes occur while she is traveling, independent.  Her love for the Himaggery, the Wizard she meets in the first novel, is not strong enough to cause her to subordinate her agency and independence to settle down with him, even to raise their son; instead, she arranges for her brother to raise her son, Peter.  Mavin's momutes are found upon her travels, specifically the two times she spends in another shape called a "single-horn," with another similar beast.  The name and description of single-horn evokes the image of a unicorn.  The first time, described in the first novel, she does not know anything about the other single-horn, but later in the series she learns that it was Himaggery, enchanted into that shape.  After the time he spends with the shifted Mavin, he will not allow himself to be changed back to his human form.  Later, Mavin searches for him and finds him again in the shape of the single-horn, and they share another momute in the shape of innocent beasts who live always in the present.  Mavin, like Marianne, does not change cultures radically:  the efforts she make are always to rescue individuals, primarily women and children in the different places she visits during her quests.

The focus in Marianne's and Mavin's stories upon individual empowerment and agency is different than the focus in Jinian's story which ends with humans working together to create a utopian society.  The Jinian trilogy is the third of the three interlocking trilogies set in the same world which includes the Land of the True Game. Human colonists arrived on what they considered to be an uninhabited world only to find opposition.  The world, Lom, is sentient, encompassing and communicating with all its creatures in a web of life and purpose.  Lom tries to bring humanity into the web, but humans resist; then, Lom grants humans "magical" Talents.  This causes more destruction of the "environment," as well as destruction of humans.  But there are groups working to try to change human society:  the Wizards and Dervishes specifically, who are mostly (but not all) women.

Jinian, like Marianne and Mavin, is born and raised in an unhappy family.  The sexual oppression found in the other two stories does not exist, but she is slighted and ignored while the sons are the center of attention and praise.  She discovers she is not the daughter of the woman who bore her, but the daughter of a Dervish.  When Jinian discovers her true powers—she is both a Wizard and a beast-talker, able to communicate with all animals—and the nature of the problem—the world, Lom, is trying to commit suicide—she works with all the other groups, human and others, to solve the problem.  Lom decides to live but takes away the humans' Talents as punishment, showing, as Jinian realizes, that the world believes humans are capable of learning and improving.  With the shift in focus from the individual to the cultural, the momutes change as well.  Jinian does not experience many momutes along the way, except for a few she has when she is, like Mavin, in another Shape: in this case, in the shape of an Eestie, one of the indigenous cultures of Lom.  In contrast to the earlier trilogies, the possibility of achieving a future utopian culture is strong at the end of this trilogy.

But the fourth and last trilogy, consisting of the novels *Grass, Raising the Stones*, and *Sideshow*, is not a trilogy in the traditional sense, and the

complicated narrative structure Tepper uses for these novels accompanies a distinct change in the nature of the momutes. There is no single major protagonist or linear chronology in this novel as is the case with the three earlier trilogies. The settings vary widely in time and location. Yet Tepper specifically intends them to be read as a "story": there is a metanarrative and one important continuing character which connects the three novels. The metanarrative, a spiral rather than linear structure, reveals that "Everything. . . is connected to everything else. Time imposes no limitation on this rule. . . . Past, present, future, are not disparate things, but a continuum, a recoiled helix of intercomnections. . . . In this multidimensional womb, separation is a fiction, all things are adjacent, and twentieth-century Earth snuggles close against the warm cheeks of the planet Elsewhere" (*Sideshow* 9). Tepper's three novels have a narrative structure which, it turns out, is an attempt to reverse the "natural" order of things to arrive at the utopian future while simultaneously showing a variety of pasts: that of the twenty-first century Earth (Bertan and Nela's timeline in *Sideshow*), the later Earth of Marjorie in *Grass*, other colonized planets in *Stones* and *Sideshow*.

The first two novels do not reveal the complete structure at first. Each can stand alone: *Grass* is a feminist epic revision of *Dune* in which Marjorie Westriding, a mother, goes on a journey to save her daughter, Stella. *Raising the Stones* is a feminist revision of the epic from another perspective: Samasnier Girat, or Sam, is the male protagonist of the novel. Brought up in a matrilineal and egalitarian agricultural community, he searches for the father who was left behind; he eventually achieves his dream of a father-quest based on the model of Theseus only to find that the father is the death-giver, not the life-giver. At the end of this novel, Sam is burning all his epics, planning to write new stories about all the people who have been made voiceless by the heroic stories. Only when the reader realizes that the Prophetess referred to in the second novel is Marjorie Westriding (and that information is obscured by various means), does some hint of Tepper's structure begin to manifest itself.

This trilogy first considers the idea that cultures which have achieved gender equality are not necessarily utopian, and, second, raises the question whether or not humans can ever achieve utopia without definite intervention from without (The Hobbs Land Gods, also known as the Arbai communication device). In this trilogy, momentary utopias are few and far between, and are tied to individual women leaving their families and societies to travel with a nonhuman companion, but complete utopia is achieved by the end of *Sideshow* when Homo Sapiens becomes Fauna Sapiens.

The second of the important links between the three novels is an individual, or, more accurately two individuals: Marjorie Westriding and First, the foxen Marjorie travels with. The representations of Marjorie Westriding contrast with Tepper's earlier female protagonists. In the first novel, Marjorie achieves her own momute and extends it, gaining personal enlightenment by undertaking a quest to save her daughter and by experiencing a vision of "God." Her increasing knowledge and understanding lead her to reject the values she had been taught in her Catholic girlhood, to leave her husband, and to undertake a new Journey with First, the foxen she meets on Grass. In the second novel, she is not a character as such; instead, almost a quarter of the way through the

novel, the story is told of the visit of a Prophetess to Thyker a thousand years before. The story tells of her arrival through an ancient and unknown door; she rides "upon a partially visible and quite formidable creature," and she introduces herself as "Morgori Oestrydingh." She is on a quest to find the Arbai, but she also wants to create a new society and apparently stays on Thyker long enough to teach the vision of a new society. Excerpts of her sermon are quoted in the text, including her "last and greatest commandment. . . 'Even when people are well-meaning, do not let them fool with your heads,' " and the first words she spoke: "This I say unto you, be not sexist pigs" (130–132). After a thousand years or so, in the present of the novel, the words of the Prophetess have been canonized, meaning interpreted by others, heresies eliminated, and twisted out of all recognition. "Be not pigs" is judged to mean avoid eating pigs, or anything resembling pigs; not fooling with heads is defined as meaning no hair cuts as well as no psychologists or educators being allowed to "change" anyone. The institution of the church, with an elite and a hierarchical status, can take the original words of feminism and freedom and twist them into an excuse to oppress lower-status groups, including the believers who cling to the "naïve" reading of the prophecy.

Like Mavin, Marjorie finds freedom and happiness, her utopia, in a quest; like Mavin, she finds happiness in a nonhuman companion, the Great Dragon, the First of the foxen. Also, like Mavin, she is not content to be the isolate/exceptional individual; she continually works or meddles, some would say, to help people, rescuing children, especially girls, and trying to restructure human societies. In *Sideshow*, Fringe Owldark meets an old woman called Jory in her childhood; when the group is on a Journey, they meet Jory, and Asner, again, and travel with them. By the end of the novel, it is revealed that Jory is Marjorie, that she succeeded in her quest to find the remnant of the Arbai and stayed with them until she died, and that her companion is Sam Girat from Hobbs Land. But death is not final in any area where the Arbai Device, or the Hobbs Land Gods, exist, because resurrection can take place. Jory's travels on Elsewhere and her recruiting of people to try to change Elsewhere are revealed to be the work of a resurrected Jory who cannot act completely against the Arbai device; her adopted daughter Fringe is the one who takes over and who also commits to further travels with First.

Marjorie does not begin the novels as a feminist or a Prophetess; rather, it is something she grows into over time. Part of her task is trying to change society, and training others (men and women) to change society, or perhaps human nature. As the ending of *Sideshow* makes quite clear, humanity is finally changed, but the question is by whose agency. Some "progress" from the "past" (twentieth-century Earth) is gained with the colonization of space and the development of technology. But not everything has changed, and Brannigan Galaxity's project to avoid the Hobbs Land Gods shows how easily institutions can still oppress populations. The question that is at the heart of Elsewhere, "What is the Ultimate Destiny of Man," is answered: It is to stop being only man, meaning that evolutionary, genetic change, a change in species, is necessary and probably desirable. Utopia is achieved for men and women, and for other species, but not through their own efforts.

In fact, individual efforts to reform society or culture, whether coming through religious or educational institutions, fail or become viciously oppressive. *Sideshow* quite explicitly presents an unflattering view of academics undertaking social engineering projects: they are the ones who end up as the ghosts in the machine, acting out mass orgies of perversion and destruction because of their arrogance. On Elsewhere, a planet where some humans, led by academics, retreated from the Hobbs Lands Gods, human diversity has become an excuse for the most extreme forms of torture and oppression. The Arbai population on Elsewhere refuse to extend their com-munication device, an "empathetometer," beyond their self-chosen boundaries. On Elsewhere the old problems of humanity still exist: oppression of women and children and minority populations in (mostly) patriarchal societies dominated by institutional religion. Only at the end, forced by Fringe, does the Hobbs Land Gods extend into all of Elsewhere.

The utopia Tepper envisions is not forced upon anyone—any individual can reject communion/communication. Those who completely reject the Arbai device do so and retreat to Brannigan Galaxy to be studied as the only representatives left of "unalloyed" humanity, not the most positive of endings, but given the nature of those who reject the Arbai device (the minority population most dedicated to holding onto power by the rape, torture, and murder of anyone who disagrees with them), I doubt many readers will feel sorry for that group. Tepper's full utopia shares many of the values of the seventies feminist utopia, but there are important differences as well—differences that need to be explored in depth, in further work. But the narrative's insistence that only when genetic change takes place will human beings achieve that utopian future is a different perspective on today's present, the past of the utopias, and the utopian possibilities for the future which move beyond the momentary empowerment of individual women to take on the problems of social changes and how they are achieved.

## REFERENCES

Burwell, Jennifer. *Notes on Nowhere: Feminism, Utopian Logic, and Social Transforma-tion.* Minneapolis: University of Minnesota Press, 1997.

Freibert, Lucy. "World Views in Utopian Novels by Women." *Women and Utopia: Critical Interpretations* Ed. Marleen S. Barr and Nicholas D. Smith. New York: Lanham, 1983. 67–84.

Gearheart, Sally Miller. "Future Visions: Feminist Utopias in Review." *Women in Search of Utopia: Mavericks and Mythmakers.* Ed. Ruby Rohrlich and Elaine Hoffman Baruch. New York: Schocken, 1984. 296–309.

Roberts, Robin. *A New Species: Gender and Science in Science Fiction.* Champaign/ Urbana: University of Illinois Press, 1993.

Rosinsky, Natalie M. *Feminist Futures: Contemporary Women's Speculative Fiction.* Ann Arbor: UMI Research Press, 1982.

Russ, Joanna. "Recent Feminist Utopias." *Future Females: A Critical Anthology.* Ed. Marleen S. Barr. Bowling Green: Bowling Green State University Popular Press, 1981. 71–85.

Tepper, Sherri S. *Dervish Daughter.* New York: Tor, 1986.

———. *The Flight of Mavin Manyshaped.* New York: Ace, 1985.

———. *The Gate to Women's Country.* New York: Doubleday, 1988.

———. *Grass*. New York: Doubleday, 1989.
———. *Jinian Footseer*. New York: Tor, 1985.
———. *Jinian Star-Eye*. New York: Tor, 1986.
———. *Marianne, The Magus, and the Manticore*. New York: Ace, 1989.
———. *Marianne, the Matchbox, and the Malachite Mouse*. New York: Ace, 1989.
———. *Marianne, The Madame, and the Momentary Gods*. New York: Ace, 1988.
———. *Raising the Stones*. New York: Doubleday, 1990.
———. *The Search of Mavin Manyshaped*. New York: Ace, 1985.
———. *Sideshow*. New York: Bantam, 1992.
———. *The Song of Mavin Manyshaped*. New York: Ace, 1985.
Williams, Lynn F. " 'Great Country for Men & Dogs, But Tough on Women and Mules': Sex and Status in Recent Science Fiction Utopias." *Women Worldwalkers: New Dimensions of Science Fiction and Fantasy*. Ed. Jane B. Weedman. Lubbock: Texas Tech Press, 1985. 223–246.
Wolmark, Jenny. *Aliens and Others: Science Fiction, Feminism and Postmodernism*. Iowa City: Iowa University Press, 1994.

# Of Dystopias and Icons: Brin's *The Postman* and Butler's *Parable of the Sower*

## Oscar De Los Santos

It is glaringly obvious, after reading David Brin's *The Postman* (1985) and Octavia Butler's *Parable of the Sower* (1993), that the novels are not utopian visions. Indeed, utopias are seldom plot-driven and better defined as futuristic travelogues of idealized governments and technological advances which yield near-perfect societies and/or perfect worlds. Since utopias center on pristine projections of the future, they can make intriguing but seldom exciting reading. Moreover, as Lester Del Rey notes, too often utopian writings are further debilitated by their writers' tendencies to pontificate, "the dreadful preachiness all too common":

> Utopias are not meant for entertainment. They are works of propaganda. The writer is saying to the reader: "See, I know how things should be. I've got it all figured out. Now just relax and I'll show you how great things would be if you just had enough brains to leave things up to me and become disciples." (344)

Since *The Postman* and *Parable of the Sower* focus on the battle- and economic-ravaged United States of the near future, it seems more logical to categorize them as dystopias. As John Clute observes, "The single most prolific stimulus to the production of dystopian visions has been the political polarization of capitalism and socialism" (360–361). While *The Postman* and *Parable of the Sower* do not focus exclusively on a battle between political ideologies, the former does take place in the wake of a global war between superpowers representing divergent poles of political thought, and the latter's setting is entrenched in an America that is succumbing to the dictatorial whims of big business. Still, the novels are not exactly full-fledged dystopian projections, but rather, fine variations of such. Brin and Butler remove themselves from the familiar version of the dystopia that predicts gloom and doom and eventually culminates apocalyptically, with the demise of humanity. Because Brin and Butler offer potential solutions to the problems that they

project, their dystopian texts differ from many others. Del Rey laments that, too often, dystopian novels simply present problems rather than work to solve them:

> The motive that shows through from dystopias is not greatly different from that of the writers of utopias. The books carry the message from the writer: "Look, you stupid idiots. I'm warning you! Unlike you, I can see where all the wrong things you are doing will lead you—and here is where! Listen to me and beware." . . .

> Sometimes, of course, the things that should be done to prevent the doom are obvious, as in the case of overpopulation. But nobody knows how to apply them. The dystopian writer can't be bothered figuring that out, but simply delivers his jeremiad. The true science fiction writer would be trying out methods fictionally, instead of ranting." (346–347)

Unlike the dystopian texts to which Del Rey refers, *The Postman* and *Parable of the Sower* do much more than predict a terrible fate for humanity. The novels certainly frighten on one level, but they are driven by a mutual element: restorative vision. Both novels offer ways to stave off the apocalyptic dystopian visions of the futures they present. For Brin, the key is to restore the country to some positive ideals that it once believed in and use those ideals to move forward and repair the unraveling social order. For Butler, the solution lies in reempowering humanity to believe in itself rather than some nebulous supernatural force that may or may not deliver it from the physical and spiritual corruption of the planet. Indeed, solutions are the driving force behind *The Postman* and *Parable of the Sower*.[1] Brin favors the patriotic approach to staving off apocalypse, while Butler uses religious iconography as a springboard to a humanistic philosophy. However, regardless of approach, each author successfully crafts an amalgamation of the dystopian tale. The optimism imbedded in even the bleakest moments of *The Postman* and *Parable of the Sower* centers around the principal character in each novel (Gordon Krantz in the former, Lauren Olamina in the latter) and the icons they either appropriate or recast in order to help humanity.

## REVITALIZING AND REDEFINING ICONS

When does a lie become a truth? Is there value in perpetuating and sustaining certain lies? Or in reconceiving old myths to suit one's purposes? In the case of Gordon Krantz, the principal character in David Brin's *The Postman*, a lie becomes a key motivator in the rebuilding of a war-torn American society. Gordon dons the uniform of a United States postal officer and people begin to see him as a symbol of authority and respect—a ticket out of the chaos in which they find themselves and an icon of hope that a more orderly existence can and will be restored. Brin provides readers with a textbook lesson in semiotics when he reminds us of the power of icons, symbols, and words in his novel.

In *Parable of the Sower*, on the other hand, Octavia Butler interrogates the concept of God and appropriates the word to reshape a deity which provides hope for a young girl who does her best to battle the seemingly imminent apocalypse facing her world. Lauren Olamina, the novel's principal character, quietly rebels against her minister father and formulates her own visions of power and improvement of a bleak American future. Like Brin, Butler presents

a vision of a radically altered United States that is on the brink of economic and social collapse, a nation in which the individual is virtually powerless under the dictator-like operations of big business. However, Butler resituates power onto the individual when she shows that biblical concepts and words may be interpreted not only supernaturally, but humanistically. Thus, traditional biblical icons and words become blueprints that may be used for humanity to combat totalitarian corporate empires and transform a devolving world into a more positive place. Together, David Brin and Octavia Butler negate the collapse of order in their dystopian settings by reminding us of the power of icons and their capacity to sustain multiple meanings and interpretations.

## APOCALYPSE AS ICON

As many science fiction writers have shown us through the years, the term *apocalypse* can be used as a metaphor not only for a religious event signaling the end of the world (a supernatural event akin to the biblical "second coming," for example) but also as a term which underscores the compromising of human existence via global threat or invasion of the species. Certainly, the potential demise of humanity signals the advent of an apocalypse. Science fiction has often played out in various texts the idea that humanity's very existence is threatened by an alien invasion, by some kind of supernatural force, or by its own misuse of power. It is the latter issue which concerns Brin and Butler and a host of other science fiction writers. I have chosen to link Brin and Butler in this chapter not only because *The Postman* and *Parable of the Sower* share a common setting—an imperiled United States in the near future—but also because both authors push the traditional form of science fiction text into poststructuralist territory as they work with symbols and either revitalize them or redefine them to suit their purposes. As much as the books are anchored in the usual modernist mode of storytelling, there are faint echoes of postmodernism here, especially in Butler's novel.[2]

## *THE POSTMAN*

Brin's novel presents a world of disorder and chaos. Global societies have collapsed as a result of nuclear exchanges and now, after a thirteen-year thaw, former college student and self-described "last idealist" (79) Gordon Krantz makes a westward trek across the United States, searching for a place— anyplace—that has begun to restore the order and stability of a prewar nation.

Of primary importance in *The Postman* is the manner in which Brin uses signs that represent a staple of American culture which can be found in virtually every city and town throughout the country. These signs are related to the U.S. Postal Service. The image of the postal carrier in his uniform links a substantial portion of the population to a prewar American culture from which it is far removed, but for which many people continue to hunger. The study of semiotics has long reminded us of the value and fluidity of signs and sign systems, and some semioticians have noted that cultures themselves have signs which identify and represent them to their inhabitants as well as those living outside a culture. For example, Yurij Lotman and B. A. Uspensky assert that

culture appears as a system of signs. In particular, whether we speak of such features of culture as "being man-made" (as opposed to "being natural"), "being conventional" (as opposed to "being spontaneous" and "being nonconventional"), or as the ability to condense human experience (in opposition to the primordial quality of nature)—in each case, we are dealing with different aspects of the semiotic aspects of culture. (Adams and Searle 410)[3]

In the novel, Brin highlights several distinct icons that are indicative of prewar order, stability, and union.  For example, Gordon longs to see the dimly remembered sky glow of city lights because they are symbolic of a United States "before flames blossomed and cities died" (Prelude).  (He will cry when he finally sees electric lights in one of the towns he visits.)  However, the most significant icons in the text are the dead postman's jacket and cap which Gordon dons after providing the long-dead officer's remains with a burial.  When he stumbles upon the wrecked jeep, the official look of the vehicle and the symbols worn by its long-dead occupant stir deep feelings within Gordon, "The jeep, the symbolic, faithful letter carrier, the flag patch. . .they recalled comfort, innocence, cooperation, an easy life that allowed millions of men and women to relax, to smile or argue as they chose, to be tolerant with one another—and to hope to be better people with the passage of time" (24).

Shortly afterward, Gordon dreams variations of two icons that represents rebirth:  the phoenix rising from the ashes and the American eagle that is a part of U.S. Postal Service iconography.  This dream, depicting the bird as "an old wounded thing of the skies, as near dead as the [damaged, soot-stained, and fire-seared] tree" upon which it sits, yields not a new, reborn bird, but other mechanized flying icons which represent the rebirth of a thriving society (25).

What Gordon soon discovers, upon donning the postal carrier's uniform, is that he raises the hopes of countless other individuals in his travels.  Like Gordon, these people also long for the nostalgic comforts of an organized nation.  Lotman and Uspensky claim that

Culture, as a mechanism for organizing and preserving information in the consciousness of the community, raises the specific problem of longevity.  It has two aspects:  (1) the longevity of the texts of the collective memory and (2) the longevity of the code of the collective memory. (Adams and Searle 412)

In *The Postman*, there are many citizens who remember the comforts of American culture before the war.  For these people, the codes and signs representing the prewar nation are still extremely powerful.  Specifically, citizens of small hamlets and fortress-enclosed cities in the Oregon of the future hinge great hope upon the U.S. postal carrier's jacket, upon the flag sewn onto its sleeve, and upon the horse and rider on the badge of Gordon's cap.  Indeed, dressed in the postman's jacket and cap, Gordon himself becomes an icon of hope and promise in the eyes of many.  People look upon Gordon as a kind of living mythic hero (39).  They want him to repeat the story that tells how he got to be a postman, and no honest answer on Gordon's part can convince them that he is not a representative of a government on the brink of regrouping.  After all, his presence and his uniform counter his words.  Moreover, he carries evidence of a restored Union in his mail pouch:  envelopes with old letters in them,

indicative of communication between members of the fragmented nation. Gordon carries the envelopes and letters around to ease his loneliness and reminisce about better times. He reads the letters and finds solace in their ticket to another time. On the other hand, people in the towns which he visits begin to give him new letters to carry onto the next town and Gordon complies. His reasons are partially selfish: the letters and the uniform soon provide the perfect means to be let into suspicious hamlets and be provided with food and shelter for a few days. However, Gordon also acts out of pity for the people he encounters. He can't find it within himself to deny their requests that he carry mail to friends and relatives in faraway cities and towns, often without knowing if these loved ones are even alive. Eventually, he stops trying to deny that he is a postal carrier. The icons, after all, seem to speak greater truths than his protests. It is at this point that some lies begin to be slowly transformed into variations of truth.

Soon, Gordon creates the myth of the Restored United States. He says he is a representative of a country that is coming back to life, somewhere in the East. The East itself is another word which harbors many connotations and may be regarded as a kind of icon: the East holds promise for many of those in the West. It is the place where the United States was first organized and it is the place where it is supposedly being restored. Similarly, for Gordon, the West becomes an icon which holds the promise of a prosperous future as he makes his way across country, searching for a place where somebody has taken the responsibility of reviving the nation.[4] Ironically, Gordon quickly discovers the curse of the postman uniform that is entwined with its benefits. Thanks to his outfit, he finds himself admitted into several places where he would have been happy to settle down and help rebuild. However, he soon realizes that such a desire is not a possibility because people always expect the postman to keep moving.

While a few of the larger, more developed hamlets are initially suspicious of a meddlesome country imposing its regulations upon their new governments, it is no wonder that most people so readily wish to believe in Gordon's Restored United States. Such a country would eventually work to eradicate the militant survivalist gangs that now exist, especially the large and powerful Holnist gang that threatens to take over most of the western part of the United States. Gordon has spent "[s]ixteen years chasing a dream" which consists of a place where someone is rebuilding the nation; "someplace where someone is taking responsibility" (4). He is searching for the right symbol and authority figure, little realizing that he will have to become the figure and assume the responsibility himself.

I'll ask the question again: when does a lie become a truth? As Gordon learns, there is a paradox embedded in the query. Sometimes a lie can become a truth when a truth results from repeated tellings of the lie. Gordon learns to reconcile with his first lie—the donning of the postman's uniform and the authoritative image he projects—because he finally understands that there is some fundamental truth that is embedded within the lie. At the end of the novel, he is preparing to head farther west to California, fueled by yet another icon—a dying soldier's bear flag patch—which signals not an enemy from another country, in his eyes, but other human survivors on the planet. Gordon leaves

Oregon with the icons of postman's jacket and cap, and with the old postal service/Restored United States lie turned truth on his lips: "My obligations are to the nation, not to one small corner of it," he tells the citizens of Corvallis, "allowing them to go on believing things which were not lies at heart" (319).

One of the toughest lessons that Gordon finally comes to learn is that certain lies may be beneficial if they fuel positive ideals and humane progress. Such lies may bring about necessary changes, which is why "The Servants of [super-computer] Cyclops would go on spreading their own myths, encouraging a rebirth of technology" and why "Gordon's appointed postmasters would continue lying without knowing it, using the tale of a restored nation to bind the land together, until the fable wasn't needed anymore. Or until, by believing it, people made it come true" (319–320). It is important to remember that in some ways, Gordon does not simply appropriate the myths and symbols of old, but refines them slightly to create new myths that will help restore the order and stability that the damaged nation craves. As Lotman and Uspensky observe, "The longevity of the code is determined by its basic structural principles and by its inner dynamism—its capacity for change while still preserving the memory of preceding states and, consequently, of the awareness of its own coherence" (413). Many of Gordon's fellow Americans may be battle-scarred, but they are not ready to abandon the basic ideals (and idealism) that comprised the American mythology of old. By working to revitalize their country, by working to restore old truths, Brin's characters contribute to an ever-expanding American mythology.

*The Postman* is a book as much about heroes and heroism as it is about the struggles of restoring order to a nation that has collapsed. Gordon remembers reading about heroes in his youth, but doesn't see himself as one. After all, "Nearly all of them," he recalls, are "able to push aside their personal burdens . . . for at least the time when action impended" (18). Eventually, Gordon will grudgingly have to assume the role of hero because the image of the postman riding his horse and delivering mail proves too strong an image to negate. People give Gordon mail to deliver to the next town in his travels, and he does so. Moreover, he begins to swear in young men as fellow postmen. Some are barely in their teens, but they wish to be a part of the country's rebirth. Once these new postmen are recruited and mail routes are established throughout much of the state of Oregon, the myth of the Restored United States begins to become a reality.

The symbol of the phoenix or postal eagle becomes a powerful icon to these new recruits, who sport "blue tunics and leather jackets similar to his own. On their sleeves," Gordon notices the patches depicting "an eagle rising defiantly from a pyre, rimmed by the legend: Restored U.S. Postal Service" (196).

Gordon often wondered whether the right symbol might motivate people to mount a massive reconstruction of the country. He will eventually concede that his own outfit—"the letterman's gray uniform cap, its brass badge . . . the figure of a rider, hunched forward on horseback," the jacket with the U.S. flag patch which makes strangers reach out to touch his sleeve—are the symbols for which he has been searching (50).

Brin's novel introduces other iconographic myths and legends which assist humanity in rebuilding. The war has wiped out the systems of the Cyclops supercomputer and left it no more than a vast shell, but like the less-than-mighty wizard who wants everyone to believe in the power of Oz the Great and Terrible, scientists create the illusion that Cyclops is alive and well and offering instructions which will help to rebuild the country. Granted, the scientists' original motive is to con villagers out of precious food and other life-sustaining supplies in exchange for the often flawed information that Cyclops provides, but the illusion of a working supercomputer eventually provides hope to people who desperately need it. Gordon is initially incensed by the scientists' ruse when he discovers it, but he eventually sees the value in continuing the Cyclops computer illusion. Indeed, the scientists' appropriation of the computer icon parallels Gordon's own use of the postman's uniform to suit his purposes: both provide deceptions which eventually yield positive results.

Moreover, there is the legend of heroic feminist Dena Spurgen and her self-sacrificing female followers. Dena and a group of young women sacrifice themselves in a battle against Holnist survivalists. By doing so, they make a group of men ashamed to have resisted engaging in a necessary battle to eradicate a dictatorial enemy. Afterward, Dena's legend grows and her very name becomes a symbol of hope for females seeking to once again take up the battle to empower themselves in a world dominated by men.

However, it is the legend of the postman and the icons worn by Gordon Krantz which prove most influential as the country restores itself. Heroes are often adorned with icons and Gordon proves himself to be a worthy, albeit extremely reluctant, uniformed hero. The postman role insures Gordon more respect but leaves him a permanent vagabond of sorts. Gordon recognizes that "he had to be a demigod" in the eyes of people, "or nothing at all." Frustrated, he considers himself "a man . . . trapped in his own lie" (132). However, one of the most powerful aspects of this novel is that it dares to posit that certain myths or lies are beneficial. *The Postman* underscores the value of a unified democratic nation and stresses the possibility that lies can eventually be transformed into truths.

## PARABLE OF THE SOWER

Brin takes existing icons and resurrects the concepts and principles that lie at their foundations. In *Parable of the Sower*, Octavia Butler takes the idea of God and its textual signifier—the word God—and transforms them into an ideology which situates power on humanity rather than a supernatural being. Butler's text differs from Brin's from the start because the latter deals with several concrete symbols (the postal carrier and the U.S. flag, for example) upon which to hang the ideas of a unified country, freedom, and such, while the former interrogates the concept of a deity. The word God may be regarded as a concrete signifier, but the concept of a deity is subject to a wide diversity of choices. As Charles Sanders Peirce, Umberto Eco, and other semioticians have stressed, not only may objects themselves be regarded as signs that are open to interpretation, but "even the concepts of the objects. . . must be considered in a semiotic way." Therefore, *"even ideas are signs"* (Eco 166, emphasis Eco's).

All that you touch
You Change.

All that you Change
Changes you.

The only lasting truth
Is Change.

God
Is Change.

EARTHSEED: THE BOOKS OF THE LIVING (Butler 3)

*Parable of the Sower* opens with this verse. It is the first entry in the journal of Lauren Olamina, the young African American heroine in Butler's novel. Lauren will fill her journal with parables and call it *Earthseed: The Book of the Living*. She is only fifteen when she begins to write her verses and eighteen at the end of the novel. However, her wisdom runs deeply, as her writings reveal. Lauren is the daughter of a minister, but "At least three years ago, my father's God stopped being my God. . . . My God has another name" (6). Change is the God of which Lauren conceives. More about that in a moment. However, it is significant to note that Butler immediately begins to recast traditional symbols when she introduces Lauren Olamina as her principal character.

If I asked an audience to conceive an image of a prophet in its head, some people might come up with a white haired and robed figure holding a book in one hand and a staff in the other; others might update the image and have the prophet wearing a finely cut suit and preaching from a pulpit; still others might simply conjure a picture of Charlton Heston in their heads. Cleverly, Butler dismisses all of these traditional icons and recasts her prophet. Granted, Lauren is the daughter of a minister, but that is as close to the old concept of visionary as Butler gets. First, Lauren is a female and female ministers are still fairly rare in most religious circles; indeed, history has most often cast religious prophets as male. Second, because Lauren's dead mother abused an experimental drug when she was pregnant, Lauren is gifted with hyperempathy, a blessing and curse which allows her to feel pleasure and pain when others in close proximity experience these feelings. Butler creates a scientific reason for this condition— her mother's drug abuse—however, the result is that Lauren is gifted in a way that her followers are not. Third, Lauren has visions: not mystical "fire and brimstone" visions, but strong projections of a plan to improve humanity's struggling existence. Finally, she is a prophet with a following. People begin to follow Lauren north, where she intends to forge the first Earthseed colony and implement her plan to improve the world. To sum up, Butler's vision of visionary is a young African American female with keen insights into the decline of the human race and the manner in which this decline might be curbed. Lauren Olamina is a woman with positive visions which she presents for her followers' consideration via her discussions and her Earthseed texts. "We adapt and endure," she declares in one of her parables. "For we are Earthseed/ And God is Change" (15).

Most of Lauren's Earthseed writings are hinged on common sense and the need to improve one's own conditions rather than rely upon an unseen supernatural force. They are presented in a poetic format and as such resemble traditional prayers in appearance, but here again Butler reconceives the notion of prayer and the idea of a Bible. If this is a religious Bible, it is one with a recast God as its focal point. "God is Change," Lauren stresses throughout her verses, but rather than worship the concept, she advises her followers to subscribe to the idea of change and be prepared to change with the times in order to improve their existence and stay alive, " 'Change is ongoing,' " Lauren stresses. " 'Every thing changes in some way—size, position, composition, frequency, velocity, thinking, whatever. Every living thing, every bit of matter, all the energy in the universe changes in some way' " (195). When some of her followers have trouble understanding the idea of personifying change into a being—a god— Lauren patiently explains that that is not exactly what she has done. "'Earthseed deals with ongoing reality, not with supernatural authority figures. Worship is no good without action' " (197). Even prayer to this God of change is not used in the traditional fashion. Prayer is simply a reminder that "God is Change" and that human actions leading to the improvement of the race are vital if the race itself is to survive. Reading or listening to Lauren's Earthseed verses may be construed as a kind of prayer, but this activity is beneficial only to remind oneself of the principles of the Earthseed philosophy, not the power of some omnipotent deity.

The reinvention of a deity in *Parable of the Sower* is worth a little more discussion. Time for another thought experiment: If I asked you to come up with a vision of a god in your head, what would you envision? A kindly old man? A bright light at the end of a tunnel? Something else? Well, regardless of the image you conjure, many religions have a deity at their center who demands that his (it is often a male god) followers obey a certain set of commands and worship him as divine ruler. Lauren's vision of a deity, on the other hand, is faceless, genderless, and rooted in the concept of changing and improving human life. While other religions project the notion that we are cast in God's image and therefore should strive to act in a moral and ethical fashion in order to honor the supreme ruler, Lauren's projection of a god hits far closer to the human shell than many concepts of a deity. Paradoxically, Lauren's god seems very close to an atheistic existentialist god. Sartre tells us that a man is no more than the sum total of his actions and that actions are the key to affirming one's existence.[5] Similarly, Lauren's god is Change and that Change is forever linked to the activity—the actions—of human beings. Therefore, if God is the sum total of our actions, one of the things she is positing via her philosophy is that we are ourselves the closest manifestations of a deity that we are likely to encounter. Several of Lauren's parables allude to this notion. For example: "The Self must create/ Its own reasons for being./ To shape God,/ Shape Self" (231). Lauren's discussions—her preachings, if you will—also emphasize the idea that change is the only constant and that it is up to us to take control of this constant and do our best to ensure that forthcoming changes work to our advantage:

There's power in knowing that God can be focused, diverted, shaped by anyone at all. But there's no power in having strength and brains, and yet waiting for God to fix things

for you or take revenge for you. . . . God will shape us every day of our lives. Best to understand that and return the effort: Shape God. (197)

Lauren's reinvented religion—her humanized religion—even includes a version of Heaven. It is not some puffy cloud paradise with golden gates and flying angels but the stars above, the cosmos that must be reached and explored. " 'The Destiny of Earthseed is to take root among the stars' " she emphasizes to her followers. If humanity is to survive long into the future and achieve even a semblance of immortality, then it must focus its efforts beyond Planet Earth and move off of it. Even before she begins her Earthseed philosophy, the young Lauren Olamina understands the importance of the heavens. Like Gordon Krantz in *The Postman*, Lauren's stepmother longs for the blaze of the artificial city lights of her youth, a signal of better times. However, Lauren is content with the natural brilliance of the night sky (5). A little later, she is saddened to hear that a female astronaut will be returned to Earth rather than be allowed to drift toward Mars, which was her desire if she died in space. Unlike many politicians and her minister father, Lauren is very much in favor of the space program. She understands the importance of space in humanity's long-term survival map.[6] A few years later, when she is leading her following into northern California to begin the first Earthseed colony, Lauren continues to stress that heaven is the heavens and humanity's best hope of attaining anything close to immortality:

"The Destiny of Earthseed is to take root among the stars," I said. "That's the ultimate Earthseed aim, and the ultimate human change short of death. It's a destiny we'd better pursue if we hope to be anything other than smooth-skinned dinosaurs—here today, gone tomorrow, our bones mixed with the bones and ashes of our cities. . . . After all, my heaven really exists, and you don't have to die to reach it." (199)

## "GOD IS CHANGE"

Because many utopian and dystopian stories are static or doomed from the start—not much happens in the former and the inevitable demise of life occurs in the latter—Lester Del Rey believes that both categories of these texts are "essentially denying the continued change that science fiction considers basic" (347). Yet unlike many dystopian novels, change is the principal element at work in both *The Postman* and *Parable of the Sower*. Indeed, according to Lauren Olamina, "God is Change."

Both Brin and Butler take old icons and revitalize them to implement positive changes. The concept of the United States—the flag, the vision of a unified republic—is given fresh life in *The Postman*, while the concept of God is reconceived by Butler in *Parable of the Sower*. Both novels show humanity turning to icons to keep the species alive. Curiously, while both authors wish to show the value in retooling icons, there is also great disparity in their ideologies. Brin seems to posit that there is value in the telling of lies and that humanity can empower oneself by revitalizing certain myths, while Butler seems to move us away from such an assertion as she appropriates certain myths, deconstructs them, and uses them in a radically new fashion. Both *The Postman* and *Parable*

*of the Sower* call to mind the distortion of truth and the interrogation of historical incidents in the powerful works of magical realist Gabriel García Márquez. In *One Hundred Years of Solitude*, for example, the author writes a banana plantation massacre into his novel which chronicles the senseless slaughter of several thousand striking workers. However, as García Márquez explains it, the massacre "didn't come from any storytelling. It is, more or less, based on historical reality." The incident occurred in García Márquez's hometown of Aracataca, Colombia, but "there were not 3000 dead, of course. There were very few deaths." On the other hand,

Nobody has studied the events around the real banana strike—and now when they talk about it in the newspapers, even once in the congress, they speak about the 3000 who died! And I wonder if, with time, it will become true that 3000 were killed. That is why, in [another García Márquez novel,] *The Autumn of the Patriarch*, there is a moment when the patriarch says, "It doesn't matter if it is not true now; it will be with time." (Dreifus 76)

Like García Márquez's indictment of historical mythmaking, Butler's novel calls for a reassessment of ancient texts and symbols in an attempt to anchor them to a tangible reality. Her philosophy on the use of icons and myths runs contra Brin's. Moreover, of the two novels, Butler's reconceptualization of icons is the most extreme because she moves beyond the traditional supernatural deity and boldly—some might say hubristically—emphasizes man and woman's own godlike potential. Still, regardless of the clashing ideologies embedded in their cores, both *Parable of the Sower* and *The Postman* may be gauged as positive projections of humanity. Each book stresses that we have symbols and philosophies that can assist us in the battle to prevent apocalypse if we are willing to work toward positive changes. Brin himself has written that one of the motives behind his writing this novel was to combat the pessimism often found in dystopian texts:

*The Postman* was written as an answer to all those post-apocalyptic books and films that seem to revel in the idea of civilization's fall. Instead, this is a story about how much we take for granted—and how desperately we would miss the little, gracious things that connect us today. The central character is a special kind of hero, toughened by griefs and trials, yet still somehow uncalloused and willing to hope—the last idealist in a fallen America. A man who cannot let go of a dream we all once shared, who sparks restored faith that we can recover—and perhaps even become better than we once were. In this era of cynicism, we need reminders of the decency that lies within. We are in this together. ("Novelist David Brin's Notes," *The Postman* DVD)

Brin and Butler succeed in reminding us that there is hope aplenty to be found in the midst of turmoil and the shadow of our seemingly impending demise.

## NOTES

1. It is significant to note that Brin and Butler steer clear of the technological solution that many dystopian texts favor, when they bother to present any solution at all to the despair they project. Clute points out that "The standard scenario" of dystopian science fiction texts that are driven by revolution "involves an oppressive totalitarian

state, which maintains its dominance and stability by means of futuristic technology, but which in the end is toppled by newer technologies exploited by revolutionaries" (361). Yet, both Gordon Krantz in *The Postman* and Lauren Olamina in *Parable of the Sower* rely on more fundamental ideologies to empower their crippled cultures. The novels are not technophobic; both Gordon and Lauren laud the technology of the recent past and recognize that restoring and surpassing it will boost humanity's fight to recover from its current crises. Neither do they prophesy that technology is the solution to all of humanity's problems.

2. Let me state that I do not believe that either *The Postman* or *Parable of the Sower* is a full-fledged work of postmodernism. Nevertheless, as we prepare to explore the symbols embedded in both texts, it is interesting to note that both works call to mind certain aspects of postmodernism. Brin's story resonates with postmodernist characteristics but ultimately resists key ideas that are associated with the postmodernist movement. Butler's novel, on the other hand, seems slightly more comfortable with the postmodern notions of freeplay and endless permutations being derived—and extended away—from a central (or centered) idea.

Derrida, Lyotard, Linda Hutcheon, and others have posited that poststructuralism and postmodernism liberate the text from one concrete meaning and show the value of nontextual discourse in the illumination of ideas. In its more radical forms, postmodern thought embraces chaos theory and posits that culling brief pockets of meaning in the midst of turmoil—either a chaotically organized text, a chaotic psyche, or a chaotic situation in the plot of the story—is the best we can hope to accomplish as we struggle to understand a text.

Like most science fiction writers, Brin and Butler largely steer clear of the freeplay inherent in works of postmodernism and write stories that have fairly direct, well-organized narrative structures. Nevertheless, Brin's *The Postman* seems far more reluctant to leave behind traditional order and meaning than Butler's *Parable of the Sower*. It is Gordon Krantz's struggle to return to an ordered existence by resurrecting the past that anchors *The Postman* most firmly in modernism, in spite of the book's iconographic explorations. *Parable of the Sower* also has a chaotic situation driving it: the collapse of economic and social order. Moreover, like *The Postman*, Butler's novel has as its principal agenda the restoration of an ordered existence. However, while Brin works to restore order by resuscitating traditional meanings embedded in old referents, Butler sets out to extend the meaning of traditional words—which themselves may be regarded as icons—and use them in a fashion that in some ways runs counter to their traditional meanings. Butler, then, seems closer aligned with contemporary poststructuralist thought and semiotic theory. *Parable of the Sower* posits that signs, be they words or even abstract concepts, may be appropriated by their readers and used to signify a multiplicity of literal and metaphorical meanings. These meanings may complement the original ideas embedded in the sign or phrase, but they may also be given new insights by the appropriator. Yet *Parable of the Sower* has as one of its principal goals the deliberate battle against disorder and chaos. Thus, while the novel appropriates some of the liberal interpretations at work (or play) in the postmodern movement, it is ultimately grounded most firmly in traditional modernist construction and objectives.

3. Of course I do not wish to lump together or trivialize the myriad of ethnic cultures which together comprise the United States of America. However, I point out that American culture in general certainly has many distinct signs which serve to identify it and which many Americans, regardless of ethnic heritage, recognize and accept as American.

4. Both Brin and Butler use classic direction imagery in their novels. Directions are themselves icons heavily encoded with symbolism in many texts. Hence, Gordon's surviving Americans readily believe that the nation is being restored in the East, not only

the place where the United States was founded, but a direction which is often associated with light, life, optimism, and promise. The same might be said of the North, where Lauren Olamina travels to begin the first Earthseed colony.

5. See Sartre's *Existentialism*, *Existentialism and Human Emotions*, and *Being and Nothingness*.

6. To reiterate an earlier point (see Note 1), Butler and Brin's novels deviate from many dystopian texts which precede theirs: stories which prophesy the dangers of scientific and technological advances. These authors regard science and technology as friends rather than foes. For counters to Brin's and Butler's position on this subject, see Bertrand Russell's *Icarus, or the Future of Science* (1924), Aldous Huxley's *Brave New World* (1932), and S. Fowler Wright's *The New Gods Lead* (1932).

## REFERENCES

Adams, Hazard, and Leroy Searle. *Critical Theory Since 1965*. Tallahassee: Florida State University Press, 1986.

Brin, David. "Novelist David Brin's Notes." *The Postman* (DVD). Dir. Kevin Costner. Warner Brothers, 1997.

———. *The Postman*. New York: Bantam/ Spectra, 1995.

Butler, Octavia. *Parable of the Sower*. New York: Aspect/Warner, 1993.

Clute, John, and Peter Nicholls, eds. *The Encyclopedia of Science Fiction*. New York: St. Martin's Griffin, 1995.

Del Rey, Lester. *The World of Science Fiction, 1926–1976: The History of a Subculture*. New York: Garland, 1980.

Dreifus, Claudia. "*Playboy* Interview: Gabriel García Márquez." *Playboy* Feb. 1983: 65–67, 70–74, 76–77, 172, 174, 176–178.

Eco, Umberto. *A Theory of Semiotics*. Bloomington: Indiana University Press, 1979.

Lotman, Yurij, and B. A. Uspensky. "On the Semiotic Mechanism of Culture." Adams and Searle, 410–422.

# 13

# Beyond Personal Introspection: Classroom Response to Sherri Tepper's *The Gate to Women's Country*

## Tamara Wilson

During the spring semester of 1998 I had the opportunity to explore in a small discussion group class a text that has long influenced my development as a feminist, Sheri Tepper's *The Gate to Women's Country*. In the post-"convulsion" agrarian society of Tepper's vision, women and men (for the most part) live separately, either in the towns of Women's Country or in the garrisons of the Warriors. The chapters of the text pose the "reality" of the story against the scenes of *Iphigenia at Ilium*, a play (created by the people of Women's Country) based on the events of the Trojan War. Employing flashbacks, Tepper leads her protagonist, Stavia, and the reader to a fuller and often painful understanding of what Women's Country is and how people act, in and out of the context of this utopia. In the texts that reach us on an intimate level, we see ourselves unfolding in one or more of the characters.

When I consider the significant texts (besides Shakespeare) of my life, three come to mind: Robert Heinlein's *A Stranger in a Strange Land*, which made for an interesting adolescence; *The Mist's of Avalon*, by Marion Zimmer Bradley; and, so far, *The Gate to Women's Country*. When I remember and reread these texts, it is rather like looking at a photo album of my past because personal events of my life are linked with these texts.

I encountered *Women's Country* at a critical point in my life, just as I planned to leave my job as an accountant and pursue my Master's degree and eventually my Ph.D. The text became my constant companion, much in the way actors may keep a copy of *Hamlet* handy as a source of continuing investigation and reflection. *Women's Country* became more than the simple "brain candy" I originally thought it to be as I picked it up from the used bookshelf; the text both comforted me and provided a forum in which to analyze my world.

I am an avid rereader of text, following my personal reading pattern that evolved with *Stranger* and *Mists*. However, unlike my exceedingly private

experiences with these prior texts, I found myself, eventually, longing for others with whom to share the text, an unfulfilled desire until 1998.

When I was presented with the opportunity to design my own "Themes and Types" class at the University of North Florida, the creative process was very swift. The class examined the concept of "revision" in three pairings: Shakespeare's *Hamlet* and *Rosencrantz and Guildenstern are Dead*, by Tom Stoppard; the folktale "The Robber Bridegroom" and Margaret Atwood's *The Robber Bride*; and finally, excerpts from *The Iliad*, the play *Ajax* by Sophocles, and *Women's Country*. The decision to use Tepper's text was not made lightly, nor did I rest easy until, after consulting colleagues and critical responses to Tepper's work, I was convinced that the text offered literary merit, not a self-indulgent foisting of my soul-searching on unwitting students. The merit of science fiction/fantasy texts like *The Gate to Women's Country* is hotly debated and therefore few texts have made their way beyond the genre into classical or "literary" works. Within this concern is also the topic of utopias themselves. It is one thing to read of past failed utopias, like Brook Farm in Hawthorne's *Blithedale Romance*; it is quite another to examine our possible future—shades of *1984*, and so on.

Early in our exploration of the text, the class reacted quite strongly to the decidedly feminist slant of Tepper's offered utopia. In contrast to the classic texts of *The Iliad* and *Ajax*, the roles of women in *Gate* challenged many assumptions held by students of both sexes. While all of us agreed that it would be wonderful to be given the freedom to study all we wanted, once the real ramifications of the semiannual Carnivals were understood, enthusiasm drained like a water balloon with a hole in it.

Carnival in Women's Country is a two-week celebration during which the women of the towns and the warriors of the garrison sing, dance, and have "assignations" (private romantic encounters). Except for those four weeks of the year, all carnal contact between men and women is strictly forbidden. The rituals of a society are indicative of that society's attitude toward the focus of these rituals. Love, between men and women, in Women's Country has a very limited time and space.

The device of Carnival also serves to strengthen the bond between mother and daughter, an essential feature of Women's Country. Warrior-lovers never enter private homes; an intriguing aspect of this utopia when we consider Luce Irigaray's observation, from "The Poverty of Psychoanalysis," that "the daughter cannot identify with a desiring woman" (74). The carnivals are always described from memory, or anticipation, providing another degree of separation. Stavia repeatedly identifies with her mother, Margot; Stavia is a small Margot and when Stavia joins the council and wears the robes of power, the identity is even closer. The only scenes of sexual intimacy are between Stavia and Chernon. Their intimacy is flawed and distasteful, evoking a silent chair-squirming by all the students, a sign an impact is being made. Never are we shown a loving intimacy between Margot and Joshua—only after Stavia's life-threatening adventure is she (and are we) told he is her father.

The connection between mother and daughter is heightened by this omission in *Gate* over that of our conventional patriarchal system. Furthermore, women in this culture are named by their mother's name; for example, Stavia is

Stavia Margotsdaughter Marthatown, and Margot Renesdaughter Marthatown, like the Scandinavian tradition of Borgson and Svenson. Perhaps this seemed a minor matter to my students, but those women searching for identity today are confounded by the succession of male names. In this feminist-dominated society, Tepper tries to realize Irigaray's proposal that "the love for women-sisters is necessary if we are not to remain the servants of the phallic cult, objects to be used by and exchanged between men, rival objects on the market, the situation in which we have always been placed" (44–45). Time and again in the text, the soldiers outside the gates of Women's Country threaten just such a fate. But in Women's Country, girls don't know who their fathers are; the warrior fathers of the sons of Women's Country don't acknowledge girls at all and claim the sons at an early age, further disassociating females from males.

In this "utopia," all boys are turned over to their "warrior fathers" at the age of five to be raised in the garrison until they are fifteen. During this period, sons see their mothers and female relatives only during Carnival. This is the pattern of their lives for the next ten years, when they have the option to return to Women's Country as a servitor or remain with the warriors. A point that eluded several male students was that a boy had ten years after his fifteenth birthday to make his choice. Even understanding this, many were appalled at what they regarded as "the early age" at which this final choice must be made, something that had not bothered me at all. Was it because I am a woman, and the choice would never apply to me, or because the majority of students in this class were at or would soon approach that critical age of twenty-five? In fairness, I made a significant career change well after twenty-five. How are the rules different for me? Women's Country, as it will become even more apparent, is not a culture of easy choices or a utopia for the indecisive.

Upon our further investigation of the text we discovered that women of this utopia are also pressed to conform to the plan. As appealing as perpetual, free education sounds to us as academics, it does not suit everyone. Myra, Stavia's older sister, is rebellious and frustrated by the demands of Women's Country. At one point Stavia observes that her sister "had wanted to do nothing but dance. But what good would a woman be who could only dance?" (156–157). Our society is just such a one-profession-oriented system, but the rising number of people, like myself, who shift careers mid-life is indicative of our dissatisfaction with this system. Is the three-pronged plan of Women's Country, a skill, a science, and an art, any better? Not for Myra or, I am sure, for some of the class, who will be relieved to see an end to their formal education and begin to reap the financial gains it promises. Sadly, but predictably, rebellious individuals do not fare well in Tepper's text.

Myra, along with Barton, Chernon, and Michael, meet unhappy fates because of their challenges to the authority of Women's Country. Myra, who is a foil to Stavia, is a typical rebellious teenager at the mercy of her hormones. Of these four challengers, she alone survives because her rebellion is of a minor sort, but it is a fragmented survival. The rest are warriors, who seriously threaten the foundation of Women's Country; they all perish.

Barton and Chernon (whom the entire class came to despise) are manipulated by Michael, the leader of the garrison of Marthatown, to court Myra and Stavia, respectively. Michael hopes to overthrow the laws of

Women's Country, by moving the garrison into the town and discovering "the secrets women have" (146). The seemingly defenseless women and servitors of Marthatown prevent Michael's coup by killing or arraigning the death of all three men. Tepper carefully strips all redeeming characteristics from any of these men—leaving the class glad to see them destroyed. However, Women's Country is not dedicated to the destruction of all dissenting voices.

Septemius is an outsider whose perspective on both Women's Country and the rest of the postconvulsion world provides a relatively objective view within the text. He is a senior citizen, sexually inactive and restrained in his criticism of Women's Country. Because of these qualities, Septemius is actively sought and respected by the important people of Women's Country. Women's Country encourages outsiders to enter its culture, absorbing the skills and information new people bring. Josh and Corrig are guarded from the reader until practically the very end, whereas Septemius is almost immediately accessible. All the students liked him and the perspective he offered increased our acceptance of Tepper's world. However, there are some external elements of the postconvulsion world that Women's Country cannot accept.

The most significant challenge to Tepper's utopia comes from the Holylanders, a people "we would not like to add to ours," says Margot, Stavia's mother and a member of the council of Marthatown (291). The Holylanders are the antithesis of Women's Country, and they are chillingly familiar.

This isolated culture is extremely repressive to all women and most of the men, except the few privileged Elders of the community. Education is available only to the men and closely controlled by the family elder, one man with multiple wives. Two young men of the Holylanders abduct Stavia and Chernon. Once brought into this culture, Stavia is abused on many levels, and nearly dies. Chernon, her lover, sees the potential to use this culture; this sets the wheels of Women's Country in motion against himself and Michael, once Stavia is rescued.

The rescuers are a combined force of the talents of servitors, men who chose to return to Women's Country from the garrison, and the chicanery of Septemius. Using martial arts fighting and playing on the superstitious nature of the Holylanders with angel feathers and footprints on the ceiling, they free Stavia. The true nature of the servitors is revealed at this point as these men, who forswore battle and garrison life, reveal just what consummate and clever fighters they are. They quickly remove Stavia from the Holylanders and scare them into a paralyzing fear of the people of Women's Country, thereby ensuring the future safety of Stavia, and all of Women's Country.

Stavia's rescue and recuperation reveal the hidden inner structure of Women's Country and prompt Septemius to make the most significant observation of the female condition in the entire text in a conversation with Margot, as they watch over Stavia:

Misplaced nurturing [is] the biggest chink in your female armor. The largest hole in your defenses. The one thing you cannot and dare not absolutely guard against, for your nature must remain as it is for all your planning to come to fruition. You dare not change it. Still, it is hard when your own female nature betrays you into believing the ones who abuse you need you or love you or have some natural right to do what they do. (290)

When I pointed out this passage to my students, there was some measured nodding from the women and a puzzled look from the men. Clearly it gave them something to ponder.

Something also to ponder is the basis of power in every city of Women's Country, the council or the "Damned Few," as they call themselves. The existence of this secretive Machiavellian group in Tepper's utopia is unsettling to both the reader and those who discover their existence. The "Damned Few" use such governmental tactics as birth and parentage control by artificial insemination and sterilization, both temporary and permanent, to preserve their utopia. Ironically, this "truth" (in the reality of this feminist text) undermines many hard-won rights of contemporary feminist activists. The revelation of the extent of control by the "Damned Few" exercises over the people of Women's Country comes after pages of musings by women, warriors and outsiders on the "secret power" of Women's Country.

At this point the class consensus was "Ah hah!" We knew there was something going on. But most were offended and overwhelmed by the level of control the "damned few" exercised over the people of the text. Certainly the proposed annihilation of the Marthatown Garrison was as shocking to these readers as it was to the characters of the story.

So, as often happens, the grass was not as green as we thought. Tepper's Stavia is very endearing; one student, a nontraditional divorced mother, remarked "we (Stavia and she) need to go have a cup of coffee." Clearly, Tepper creates a well-developed character in her protagonist. Throughout the text we have followed her from the painful rejection by her son, Dawid, back through the events that lead to that sad event, which encourages us to consider the sad events of our lives. Indeed, as every utopian story does.

*The Gate to Women's Country* is not just a feminist utopian novel. It also raises issues of power and sacrifice. Sacrifices are often unwitting ones for every (wo)man of Women's Country. For Stavia and Joshua, her father who cries "for them all" in his role as Achilles in the play at the close of the novel, their sacrifices are brutally clear (315). The warriors of the Garrison are both genetically and physically lost. Women's Country is a painfully necessary construct, not a paradise. The real utopia for Women's Country, one yet to be reached by the close of the novel, will arrive only when all men return and the Garrison of Warriors no longer exists.

This goal of nonaggression seems reasonable. However, the methods of Tepper's text leads to careful examination of "the means to an end" employed in our world today. Shall we be unwitting "sheep" or among the "damned few" of our world? Neither is a comfortable position to contemplate, but *The Gate to Women's Country* insists we consider them closely. As we close, mirror works within mirror; Stavia sees herself in the play and we see ourselves within Women's Country.

So, where does this leave us? Why, despite our disillusion with Tepper's text, are we talking about it? The answer to this question is well expressed by Peter Fitting in his essay, "Recent Turns from Utopia": "While there is much to love and enjoy in this privileged corner of our world, the utopian impulse at the heart of all science fiction, the awareness of the fundamental insufficiencies of the present, and the longing for a more just and

humane world should not be denied" (156). Is not the true goal of education to question? Certainties are for the "sheep." In the classroom that spring my students and I opened ourselves to questions. I am not dismayed that they still remain.

## REFERENCES

Fitting, Peter. "Recent Turns from Utopia." *Feminism, Utopia, and Narrative*. Ed. Libby Falk Jones and Sara Webster Goodwin. Knoxville: University of Tennessee Press, 1990.

Irigaray, Luce. *The Irigaray Reader*. Ed. Margaret Whitford. Oxford: Basil Blackwell Ltd., 1991.

Tepper, Sheri S. *The Gate to Women's Country*. New York: Doubleday, 1988.

# 14

# The Nature of "Outsider Dystopias": Atwood, Starhawk, and Abbey

## Sharon Stevenson

English literature describes plenty of bad places, but perhaps the earliest one and one we might expect to qualify for a dystopia is Hell in Milton's *Paradise Lost*. It has a burning lake that puts off no light and a sulphurous plain that burns the feet. We are told the place is dismal: "A dungeon horrible . . . /where peace/And rest can never dwell . . . /torture without end" (I, 60–67). However, the fallen angels are able to build a palace, Pandemonium, and they while away the time in Satan's absence—he is gone to scout out Earth—by staging philosophical debates, singing epic tales of their own battle feats, tearing up the place, and exploring. Of course those explorations turn up an icy plain where the damned are to be buried, immobile for a time before they're sent back to be chained on the burning lake. But nobody is apparently suffering anything at the time we see them. In fact, Mammon says being in Hell is better than singing hymns all day in Heaven (II, 239–249).

Can Hell then be a dystopia if the characters themselves do not experience palpable suffering? The answer is no. Characters in a dystopia must experience pain and suffering, or if they are so incapacitated by drugs or some control device that they aren't aware of their state of suffering as happens in Kurt Vonnegut's "Harrison Bergeron," then at least the readers must recognize it.

And what about the kind of people who suffer? They need not be perfect, but they do need to demonstrate values similar to those of the readers. Milton's fallen angels chose their fate because they were ambitious or envious and because they had no idea Christ was so strong. In other words they chose the wrong values. They are not worthy to be pitied. Although the fallen angels do value liberty and freedom to choose not to bow down or pay homage to Christ—values we in the twentieth century might support—Milton clearly signaled them as dangerous, values that produce Sin in the world. Milton's Hell, then, is a punishment justified for wrong values and unlawful behavior. It is a bad place, but it is not a dystopia. In a dystopia misery and suffering must

happen to good, though perhaps flawed, people in circumstance's beyond their control.

If, however, we turn then to books that deal with suffering and misery, we can think of plenty that are not dystopias. Take for example Bessie Head's novel *A Question of Power*. The main character is Elizabeth, a woman without a country. She has left South Africa for Botswana because in South Africa she has no race. She is the offspring of an African stable boy and the adult daughter of a wealthy Afrikaner judge, who "saved" his daughter's life by declaring her insane. In the asylum she had her baby, Elizabeth, but afterward hanged herself, leaving the baby to foster care since neither family would claim her. As an adult Elizabeth is denied a teaching job in any of the school systems and is married to a man who is having affairs with other men. She chooses to leave South Africa knowing that she can never be repatriated. In Botswana, Elizabeth finds herself equally lost, a foreigner living in a very insider community. The story becomes the tale of her mental breakdown. The community seems to have a supernatural control of her, and in her delusions two men take advantage of her: one quite an evil type, the other a holy man type who eventually becomes evil, too. Nothing is stable for her, and the medical treatment she receives is simply another exercise of power over her.

Plenty of suffering here; the character has the right values; and the circumstances are certainly beyond her control, but the novel is not a dystopia because it does not portray the future or a re-created past. It depicts the present, the reality, of South Africa and then Botswana in the 1980s. It does not offer a fantasy of a state that might be. It offers an already accomplished fact: the terrors of apartheid, patriarchy, superstition, and modern medicine. Elizabeth's trauma is caused by factors that are unique to her individual situation: a mixed blood person cut off from family in a fanatically pure-race state; an educated woman with no opportunities, taken advantage of by opportunist men; in exile, a foreigner without the language and customs of the people around her; a woman with a Buddhist-Christian world view caught in a spirit possession society. She is a metaphor for the absolutely isolated outsider, made more poignant by her responsibilities to her son; no wonder she goes insane. The novel reminds us more of Camus's *The Stranger*, an individual caught in overwhelming social circumstances, than of Huxley's *Brave New World*, which involves the whole society gone on wrong principles.

In a dystopia the author must create a fantasy society or state of the future or the past where the characters experience palpable suffering which the readers fear are not the result of individual circumstances, but which could happen to them, given the right social conditions. Far from "creating wonder" (Manlove 16) as the fantasy does, the dystopic novel seeks to create fear and paranoia, the belief that factors outside the readers' control may actually be coalescing to descend on them and cast them into just such a situation as is experienced by the characters in the dystopia. In the classical period Olympian gods and the Fates provided the factor beyond the heroes' control, and in the Middle Ages it was Fortune and God's grand design. But neither of these controlling devices created dystopias. They created *exempla*, life stories that teach virtue by exposing a tragic flaw, sinful behavior, or bad judgment. Largely the product of the twentieth century, dystopias are the literary

embodiment of social science analyses such as Marx's exposé of the monolithic nature of the state and Stanley Milgram's study of the power of social belief systems. Dystopic artists do not conceive of the evil as an internal flaw in the protagonist which must be controlled or as a lack of individual virtue. The evil in a dystopia is usually a faceless, all-encompassing state, bureaucracy, or belief system that annihilates or restricts some set of values the readers believe are indispensable to both their own and the characters' ability to function as fully dignified human beings. The more plausible the ideology and working of the evil fantasy system, the greater the paranoia the reader will feel.

In 1980 Edward Abbey, an environmentalist best know for *Monkey Wrench Gang* and *Desert Solitaire*, published a dystopia entitled *Good News*. Projected only a short time into the future, Abbey's book begins with a three page description of the background of his dystopia:

The fragile webs of a planetary economy frayed apart in an ever-intensifying system. One breakdown in a small Mideastern nation led to massive dislocations, anger, and panic in great nations thousands of miles away. . . . Each industrial nation attempted to supply its needs by exploiting to the limit—and then beyond—its own resources of land and forest, water and metals and minerals. . . . Religious fanaticism joined with nationalism and secular ideologies to destroy . . . the sources of power on which the overindustrialized nations depended. (2–3)

Thus our current unsustainable lifestyle causes the collapse of the state and provides the backdrop for Abbey's projected civil war between the country and the city. Chief, a religious fanatic and ex-military man turned university professor, takes over Phoenix and builds an army which he intends to lead to Washington, D.C., capturing what's left of the food-producing areas along the way and ultimately establishing "a strong centralized State, capable of dealing quickly and mercilessly with enemies" (96).

The landscape of the novel is replete with abandoned vehicles, hanged bodies, wrecked shopping malls, and trashed university buildings. Dinner is dog, and motorcycle squads from the city rustle cattle, so the setting is ripe for the description of an oppressive state that creates suffering and misery for those who value peace, love, cooperation, and integration with nature. The suffering and misery are there. Brock and his Apache sidekick like to torture people; Chief likes to hang people; and Barnes shoots as many people as he can in putting down the rebellion. But the misery and suffering happen to characters that the reader meets only peripherally, not intimately. The main characters escape the soldiers time and again, often in very interesting ways. One leaves the Chief's personal steward, Corporal Buckley, out cold in his own underwear and her negligee on the Chief's bed. Another talks Apache into "flying" off a cliff in much the same way little kids talk each other into "flying" off the garage by flapping their arms. So the novel aims at humor, too, but as a dystopia that creates fear and paranoia in the readers, it is not successful. The heroes are simply not in circumstances beyond their control.

In fact the novel projects the disintegration of the contemporary corporate society as a return to the "Wild West" of previous eras. The opening chapter finds the heroes camped out around a fire. Later they go to a bar complete with sexy barmaid, wimpy piano player, and the bad guy who

threatens to shoot the piano. It is a strange mix of "Road Warrior" landscape and Wild West action. But because the readers are familiar with such a Wild West landscape, no paranoia is created, only glee that insidious shopping malls have finally bit the dust.

The disintegration is given to us in the initial three pages but the readers do not know how it happened. There are no flashbacks that show how Phoenix gradually fell apart and the megalomaniac gained power. Corporal Fannin delivers a long nostalgic piece about how wonderful it was to have flush toilets, padded dashboards, reclining bucket seats, drive-in movies, drive-in banks, drive-in liquor stores, and so on (120–121). The passage is a satire on our world for sure, and it does cause us to think about the excesses of our lifestyle, but nowhere are we frightened of the circumstances that produced the disintegration or the world that it produced. We do not see how it fell apart so we are not terrified that it could happen to us. The bad guy is a megalomaniac, but he's a bungling megalomaniac, and the world has dealt with much worse powers than his—and won.

Abbey's book is a good dystopic adventure story and really quite hopeful, but it falls short of greatness because it does not create a landscape for the future that is unknown, unfamiliar, and frightening; because the source of evil resides in a human "bad" guy, not in a faceless, monolithic state; because the heroes who resist have far too much freedom of movement and skill at defeating the "bad" guys; and because the reader does not clearly see how this situation could have happened either cataclysmically or so insidiously that it could not be detected. In short, we are entertained, but we are not paranoid.

Miriman Simos, a new age guru who uses the pseudonym Starhawk, has written a delightfully imaginative utopia entitle *The Fifth Sacred Thing*. Chapter one begins in San Francisco in 2048 where principles of diversity have triumphed. A blend of races and religions live under principles of the Goddess, the Earth Mother, worshipping the four sacred things—earth, air, fire, and water—and the fifth sacred thing, spirit, which has allowed them to create new crystal technologies whereby rocks yield their power without violence and the civil defense system is a few old women who listen to the environment and human thought messages that traverse the universe like radio waves.

The second chapter, however, is set in Los Angeles, which, in order to get rid of Spanish words, the Millenialists and the Stewards—the antagonists who are puppets of the Corporation—have renamed Angel City, the site of the dystopic pole of the novel. Here the male protagonist is incarcerated in The Pit, a prison for those who have committed crimes against the state, such as stealing water, healing through Witch power, or disabling a nuclear power plant as our hero has done. The novel alternates between the two poles of utopian San Francisco and dystopic Los Angeles, but then the Millenialist Los Angeles army invades the San Franciscan utopia. The utopians fight with nonviolent civil disobedience and passive resistance. The Millenialists try to create a traitor, but ultimately the psychic and spiritual power of the utopians triumph by winning over a few of the outcast individuals in the army.

Rather than envisioning a return to the Wild West when American lifestyle loses its sustainability, Starhawk's dystopic chapters prophesy continued luxury and medical care for a select few who control the masses.

Some people still have swimming pools, while others must steal water to drink. Some people must practice moral purity while others can take advantage of the blond-haired, blue-eyed children who are cloned for sexual sadism and masochism. Bacteria and viruses are used to wipe out undesirable populations. Soldiers, known solely by numbers like "Ohnine," are given antidotes but only so long as they are loyal to the state. Chain gangs are controlled by electronic shock devices embedded in bracelets. Starhawk takes familiar or possible phenomena and gives them solely evil purposes in order to make her dystopic landscape frightening.

She is also able to create real suffering and misery for her character Bird, who struggles to regain his memory. By giving him simple home, grandmother, mother, playmate-next-door memories at first, she draws us into his mind and his psychological state so that we have already identified with him when he begins to remember torture. These memories are made all the more poignant and fearful by the fact that at any minute he could be subject to the torture all over again.

Many flashbacks allow the readers to piece together what happened as the natural resources to support the cities were bought up by the Corporation. History was rewritten so that the big earthquake in 1999 was interpreted as Christ's return to earth. However, instead of saving it, He repudiated it, claiming it was too sinful, too much under the control of the devil. This myth gave the Corporation the rationale for getting the government Stewards to pass the Four Purities: Moral Purity, Family Purity, Racial Purity, and perhaps Religious Purity. Such a fictional history of the dystopia plays on Californians' fears of earthquakes, scarcity of water, and immorality. But readers never, in fact, feel real paranoia in this novel because the dystopic scenes are relieved by the highly imaginative utopian scenes which create a longing for powers we don't have: natural healing with ch'i, democratic decision-making through discussion, power from crystalline structures, shared rituals that involve singing, chanting, drumming, and dancing, and daily communication with the dead. Starhawk's vision of the future is clearly not dystopic, but her work warns that it could be. She prefers to leave us not with fear and paranoia, but with the wonder of the utopia which she thinks may be possible through new-age spiritualism and a rebirth of communication with the earth and with others through ritual.

*The Handmaid's Tale* by Margaret Atwood does not have two poles. It is a pure dystopia nearly devoid of hope except through a postmodern ending indicating that the whole book, all 400 pages of it, has been a research presentation at an anthropology conference; hence the principles of humanism survived albeit perhaps outside the United States. The nearly faceless antagonists in the book have used the Modernist principle that ideal states may by theorized and created. But since the antagonists are members of the U.S. Radical Right, the society they have created is a literal manifestation of biblical passages. A highly developed caste system is established whereby people are allowed to function on only one aspect of their humanity, their economic service to the state. The men are largely defined by their work roles and are assigned wives, depending on the value of their work to the state. For example, Nick, the chauffeur in the story, is not allowed a wife, and neither are the Guardians, the

young men who keep the checkpoints about town, but some set of men are allowed Econowives, women who must serve at least two functions: housekeepers and baby-makers. The other women all have one-dimensional roles: Wives, "the lady of the house" role, are strictly for show; Marthas are housekeepers; Handmaids are women assigned to produce babies if the Wives cannot; Jezebels are women who inhabit clubs designed officially for entertaining foreign trade diplomats; Aunts train Handmaids and supervise Jezebels; and Unwomen are sent to work in the Colonies in radioactive or chemically contaminated areas.

The antagonist is the Commander, Fred, who represents the state, one of the Sons of Jacob Think Tank members who dreamed up and implemented the Society of Gilead. The anthropologists of the future guess that his name is Fred only because the protagonist Offred is, like all the Handmaids, given the name of her Commander preceded by the preposition "of," signifying "belonging to": Ofglen, Ofwarren, and Offred. Thus the antagonists strip others of their identity while keeping their own and creating privileges for themselves. Fred, however, is quite disarming. He likes to play Scrabble. He likes costumes and speak-easies. He likes sex with affection and for entertainment, not the sex of the Ceremony. So how can such a character be an antagonist? He can't. The individual, although he is a powerful Think Tank member and a creator of the repressive society, is powerless to stop it. It is larger than he is. The creator is caught in his own system. This portrait of the antagonist may explain why Atwood, unlike the film version, does not make the heroine try to kill Fred, despite her opportunities and encouragement from the Mayday underground. Atwood does not want to embody the evil in one man or even in a few Think Tank members. The real antagonist is the faceless power of a state driven by religious fanatics who are determined to obliterate the individual freedoms of those outside the white male Radical Right power structure.

So what is it that creates suffering in Atwood's book? It is the extreme deprivation the narrator suffers. She has no purpose except to provide intercourse on schedule and to do the grocery shopping. She is the outsider, cut off from all social interactions with others except on the walk to the stores, and on Birthing and Particicution Days. As she waits to be used by the Commander, so we wait too, reliving her memories, longing for normal things we take for granted like small talk and touch. As her situation grows more and more precarious, so our anxiety grows. We are limited to her information and, like her, ignorant of what may be happening in other places, of who might be trusted, of what options there might be for escape. The memories of her former life— her husband, her child, her job, her mother, and her friends—which we recognize as our lives, create a counterpoint to the dystopia from which our own world looks utopian, despite its limitations. But these memories make the suffering all the greater because they are unattainable, because they will never be reality again. Her past and the identity which arose from it have been thoroughly obliterated. But we remember that past because it is our present; thus we create a complete utopian pole for the novel simply from the disjointed flashback scenes scattered throughout the novel.

The effect of Atwood's depiction is sheer paranoia. She plays on fears we already have: leaking nuclear power plants, chemical contamination, Islamic

extremists, plastic money, automatic withdrawals, book burnings, loss of the right to hold a job outside the home. Published in 1986, the novel seems to grow only more and more apt to our political climate at the end of the century. She creates so much paranoia, in fact, that we begin to say with the narrator: "I'd like to believe this is a story I'm telling" (52). But then we are forced to conclude, again with the narrator, "It isn't a story" (52), because, of course, we have become so paranoid that we believe a takeover by the Radical Right is a real possibility.

A dystopia then is more than a bad place; it is a familiar, yet unfamiliar, malevolent place where good or at least average people suffer deprivation of basic freedoms required to be fully human, and this suffering occurs at the hands of a faceless system, either social or governmental or both, that is beyond the protagonists' power to control or change. The dystopia is not an exposé of a current condition, but a warning about some condition that might develop from a tendency in the readers' contemporary world or about a past condition that might re-emerge. The dystopia creates paranoia not only from the suffering in the novel but also from the readers' own social milieu that supplies additional information about the tendency portrayed; that is, readers must already know something about environmental problems or the power of the religious right. They sketch in the detail of exactly how their current society came to destruction, based on the general conceptions supplied by the novelist. Thus the readers help to create the fantasy, not of an optimistic potential, but of a pessimistic potential, of a worst case scenario, not simply for an individual, but for system-wide oppression.

How have we in the twentieth century become interested in such man-made disasters? The rise of social science and cultural studies which outline the power of the system acting on the individuals in it is only one portion of the answer. The dystopias created in the modern period, the early part of the twentieth century, were all written by artists who were part of mainstream thinking and who perceived the dystopic threat as the takeover of outsider values. In Arthur Koestler's *Darkness at Noon* the dystopic threat is the Communist purge that could take over the West. In Aldous Huxley's *Brave New World* the dystopic threat is godless science that would replace sacred love and procreation with test-tube babies. In Anthony Burgess's *A Clockwork Orange* the dystopic threat is the development of a new "ethic" of violence in Western youth. These are all created about a threat to the dominant "correct" cultural values.

Dystopias of the postmodern period turn the tables. Outsider voices— Abbey, Starhawk, Atwood; the environmentalist, the new age spiritualist, the feminist—warn that the values we currently practice and even cherish contain the seeds of our demise. It is not some outside force or political system, some new direction in thinking, some minority group, who will destroy our world. It is our love affair with the machine, with throw-away, unsustainable conveniences; our failure to rein in the materialistic, profit-oriented capitalist corporation; and our unwillingness to move against the racist, sexist, homophobic status quo of our national Puritan religious background, in short, the dominant values of our society.

Why is it that we would believe that our own dominant values might destroy us?  Because we are the Empire, and we have the historical belief that the Empire destroys itself:  Alexander the Great's drinking, megalomania, and desire to be worshipped as a god; Rome's preoccupation with decadence—the games, the circus, the spectacle, the baths, the willingness to put up with inhumane, immoral, and unjust emperors; Germany's failure to stop megalomania, genocide, and economic greed.  These are simplistic explanations for complex phenomena, but they are the tenets that underlie our thinking about the past, and they are the reasons we believe the postmodern dystopic writer. Dystopia is historical fact.

It is no accident that the postmodern dystopic writers like Abbey, Starhawk, and Atwood are connected to current social movements.  In the postmodern era it is progressive social movements that try to correct or destroy inhumane or unjust tendencies of Empire.  Consequently, postmodern dystopias portray groups of people acting together to overcome the evil state.  They often display a fantasy of what we might wish for in an environmental movement or a new-age movement, or as in *Handmaid's Tale* the triumph of a state that embraces and respects diversity of both gender and race.  We have always said that art can never be linked to politics; that if it is, it will be reduced to mere propaganda, to didacticism.  But in the postmodern period when the enemy is an inhumane system, it will be the dystopic writer, representing a progressive social movement, who will prophesy the future. The question is:  will we hear her?

## REFERENCES

Abbey, Edward. *Good News*. New York:  E. P. Dutton, 1980.
Atwood, Margaret. *The Handmaid's Tale*. New York:  Ballantine Books, 1985.
Burgess, Anthony. *A Clockwork Orange*. New York: Ballantine, 1988.
Camus, Albert. *The Stranger*. New York: A. Knopf, 1975 (c 1942).
Head, Bessie. *A Question of Power*. Oxford:  Heinemann, 1974.
Huxley, Aldous. *Brave New World*. New York: Harper & Row, 1946.
Koestler, Arthur. *Darkness at Noon*. New York: Macmillan, 1958 (c 1941).
Manlove, C. N.  "On the Nature of Fantasy."  *The Aesthetics of Fantasy Literature and Art*. Ed. Roger C. Schlobin.  South Bend, IN and London:  University of Notre Dame Press and Harvester Press, 1982.
Milton, John.  *Paradise Lost* in *The Complete Poetry of John Milton*.  Ed. John Shawcross.  New York:  Doubleday, 1971.
Starhawk. *The Fifth Sacred Thing*. New York: Bantam, 1993.
Vonnegut, Kurt. "Harrison Bergeron." *The Road to Science Fiction #3: From Heinlein to Here*. Ed. James Gunn.  New York: Mentor, 1979: 316–322.

# 15

# News from Somewhere: A Case for Romance-Tradition Fantasy's Reformist Poetic

## Kelly Searsmith

The problem is this: Those theorists who initially used contemporary literary theory to expand our understanding of fantasy tended to dismiss or neglect romance-tradition fantasy in favor of the gothic or the Todorovian fantastic (Jackson, Armitt, Monléon), because they understood those genres to be—at least to some degree—inherently subversive. Those theoretically informed critics who later attempted to recover particular genres within the romance tradition have, in turn, tended to oversell their subversiveness, this being the aesthetic coin valued within the postmodern realm (Auerbach and Knoepflmacher, Zipes). After I describe the postmodern critique of romance-tradition fantasy,[1] I will sketch out some of the ways in which fantasy theorists have ignored or attempted to address this theoretical divide, before giving my own sense of how it may best be bridged.

Postmodern theorists have tended to characterize romance-tradition fantasies as either accepting or actively promoting the status quo, claiming that they are inherently socially conservative. Such fantasies, they charge, don't profoundly challenge readers' values, their society's ideology, or readers' belief in or acceptance of that ideology. Instead, fantasies of this kind tend to give readers a ready escape from the dissatisfactions of modern subjectivity and sweeten the already too palatable discourses that support and constitute the dominant paradigm. To characterize more specifically the postmodern dissatisfactions with romance-tradition fantasy and its traditional body of scholarship, I will mainly refer to Rosemary Jackson's *Fantasy: The Literature of Subversion*, one of the earliest and most influential attempts to explore the political implications of Todorov's landmark structural analysis.

In *The Fantastic*, Todorov marks off a genre of epistemological hesitation between natural and preter- or supernatural explanations for otherwise impossible events. The fantastic's main effect, hesitation, is distinctly modern since it depends upon an audience that is invested in a rational, positivist

worldview. Todorov defines other forms of fantasy in relation to the degree of hesitancy or resistance to the impossible which they induce in readers. Using this scheme as her starting point, Jackson weds Marxist and psychoanalytic theory in Jamesonian fashion to speculate about the cultural work that is done through fantasy's manifesting of the impossible. Jackson argues that fantasy "attempts to compensate for a lack resulting from cultural constraints: it is a literature of desire, which seeks that which is experienced as absence or loss" (3). The impossible events that fantasy texts manifest are, for Jackson, the "unsaid" and "unseen" of culture; their inclusion in a text represents a desire for something not present in consensus reality, something illegal, unacceptable, banished. Fantasies always manifest such desires; what marks them as socially progressive or conservative is whether they expel or perpetuate it, for texts expel desire "when this desire is a disturbing element which threatens cultural order and continuity" (3–4). Jackson charges that romance-tradition fantasies inevitably expel their "potentially disturbing, anti-social drives," their "dissatis-faction and desire," and retreat "from any profound confrontation with existential dis-ease" (9).

    Jackson's definition of fantasy as an inherently subversive, or radical, medium is questionable on at least two grounds, each of which I shall discuss at some length. First, it presumes that a society's culture functions analogously to an individual's mind. This underlying analogy, which also presupposes a Freudian model of the mind, leads Jackson to restrict desire to transgressive, libidinal impulses. Second, it leads Jackson to favor certain forms of fantasy, a bias that reinforces skewed critical assessments of what may be euphemistically called a varied field.

    First, then, I believe that Jackson's restriction of desire is problematic, since what is considered impossible within bourgeois society is not limited to that which has been marked as taboo or even undesirable. Many of the wishes that fantasy evokes and fictively gestures toward fulfilling are not asocial or antisocial but socially motivated and even approved.[2] Fantasies may, and often do, represent desires that might be deemed acceptable within a given society but are unattainable as possible ends or by certain means. The utterly ideal, too, may be conceived of as an impossibility. We have only to think of the many unspoiled and secret gardens of modern British fantasy to find an implicit critique of the industrial age and a manifested symbol of the yearning for a Romantic Isle of Innisfree that is free from its effects. Perhaps an even more ubiquitous example today is the story of a latently talented youth from troubled or limited circumstance who masters wizardry or war as a prerequisite for a superior niche within his own society or another that is even more desirable. These coming-of-age tales may be seen as a transposition of the nineteenth- and twentieth-century occidental social fantasy of the self-made man. Since romance-tradition fantasies tend to represent what is impossible yet desirable, I believe they often express what Jack Zipes has called (in the case of Victorian literary fairy tale) a "utopian spirit" (*Victorian Fairy Tales* xxv). This is especially the case if we accept that even private fantasies are motivated to some degree by the political unconscious.

    Ursula K. Le Guin's theory of the fantastic provides a useful contrast to Jackson's, for Le Guin cogently makes a case for the value and appeal of a

humanistic psychological paradigm of fantasy.  In "The Child and the Shadow" (1974) and "Myth and Archetype in Science Fiction" (1976), Le Guin claims that fantastic literature's narrative structures and objects reproduce aspects of an individual writer's consciousness and appeal to individual readers through employing powerful, shared psychological constructs.  Le Guin rejects a Freudian model of the mind in favor of a Jungian one because she believes Freudian psychology does not sufficiently situate the self within the collective experience.  Le Guin also criticizes the Freudian model for presenting desire as a collection of blind, surging impulses that must only be repressed or delayed. She prefers instead to conceive of desire as the Jungian shadow, an internalized other self that embodies all "the qualities and tendencies within us which have been repressed, denied, or not used" ("Child" 59).  The shadow self that stands on the threshold between the conscious and the unconscious is a figure all of us share, all of us recognize.  For this reason, it is a far more powerful figure than Freud's "ego, the little private individual consciousness" ("Child" 58).  Le Guin believes that it is when we follow this shadow as our guide to undertake an exploration of the deepest, innermost regions of the self and come to accept the shadow as a part of ourselves—rather than always insisting it is other and projecting onto the world around us—that we both best connect with what is common to human experience and are able to become authentic, differentiated, whole individuals.  In the depths of the individual psyche, Le Guin believes one finds not "an isolated 'id,' but a 'collective unconscious' " ("Myth" 74).  For, "if Jung is right, and we all have the same kind of dragons in our psyche, just as we all have the same kind of heart and lungs in our body" readers will have been cued in to the "true myth [that] arises only in the process of connecting the conscious and the unconscious realms" ("Myth" 74).

Le Guin is careful to cordon off, as she says Jung does, the collective *conscious*, with its inauthentic *groupthink*, from the authentic collective *unconscious* that lies within the individual only, rendering it an individuality rooted in a rich, human commonality ("Child" 58–59).  Original, imaginative artistic creations present to readers recognizable truths, appealing to their inmost depths, whereas those entertainments that are commercially produced and passively consumed haven't the same power to move or to matter.

It is ironic that the postmodern Jackson and humanistic Le Guin should have so much in common in their theorizing of the fantastic.  Both believed that the collective constitutes the individual and both want literature to perform important cultural work; they differ most in how the collective constitutes the individual.  Postmodernists like Jackson assert the primacy of a socially constructed collective consciousness.  They believe that the individuals' perceptions, including their self-conceptions, are constructed out of systems of signs (i.e., discourse), and these signs are determined by the culture in which they live.  Nothing is prediscursive, and no final integration or differentiation of the self is possible.  For postmodern thinkers, identity is not a coherent understanding of a whole, unique self that one works toward; it is a negotiation of social constructs, a performance of social scripts, a mediated and dynamic process of self-fashioning.  Yet, despite this profound difference, both Jackson and Le Guin hope that fantasy can resist *groupthink*—Jackson through its potential to radically deneutralize consensus reality and Le Guin through its

potential to evoke a shared human mystery. Postmodernists frankly disbelieve
in any such mystery, for they cannot conceive of a concept that is not
determined by the language in which it is described, the identity through which
it is articulated, and the culture and historical moment in which it is first
formulated or later expressed. At its most radical extreme, postmodernist
thought finds both the sense of a unique, authentic self and of a shared human
identity incredible. Le Guin, on the other hand, believes that our common
humanity, even if it is rooted in a shadow self, is "no loss; no gain. It means that
we can communicate, that alienation isn't the final human condition, since there
is a vast common ground on which we can meet, not only rationally, but
aesthetically, intuitively, emotionally" ("Myth" 75). The postmodern account
provides no such amelioration for the individual. Instead, it finds that
encouraging the individual to recognize a fundamental alienation in modern life
results in a productive dissatisfaction, one that may lead to a more self-
conscious, somewhat more liberated, perspective.

The differences between Le Guin and Jackson's conclusions
underscore how dependent the theory of each is upon a model of individual
psychology and the type of model favored. Jackson presumes a Freudian model
because it has the most scientific élan, but her conceptualization of the fantastic
may remain only as viable as the model upon which it rests and the willingness
of theorists to accept a correspondence between the internal dynamics of self
and society. That is a criticism to which Le Guin is not vulnerable, since the
collective unconscious is fundamentally a correspondence between individuals
rather than a discursive milieu.

Second, as Brian Attebery has pointed out in recovering *The Lord of
the Rings* from her dismissal (20–23), Jackson's preference for those fantasies
that remain " 'open', dissatisfied, endlessly desiring" leads her to deal cursorily
with texts of the romance-tradition, which she believes "move away from the
unsettling implication . . . found at the center of the purely fantastic" (9). At the
same time, she unduly privileges the avant-garde.[3] This privileging of the avant-
garde—which in fantastic studies has amounted to the historical celebrating of
continental European and gothic fantasies and the current valorizing of
postmodern genres that rely heavily on metafictive, magical realist, and
surrealist technique—stems from the assumption that popular texts have merely
a containing, or quietist, function. In *The Contested Caste: Gothic Novels and
the Subversion of Domestic Ideology*, Kate Ferguson Ellis is so concerned about
the pervasiveness of this position that, as a main goal of her work, she says she
hopes "to demonstrate . . . that popular literature can be a site of resistance to
ideological position as well as a means of propagating them" (xii). The
postmodern aesthetic, on the contrary, tends to assume that only a radical form
of social critique—one that shocks, upsets, or refuses to satisfy readers—is
sufficient and that narratives that level radical critiques have greater artistic
merit or critical interest. These aesthetic imperatives are in part politicized
versions of Barthes's prescriptive distinctions between those progressive texts
that evoke *jouissance*, or "violent, climactic bliss closer to loss, death,
fragmentation," and those conservative ones that promote *plaisir*, "an easygoing
enjoyment, more stable in its reenactment of cultural codes" (Jean-Michel
Rabaté 71–72). The now pervasive Barthesian assumption is that popular

fictions naturalize cultural codes as well as the experience of reading. The question of each form of naturalization and its relationship to the postmodern critique of romance-tradition fantasy is taken up separately below.

Postmodern theorists are concerned that popular fictions readily enable readers to escape from the social reality with which they ought to be engaged. In *Resisting Novels*, Marxist critic Lennard Davis argues that fictional narratives are an opiate of the people, since they both momentarily free individuals from the dissatisfactions of their own lives and from the real problems of the world in which they live. Without such a consoling distraction, readers might be moved to eliminate what drives them to withdraw or what their withdrawal permits them to ignore. This case has most often been made unreflectively against romance-tradition fantasies in particular, since these narratives mainly avoid self-conscious political work; devote significant narrative energy to satisfying and reassuring readers;[4] and shift readers' attention to events that seem, on the surface at least, merely personally compelling and temporally or spatially (perhaps both) removed from present concerns or future visions. Tolkien's letters show that he was keenly aware of the early forms such critiques took. He expressed a patent dislike of overtly political readings of his fantasies, choosing instead to celebrate the eucatastrophic consolation they provided ("On Fairy-Stories").

Although it may well be that many romance-tradition fantasies do not usually serve politically self-conscious ends, tend to be removed from the here and now, and avoid encouraging double readings in the way that speculative fictions do, postmodern theory has itself taught us the important lessons that the personal is the political. An individual may not experience dissatisfaction with his or her life without feeling some slippage between what is and what should be, and cannot be a complexly identified being without finding that at least in some small way he or she is not a perfect social fit. Individuals have little needed contemporary theory to convey to them the basic sense that they are determined by social roles and expectations. Significantly, the fact that romance-tradition fantasies present the possibility of eluding those determinisms may both highlight their existence and signal readers that they are not absolute. For example, in *Theorising the Fantastic*, Lucie Armitt has suggested the hybridized bodies that might result from metamorphoses (purely linguistic corporealities) "represent the fusion and confusion of pre-existing dichotomies, including those surrounding race, gender, sexuality and class" (9). Such creatures may suggest the contested intersections between self and other, animal and human, and so forth, as well as point up the sense that the body may be unfixed and redefined, both in fact (through cosmetics and fashion, surgical alteration, genetic manipulation) and conception. Further, if romance-tradition fantasies actually encourage the self-conscious willing of belief within the context of a desired imaginative that has not yet been realized (rather than the willing suspension of disbelief), as Jules Zanger has argued (231), then they may tend to encourage idealistic, or utopian, desires in their readers rather putting them metaphorically to sleep via consolation and escape.[5]

Modern, western romance-tradition fantasies, for example, typically encourage readers to identify with protagonists who gain a great deal of agency within the fictive world. They often reinforce this identification by portraying

their heroes as unlikely, ordinary folk lacking in militaristic skill and living by their wits, off a store of character (de Lindt's Jacky Rowan, Tolkien's Bilbo and Frodo Baggins, Donaldson's Thomas Covenant). These protagonists' struggles are usually given clear goals and definite trajectories, and the hero's place within the scheme of things is well defined. For the time it takes to tell their tales, such narratives may well cover over an actual lack of agency and self-determinacy, or, if one's view is less bleak, exaggerate these conditions. They might delusionally, albeit temporarily, fulfill the reader's selfish wish for personal power and social acceptance; they might fail to incite collective action to address the social ills they implicitly express. That romance-tradition fantasies are prone to do so does not negate their correlative tendency to produce dissatisfaction with the actual to which readers inevitably return. They may make readers even more keenly aware of their lack of fixed identity, the limits of their agency. They have the potential to encourage readers to make the most of whatever relative autonomy they are able to practice and to seek more self-conscious, less mainstream, identifications. One has only to experience contemporary science fiction, fantasy, and horror fan culture to get a sense of this last especially. Barbara Adams, the Federation uniform–wearing jury alternate in the 1996 Whitewater trial, demonstrates this potential. Adams has said she considers herself to be a Federation officer; her wearing of the uniform in a civil proceeding was more an expression of the values she associates with that designation than of sheer fandom (*Trekkies*). The emphasis of romance-tradition fantasies on the individual as a radically self-determined, free agent may be, then, less a disabling lie than an enabling fiction.

As for the charge that romance-tradition fantasies inherently are more interested in past thought-constructs than future ones, and are therefore irrelevant to social progress (a common criticism and one made by Brian Aldiss in his Guest of Honor address at the Twentieth International Conference on the Fantastic in the Arts), I suggest that we need to consider fantasy fictions with the same complex paradigm with which we might consider even a loosely historical, or legendary, fiction, such as *Macbeth*. *Macbeth* is superficially a representation of eleventh-century Scotland, a feudal society racked by rebellion, but it is much more profoundly a play that is caught up in the concerns and ideations of its Renaissance present. The play, for instance, both frets over the gross tension of personal ambition in conflict with courtly honor, of duty to king separate from that owed to country (since it was written and performed a year after the Gunpowder Plot nearly killed James I), and repeatedly worries the vexed relationship between the metaphysics and physics of our newly humanized, gradually demystified bodies. Although, like MacDonald or Tolkien, I would not want to reduce fantasies merely to allegories of the present or projections into the future, I believe that the careful historicizing of romance-tradition fantasies will reveal that they are very much engaged with timely concerns.

Consider the differences in Tolkien and MacDonald's best-known heroic quests. In *The Lord of the Rings* (published 1954–1955, but composed beginning in 1938), Frodo's quest to destroy the ring evokes the *Zeitgeist* of a world that had known global warfare, one that had been faced with its own destruction at a time when the efficacy of individual acts of heroism upon such a vast and chaotic stage was increasingly in doubt. Written nearly sixty and

seventy years earlier, MacDonald's tales of Curdie's quests are more limited in scope, confined to the saving of an individual nation whose right governance is eroded by internal rot at a time (pre–World War I) when acts of individual heroism were still a motivating English cultural ideal.  In *The Princess and the Goblin* (1872), Curdie helps to suppress the perhaps once justifiable rebellion of a neglected residuum and, in the second, *The Princess and Curdie* (1883), to root out the materialistic, self-interested power elite that has successfully emasculated the king.  Faith in the unseen must sustain Curdie in each case, whereas Frodo's journey is more a test of physical and emotional endurance; he can but press on with the aid of a dwindling group of companions whom he must trust—a shift that marks the increased secularism of English culture in those intervening years.  As these examples imply, romance-tradition fantasies are not, it is true, speculating about such concerns as directly or as radically as do science fiction/speculative or distinctly utopian fictions, but they are also not merely retreading the same ground without reinscribing and reinventing, sometimes even quite consciously.  Modern, literary fairy tales, for instance, have proved an especially fertile ground for revisionist narratives, most notably in their feminist retellings and inventions.

Theorists have talked about the ways in which romance-tradition fantasies have naturalized cultural constructs in a number of ways, and I now turn to describing and addressing those charges.  Feminists such as Karen Rowe have criticized popular fictions for perpetuating gender stereotypes and fairy tale romance plots that make marriage the expected *telos* for the female *Bildung*.  Marxist critiques have addressed such stories' celebration of individualism, both because the individual celebrated is normalized as white, western, male, and bourgeois and because narratives that depict individuals as agents of their own destinies mystify the pernicious social determinisms against which collective action and a meta-awareness of the politics of identity are the only effective force.  Romance-tradition fantasies in particular have also been accused of quenching the fires of potentially disruptive desires in the cool baths of medievalism, or any other form of soft primitivism, and religious ideation.  What Jameson calls "archaic nostalgia," or past-ism, both keeps alive the myth that a recovery of lost origins is possible (an unproductive fallacy in a postcolonial and/or postindustrial culture) and perpetuates any number of the outdated and undesirable values that may be associated with its particular discourses.  Religious ideation is similarly problematic, for it resurrects the sense that there is a transcendent basis of and consolation for social limitations and ills.  Jackson criticizes many Anglo-American fantasy theorists, especially those of the preceding, prestructuralist generation, for perpetuating in their own work these conservative constructions and their transcendent consolations.  The "notion of fantasy literature as fulfilling a desire for a 'better,' more complete, unified reality," she writes, "has come to dominate reading of the fantastic, defining it as an art form providing vicarious gratification" (2).  Among the fantasy theorists Jackson might name here would be J.R.R. Tolkien, Colin Manlove, Humphrey Carpenter, and Ursula K. Le Guin—indeed, any of those who portray fantasy as striving to create a secondary world that proposes to imaginatively or actually transcend the lack in this one.  These theorists have reproduced the "nostalgic, humanist vision of the same kind as those romance

visions produced" by "the authors they have studied" (2). Such a vision cannot be freed, Jackson believes, from its complicity in the moral and social hierarchy from which it sprang. Some romance-tradition fantasies and genres have also been criticized for reinforcing moral and social hierarchies through the use of omniscient narration, which some postmodern critics believe establishes an epistemological perspective that falsely pretends to be disinterested and able to supersede the historical moment. Omniscient narration, they claim, is also invested with an absolute authority, reinforcing a sense of objective truth and institutional empowerment. Another common charge is that romance-tradition fantasies universalize settings and characterizations, tacitly conveying a norm that is actually inflected with particular cultural assumptions and identity markers. Tolkien's famous (non-)trilogy, for example, *self-consciously* springs from a Northern European mythos,[6] and implicitly reinforces tropes of Germanic "civilization" by setting it against the Mongol "barbarity" of the orcs (*Letters* 212, 274).

The critical dismissal of romance-tradition fantasy I have been describing—one that moves beyond justifiable critique—may be the result of an oversimplified conception of how cultural norms are constituted and by what mechanisms fictions subvert them. In my view, cultural norms are constituted by both collective ideals and usual social practices. In a homogenous culture, usual social practices such as manners, rituals, approved social types, and institutions are perceived as collective performances that express that culture's shared ideals. Those collective ideals that unify a culture also become the standard by which social practices within it are judged normal or transgressive. Romance-tradition fantasies, I would argue, do subvert cultural norms, but in a different way than narratives of that other major strand of post-enlightenment fantasy, gothic fiction. Both gothic and romance-tradition fantasies embody implicit criticisms of cultural norms through giving readers experiences of social practices that deviate from them.

Gothic fiction subverts cultural norms through exposing collective ideals as besieged and betrayed in practice. It portrays practices that are so deviant, so transgressive, that the old ideals which would have formerly condemned them are exposed as impotent; their spectral presence in these texts fragments rather than unifies, damns rather than saves, those who attempt to impose them. In this way, readers are enabled to feel a liberating thrill as they vicariously experience a dis-ordered world, still at a safe psychological distance. Gothic fictions are not necessarily radically subversive, however. Often, disturbing elements are strongly suppressed, allowing readers to enjoy the reimposition of order. Stoker's *Dracula* associates an unholy, sexualized corruption with Eastern European aristocracy and its primitive origins. Both the Count's and Lady Arabella March's transgressions against social order are punished and erased by modern, middle- and upper-class men who may be imagined to represent the new, right sort of order. In *The Lair of the White Worm*, Adam Salton's furtiveness denies scrupulous chivalry, his dynamiting of an ancestral home the sacredness of such estates and their denizens. Only through operating on ideals different from the old aristocratic ones is Salton able to overcome the symptoms of their dis-ease. The social practices that Salton reacts against, however embedded they are in the leisured voraciousness of the

aristocracy, are portrayed as deviant. Their disordering of the world is relatively limited, localized.

Modern romances, on the other hand, tend to reinforce a traditional collective ideal in the face of widespread transgressions against it; these undesirable social practices are often grounded implicitly in a displacing yet still competing ideal. Hence, when romance-tradition fantasies *are* subversive, they tend to subvert what has become or is swiftly becoming the cultural norm by marking some social practices as transgressive that average members of that culture would now consider usual. At best, the world is at war with itself and the protagonist (who represents the traditional idea) must ensure that the righteous side wins; at worst, the troops of disorder have been victorious, their government instituted, and the protagonist must negotiate a thorny course in attempting to set things right. Often, especially when most influenced by Romanticism, these struggles are more of a special kind of vision and understanding than they are for tangible victories, such as in Coleridge's *Rime of the Ancient Mariner* or Windling's *The Wood Wife*. In both of these works, separated by era and nation but not by sensibility, the forces of reason have conquered our everyday minds; materialism has become the basis for usual social practices such as the slaying of an albatross or blindness to the plight of the coyote through urban incursions into its natural habitat. Through puzzlement and sacrifice, their protagonists gain an expanded vision of the real, enabling them to encounter, express, and potentially revitalize a former and still somewhat present and longed for social idea: that nature is not inert, but imbued with living spirit(s). Traditional ideals, however, are often revised through the operation of fantasy. Coleridge's pantheism does not simply call readers to acknowledge an evangelically sanctioned, immanent deity, nor does Windling's suggest that animal spirits exist in a mere figurative sense, as an allegory for a Gaian hypothesis.

I grant that romance-tradition fantasies tend to subvert present collective practice in order to reinforce, reinvigorate, and/or reinscribe traditional ideals. Even so, I believe we ought to study even those cultural phenomena that, at their most conservative, merely reinforce cultural ideals as vigorously as we do those which subvert them. Societies form a springboard for broad-based action through consolidations of collectively held belief, even as the forces that subvert such normativizing structures help to open up aspects of cultures that may have become too oppressively defined. I do not deny the value of more disruptive subversive modes of narrative, or theory. I believe, however, that their impulse to reject traditional cultural paradigms as a legitimate basis for social progress limits their potential for appealing to and enlightening the popular mind.

Although I accept the poststructural supposition that conventional symbolic systems are not inherently genuine, natural, true, or right, I believe that they enable individual and collective agency by lending cultural capital to those who invest in them. Some poststructural accounts of resistances to colonialism have already suggested this approach. For example, Wendy Faris has argued that South American magical realism's recovery of folkloric motifs contributes, at least in part, to the recuperation of the precolonial identifications that had been rooted in them. Through appealing to these authorizing and enabling

myths, reformist poetics, on the one hand, provide a basis for conserving those established cultural elements that do have positive effects.  On the other hand, they may employ what is in my view a more pragmatic method for critiquing, revising, and—to an admittedly somewhat limited degree—transcending more pernicious cultural formations.  Romance-tradition fantasy employs cultural myths not only to reify the dominant paradigm, but also to reopen possibilities for—albeit qualified—idealistic reform.  In fact, I claim that they better enable the popular acceptance of those revised ideations that may lead to individual and collective reforms.

I have, so far, been discussing conceptualizations of fantasy as if they had not changed since the advent of modernity; now I turn to the elucidation of such a postmodern history.  In a recent Foucaultian sociohistory of the fantastic, *A Specter Is Haunting Europe*, José Monléon argues that the rhetoric of unreason developed in three distinct stages.  Initially, when the bourgeoisie were consolidating power, they kept the forces of unreason on the margins of an orderly bourgeois society.  Once the bourgeoisie were entrenched, they characterized the forces of unreason as invading social order until they were perceived as threatening from within.  Finally, as those groups previously associated with unreason began to take up the rhetoric of reason, the bourgeoisie reacted by identifying with and owning the rhetoric of unreason. This last move was in response, perhaps, to a growing sense of modern life's absurdity and banality in the absence of a central, unassailable theosophy.  Monléon's history purports to correct the view held by Freud, Todorov, and Jackson that, as Western cultures evolved toward rationalism, they increasingly made a distinction between fantastic and mimetic modes, with the mimetic being in service of bourgeois ideology and the fantastic in that of those who would subvert it.

The bad news that Monléon wants to share is that "the particular expression that the avant-garde and modernism gave to the fantastic cannot be isolated from a path whose roots lay . . . in the formation of the industrial society," since the bourgeoisie, whom Monléon also calls "the political right" (something of a misnomer), saw and seized the advantage of such discourse. The fantastic is therefore neither inherently subversive nor reifying; however, it is more often used to "defend . . . reactionary idealism" than to "denounce . . . the universalization of bourgeois determination of reality" (138).  Citing Lukacs, Monléon accepts the leftist account that the bourgeoisie are the "adversaries" of social progress.  His history is therefore a cautionary call to critics to more carefully discern to what ultimate politically unconscious ends texts employ the fantastic, for, he writes, "Only through particular analyses can it be determined" whether a text is effectively progressive or conservative.

Monléon places his hope not in the fantastic texts written between 1760 and 1930, which is the scope of his study, but in the radical, post–World War II narratives that are descended from modernism.  These he suggests may break free of cultural constraints, for they challenge language itself, "the last barrier of reason" (140).  This is the only way to take away society's power of definition, its ability to impose "strict rules" upon the individual.  For postmodern theorists, this may be the ultimate fantasy, but I would argue it is far from working toward a utopian vision.  Such visions require the struggle to find mutual definitions of

what is sacred, what contested, what inert, and what taboo. I believe that
romance-tradition fantasy remains a popular forum that, when not written with
utterly rote convention, is well suited to the patient articulation of that struggle.
It is a fictive engagement with history that need be neither radical nor
reactionary, neither negate the individual nor deny the collective, to render the
impossible ideal in all the forms not yet dreamt of in our philosophy.

## NOTES

1. By romance-tradition fantasy, I mean that strain of modern fantasy
composed of marvelous narratives (in which the impossible is confirmed as existing or
occurring within the fictional world) that evoke feelings of awe, whimsy, wonder, or
delight—rather than horror—effectively celebrating the heroic and the ideal.

2. Veronica Hollinger highlights the notion that fantasy may evoke desire for
something that is approved but impossible within a given society when she sets up the
category of a perverse utopia against the classical ideal. For Hollinger, a perverse utopia
is an imaginative space that permits the manifestation of desires that have been marked as
deviant, as impermissible, within the conventional "good place." Seen from such an
abject or subaltern perspective, classical utopia becomes a space for the manifestation of
socially approved desires, perhaps extrapolated to a logical extreme that recovers them
from the naturalization with which Hollinger charges them in her peripheral critique of
Moore's *Utopia*.

3. Theorists of the fantastic tend to form very different theories depending on
which texts they designate as the generic or modal norm—a fallacy I shall call the
"Advocacy Effect." In *The Encyclopedia of Fantasy*, Clute and Grant presuppose
conventional, or high, fantasy to be the starting point for a definition of fantasy literature.
While I believe that Clute and Grant are sensitive to having made this presupposition and
to the implications it raises, my argument is that Jackson is not. She argues too stridently
for a fantastic norm based on her own tastes, effectively undermining her attempt to
unlink a fantastic mode from the formal and structural definitions of the fantastic that had
previously existed.

4. Romance-tradition fantasies are accused of satisfying and reassuring readers
through employing conventions with which they are familiar, using language in
predictable ways, failing to trouble their underlying assumptions, or giving them any
experience of estrangement.

5. Jules Zanger's argument is that high fantasy's political work has been to
express individual resistance to faceless power, to depict a stand against impersonal
faces. The postmodern account of culture might see this as a wish fulfillment fantasy of
an impotent, socially determined bourgeois subject. Such wish fulfillments might be
labeled as dangerous or counterproductive. Among other things, they provide readers
with an outlet for any dissatisfaction they may feel as a result of their alienation and
powerlessness and reinforce the myth that individuals succeed or fail by their own efforts,
rather than acknowledging how material constraints and power relations impact their
social opportunities on many levels.

6. Many readers have also noted Celtic influences in Tolkien's fantasy.
However, at least in the case of *The Silmarillion*, Tolkien denied any self-conscious
Celtic associations. He made the denial when defending the work in a December 16,
1937 letter to publisher Stanley Urwin, who had informed him that the firm's outside
reader, Edward Crankshaw, had criticized his secondary world's metamyth as "having
something of that mad, bright-eyed beauty that perplexes all Anglo-Saxons in face of
Celtic art" (qtd. in Tolkien, *Letters* 25). "Needless to say they [the names are used] are
not Celtic! Neither are the tales," wrote Tolkien, "I do know Celtic things (many in their

original languages Irish and Welsh), and feel for them a certain distaste: largely for their fundamental unreason. They have bright colour, but are like a broken stained glass window reassembled without design. They are in fact 'mad' as your reader says—but I don't believe I am" (*Letters* 26). Here, however, it must be noted that although Tolkien continued to implicitly privilege Germanic culture over Celtic and others in his later fantasy (mainly composed during World War II), he was not sympathetic to the existing German regime. He expressed unequivocal feelings against the labeling of whole races as inferior, including both Jews and, in the faces of a growing backlash, Germans (*Letters* 37–38, 92–93).

## REFERENCES

Aldiss, Brian.  Guest of Honor Address.  Twentieth International Conference on the Fantastic in the Arts.  Ft. Lauderdale Airport Hilton; Dania, FL.  18 March 1999.

Armitt, Lucie.  *Theorising the Fantastic.*  Ed. Patricia Waugh and Lynne Pearce. Interrogating Texts.  London: Arnold-Hodder Headline Group, 1996.

Attebery, Brian.  "Is Fantasy Literature?  Tolkein and the Theorists."  *Strategies of Fantasy.*  Bloomington: Indiana University Press, 1992. 207–213.

Auerbach, Nina, and U. C. Knoepflmacher, eds.  Preface to *Mopsa the Fairy. Forbidden Journeys: Fairy Tales and Fantasies by Victorian Women Writers.*  Chicago and London: University of Chicago Press, 1992. 207–213.

Barthes, Roland.  *S/Z.*  Trans. Richard Miller.  New York: Hill and Wang, 1974.

Carpenter, Humphrey.  *Secret Gardens:  A Study of the Golden Age of Children's Literature.*  Boston: Houghton Mifflin Company, 1985.

Clute, John, and John Grant, eds.  *The Encyclopedia of Fantasy.*  New York: St. Martin's Press, 1997.

Coleridge, Samuel Taylor.  "The Rime of the Ancient Mariner."  *The Norton Anthology of Enlish Literature, Vol. 2.*  Ed. M. H. Abrams.  6th ed.  New York: Norton, 2003: 330–346.

Davis, Lennard J.  *Resisting Novels: Ideology and Fiction.*  New York: Viking-Penguin, 1987.

de Lindt, Charles.  *Jack of Kinrowan.*  1995. New York: Tor, 1999.

Donaldson, Stephen R.  *The Chronicles of Thomas Covenant, the Unbeliever.*  1977 (severally).  London: HarperCollins, 1993 (omnibus).

Ellis, Kate Ferguson.  *The Contested Castle: Gothic Novels and the Subversion of Domestic Ideology.*  Urbana: University of Illinois Press, 1989.

Faris, Wendy B.  "Scheherazade's Children: Magical Realism and Postmodern Fiction." *Magical Realism: Theory, History, Community.*  Ed. Lois Parkinson Zamora and Wendy B. Faris.  Durham, NC: Duke University Press, 1995. 163–190.

Hollinger, Veronica.  "The Utopia of the Perverse: An Exercise in 'Transgressive Reinscription' " Twentieth International Conference on the Fantastic in the Arts. Ft. Lauderdale Airport Hilton; Dania, FL. 18 March 1999.

Jackson, Rosemary.  *Fantasy: The Literature of Subversion.*  London: Methuen, 1981.

Jameson, Frederic.  "Magical Narratives: Romance as Genre."  *The Political Unconscious: Narrative as a Socially Symbolic Act.*  New York: Cornell University Press, 1975. 103–150.

Le Guin, Ursula K.  "The Child and the Shadow."  *The Language of the Night.*  Ed. Ursula K. Le Guin. (1974). Rev. ed. New York: HarperCollins, 1989. 54–67.

———.  "Myth and Archetype in Science Fiction."  *The Language of the Night.*  Ed. Ursula K. Le Guin. (1976). Rev. ed. New York: HarperCollins, 1989. 68–77.

MacDonald, George.  *The Princess and Curdie.*  1882.  New York: Penguin-Puffin Books, 1996.

————. *The Princess and the Goblin.* 1871. New York: Alfred A. Knopf–Children's Classics, 1993.

Manlove, C. N. *The Impulse of Fantasy Literature.* Kent, OH: The Kent State University Press, 1983.

————. *Modern Fantasy: Five Studies.* Cambridge, MA: Cambridge University Press, 1975.

Michaelson, Karen. *Victorian Fantasy Literature: Literary Battles with Church and Empire.* Studies in British Literature. 10. Lewiston: Edwin Mellen Press, 1990.

Monléon, José. *A Specter Is Haunting Europe: A Socio-historical Approach to the Fantastic.* Princeton: Princeton University Press, 1990.

Rabaté, Jean-Michel. "Barthes, Roland." *The Johns Hopkins Guide to Literary Theory and Criticism.* Baltimore: The Johns Hopkins University Press, 1994.

Rowe, Karen E. "Feminism and Fairy Tales." *Women's Studies.* 6 (1979): 237–257.

Shakespeare, William. *Macbeth.* Oxford: Oxford University Press-World Classics, 1998.

Stoker, Bram. *Dracula.* Ed. Nina Auerbach and David J. Skal. Norton Critical Edition. New York: W. W. Norton, 1996.

Todorov, Tsvetan. *The Fantastic: A Structural Approach to a Literary Genre.* Tr. Richard Howard. Cleveland OH: Press of Case Western Reserve University, 1973.

————. *The Lair of the White Worm.* Polegate, East Sussex: Pulp Fictions, 1998.

Tolkien, J.R.R. *The Fellowship of the Ring.* 1954. Boston: Houghton Mifflin, 1987.

————. *The Hobbit.* Boston: Houghton Mifflin, 1966.

————. "On Fairy-Stories." *Tree and Leaf.* London: Allen and Unwin, 1964.

————. *The Letters of J.R.R. Tolkein.* Ed. Humphrey Carpenter. Boston: Houghton Mifflin, 1981.

————. *The Return of the King.* 1955. Boston: Houghton Mifflin, 1987.

————. *The Two Towers.* 1954. Boston: Houghton Mifflin, 1987.

*Trekkies.* Dir. Roger Nyggard. Neo Motion Pictures, 1999.

Windling, Terri. *The Wood Wife.* New York: Tor, 1996.

Zanger, Jules. "Heroic Fantasy and Social Reality: *ex nihilo nihil fit.*" *The Aesthetics of Fantasy Literature and Art.* Ed. Roger Schlobin. Notre Dame, IN: University of Notre Dame Press, 1982. 226–236.

Zipes, Jack. *Fairy Tales and the Art of Subversion.* New York: Wildman Press, 1983.

————. Introduction. *Victorian Fairy Tales: The Revolt of the Fairies and Elves.* New York: Routledge, 1987. xiii–xxix.

# Index

# About the Contributors

MARTHA BARTTER is Professor of English at Truman State University, where she teaches American Literature, American Indian Literature, Fantasy and Science Fiction, and Mythology. A member of the Science Fiction and Fantasy Writers of America, she is the author of *The Way to Ground Zero* (Greenwood, 1988) and many articles and reviews.

JEANNE BECKWITH currently teaches English and Speech at Norwich University in Northfield, Vermont. She has been writing and producing plays since 1982. A director as well as a playwright, she has worked both in children's theatre and as a professional actor in summer repertory theatre, most recently with the Highlands Playhouse in Highlands, North Carolina. Her plays have been produced at the University of Georgia, the Bloomington Playwrights Project in Bloomington, Indiana, and the Hypothetical Theatre Company in New York City.

BILL CLEMENTE is a Professor and Chair of English at Peru State College in Nebraska, where he has taught for the past decade. In 1999 he served as a jury member for the James Tiptree, Jr. Memorial Award, and his interview with Tiptree winner Suzy McKee Chanas is published in *Women of Other Worlds*. His publications include articles on authors Suzy McKee Charnas and James Tiptree in *Foundation*, *Extrapolation*, and *Fantastic Odysseys* (Greenwood Press, 2003).

OSCAR DE LOS SANTOS, Ph. D., is Associate Professor of English at Western Connecticut State University. He is also co-chair of the English Department and its director of graduate studies in English. His co-authored fiction collection, *11:11—Stories About the Event*, was published in 2002, and his co-authored collection of essays, *Questions of Science, Answers to Life* in 2003. His main areas of interest include modern American literature, postmodernism, Latino literature, science fiction, and horror.

JOHN C. HAWLEY is Associate Professor at Santa Clara University. He has edited ten books, most recently *The Encyclopedia of Postcolonial Studies* (Greenwood, 2001) and *Postcolonial, Queer Theoretical Intersections* (2001).

CHERILYN LACY is Assistant Professor of History at Hartwick College in Oneonta, New York, where she was also Coordinator of the Women's Studies Program from fall 2000 through spring 2002. Her research centers on gender and the history of medicine in nineteenth-century France, and more generally on the intersections of gender and Western science.

THOMAS J. MORRISSEY is University Distinguished Teaching Professor of English at Plattsburgh State University. He has published widely in science fiction, and children's and Irish literature. He is co-author with Richard Wunderlich of *Pinocchio Goes Post Modern: Perils of a Puppet in the United States* (2002), and is author/composer of three musical comedies, including *Puppet Song*, a play inspired by Collodi's *Pinocchio*.

DONALD E. MORSE, Emeritus Professor of English and Rhetoric, Oakland University, Michigan, is currently Visiting Professor of American, Irish, and English literature, University of Debrecen, Hungary. He has been twice Fulbright Professor (1987–1989, 1991–1993) and Soros Professor (1990, 1996–1997), University of Debrecen. He is co-author of *Worlds Visible and Invisible* (Greenwood, 1994), the editor of *The Delegated Intellect: Emersonian Essays on Literature, Art, and Science* (1995), and *The Fantastic in World Literature and Arts* (Greenwood, 1987). Several of his essays on Vonnegut have appeared in scholarly journals in Hungary, Germany, and the United States. In 1999 the University of Debrecen awarded him an Honorary Doctorate in recognition of his service to Hungarian higher education and his international scholarship.

ROBIN ANNE REID is Associate Professor in the Department of Literature and Languages at Texas A&M University-Commerce. Her position in "Creative Writing and Critical Theory" allows her to teach everything from Creative Writing to Stylistics to Gender Theory, and she has published poetry as well as books on science fiction. Her main area of scholarly interest in recent years has been the question of how different feminist theories intersect with a variety of fantastic texts, including utopias.

ROGER C. SCHLOBIN is a professor emeritus of English at Purdue University and currently a visiting Assistant Professor at East Carolina University. He has authored six scholarly books and edited over fifty. His various other publications include over one hundred essays, various poems, short stories, reviews, and bibliographies that range over many topics. He is one of the founders of the International Association for the Fantastic in the Arts and its conference and the "Year's Scholarship in Science Fiction and Fantasy." He is past editor of *The Journal of the Fantastic in the Arts* and the author of the first original, electronic novel to be published over the Internet: *Fire and Fur: The Last Sorcerer Dragon* (1994).

KELLY SEARSMITH specializes in Victorian Literature and Studies in the Fantastic. She has served as Assistant Professor of English at Appalachian State University. Currently, she teaches at the University of Illinois where she is writing a book on the Victorian Fantastic. She has published articles on masculine reform in George MacDonald's *Phantastes* (*Journal of Pre-Raphaelite Studies*) and ad defense of romance-tradition fantasy (*Journal of the Fantastic in the Arts*).

SHARON STEVENSON is Associate Professor of English and Coordinator, Graduate Studies in English, Central Michigan University. She is a Medievalist interested in characteristics and limits of genre forms.

CARL SWIDORSKI is Professor of Political Science in the Department of History and Political Science at The College of Saint Rose in Albany, New York.

DENNIS M. WEISS is Associate Professor of Philosophy and Chair of the English and Humanities Department at York College of Pennsylvania. He is the editor of *Interpreting Man* and the author of essays on the digital culture, philosophical anthropology, and science fiction.

LYNN F. WILLIAMS, Professor Emerita from Emerson University, Boston, MA, died before she could give her paper on *Kirinyaga*, which is included in this volume, at the Iinternational Conference on the Fantastic in the Arts. She was a long-time member of the Society for Utopian Studies, and contributed many papers on utopia to various publications. Her paper on *Kirinyaga* was completed from her notes by Martha Bartter.

TAMARA WILSON is Assistant Professor at Flager College. Her areas of academic study include folklore, women's literature, science fiction/fantasy, American Indian literature, and film studies. She has presented several papers for the International Conference on the Fantastic in the Arts and the Popular Culture Conference. Contemporary culture and the vision of the future are central concerns of her work with students and in her writings.